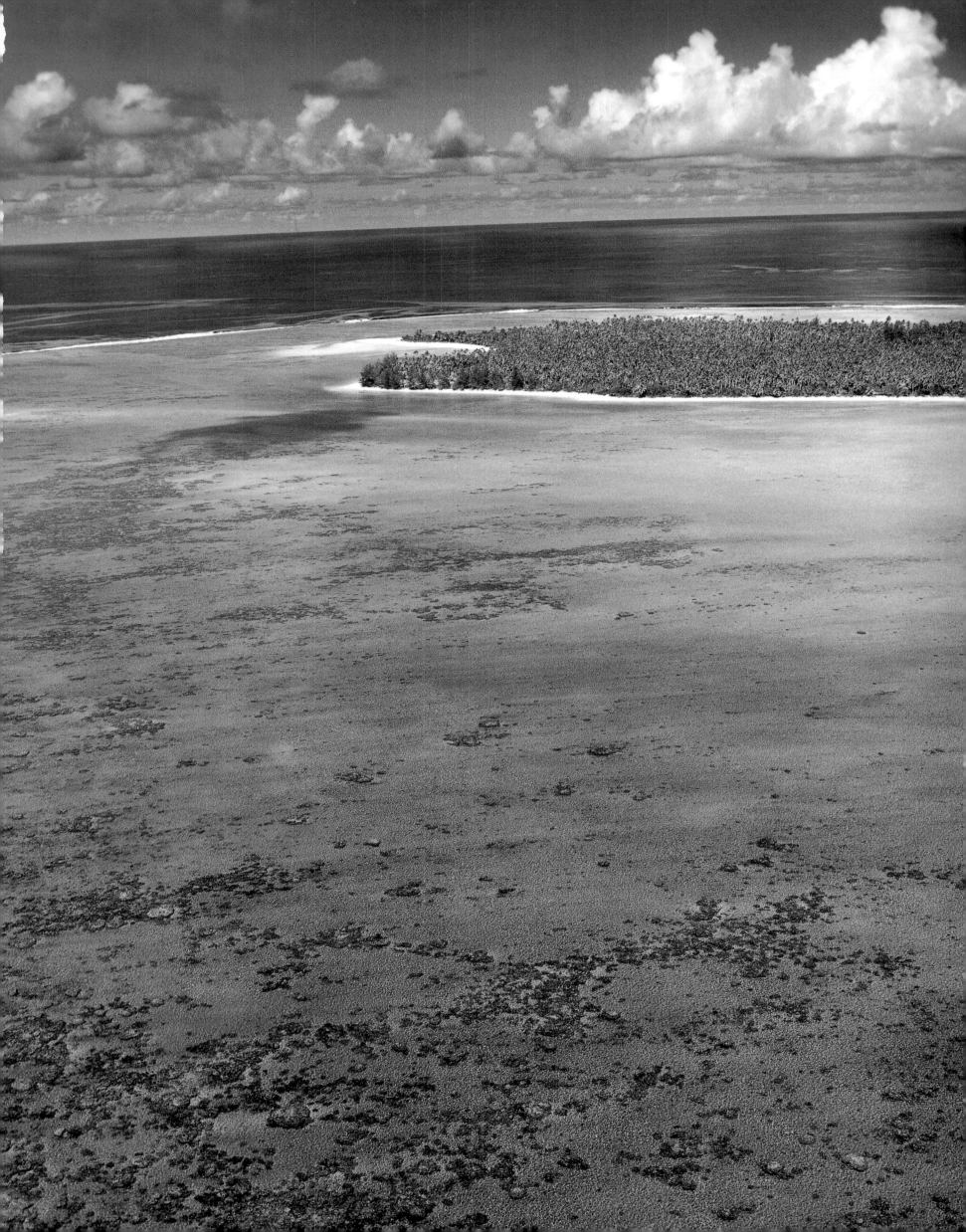

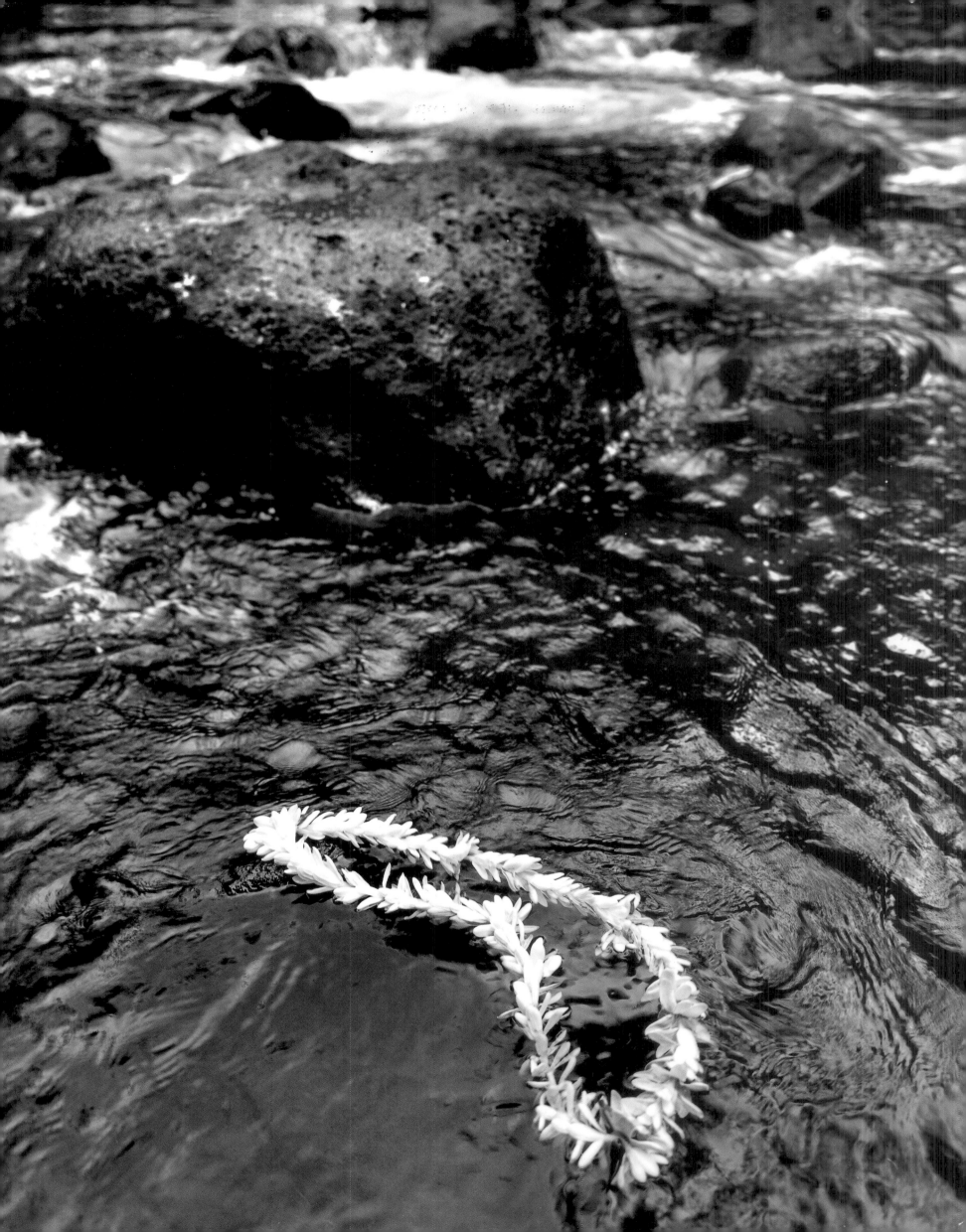

TAHITI TATTOOS

TASCHEN
KÖLN LISBOA LONDON NEW YORK PARIS TOKYO

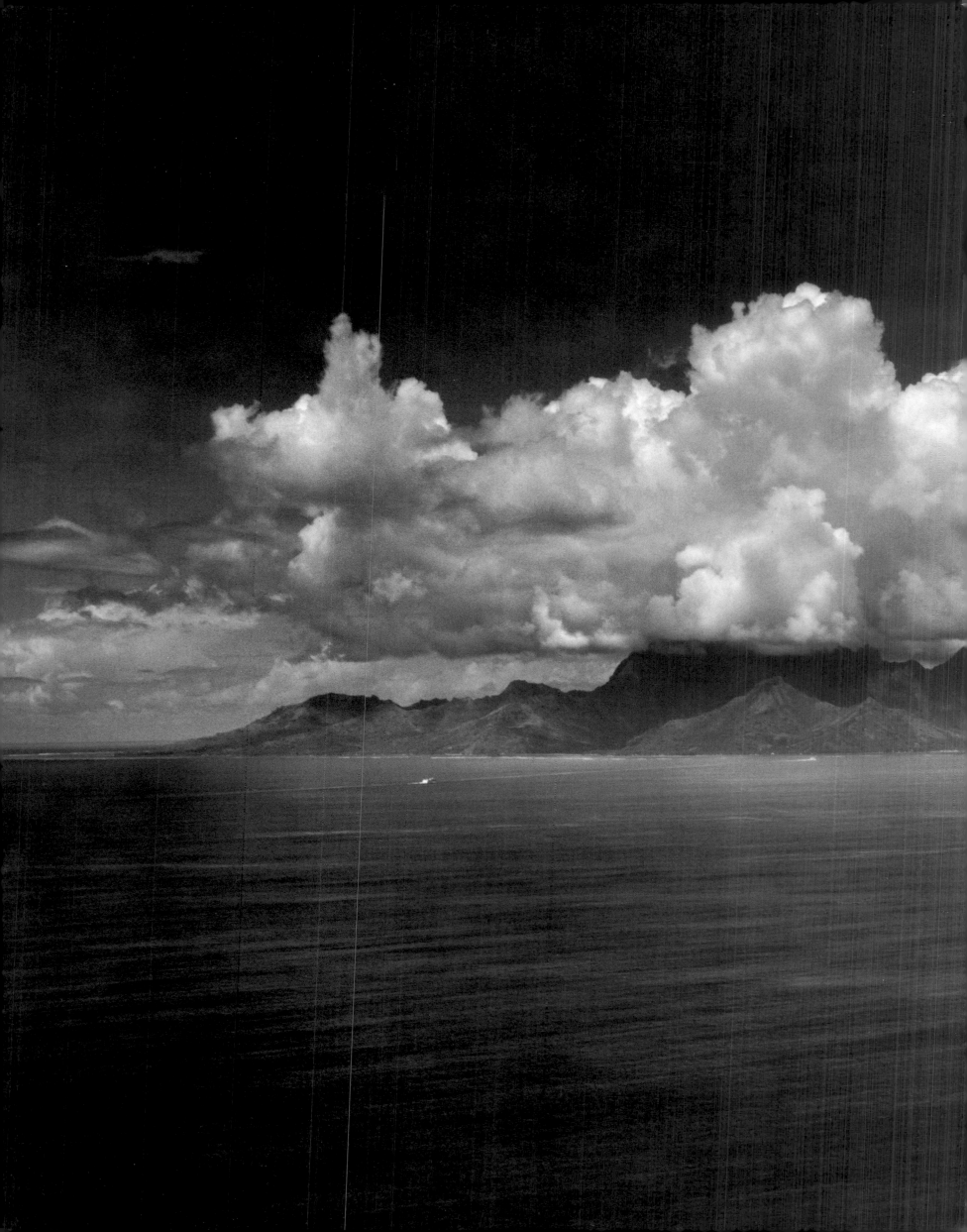

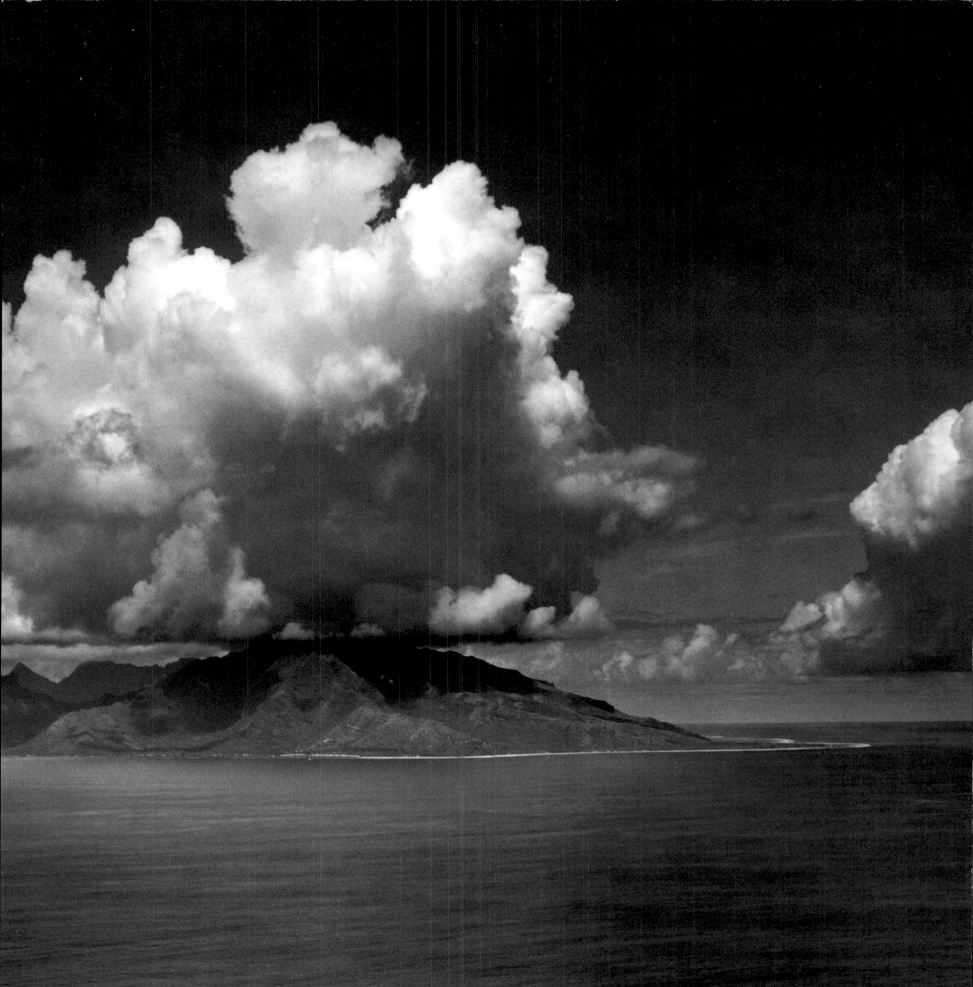

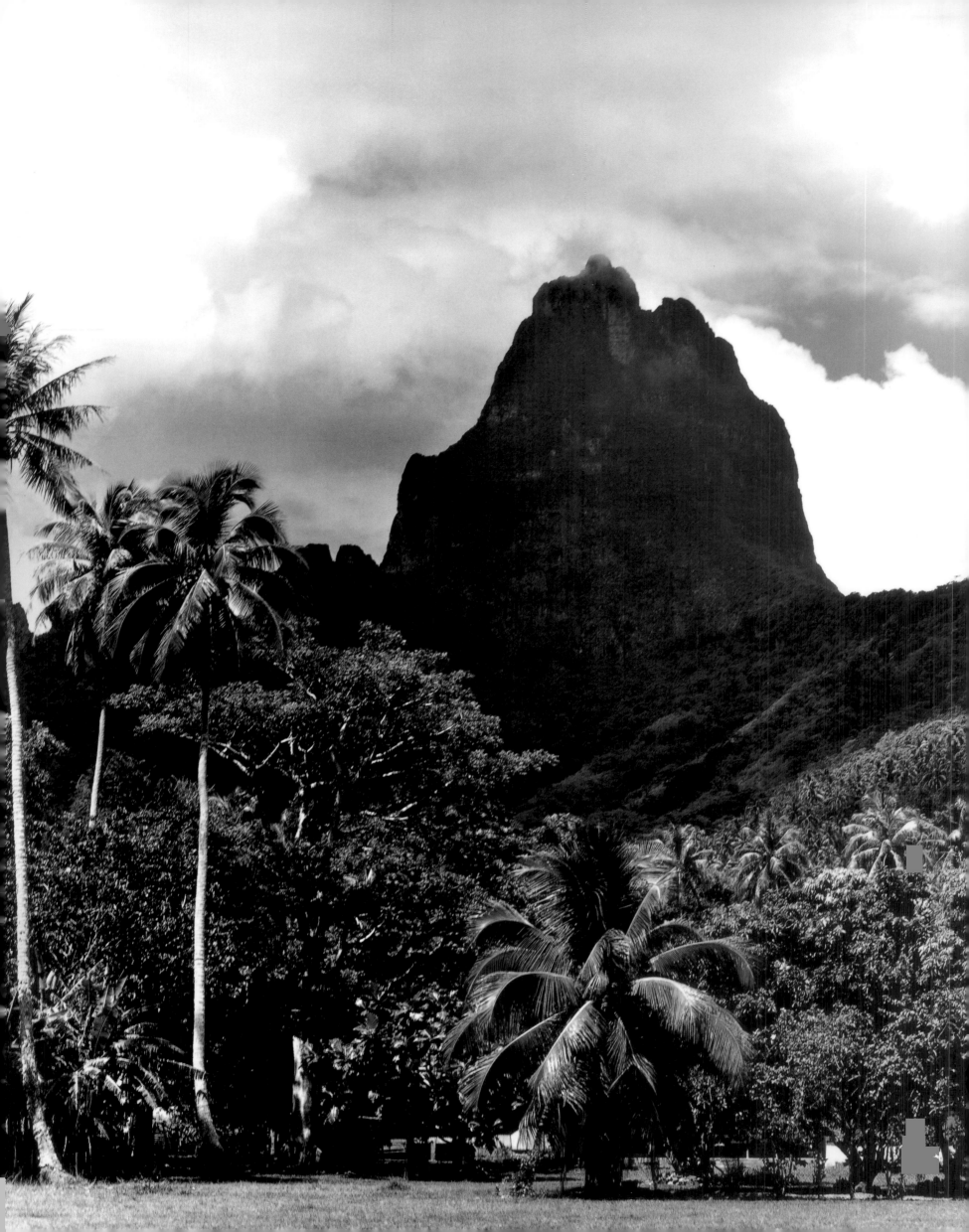

Gian Paolo Barbieri

TAHITI TATTOOS

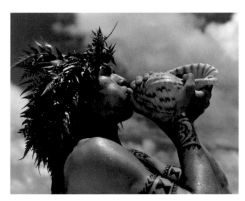

Introduction by
Michel Tournier

The History of Tattooing in Polynesia by
Raymond Graffe

Passages from "Noa Noa" by
Paul Gauguin

WHEN SKIN SPEAKS

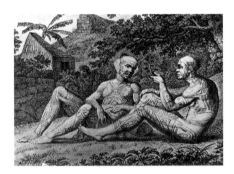

Nothing in a person goes deeper than skin, said Paul Valéry. No doubt because through skin we offer ourselves as objects one to another. First and foremost there is the colour of skin. In many societies a fastidious hierarchy reigns, with black at its base and white at its summit, passing through every nuance of brown and beige. Less than a century ago, this was true even of 'whites' in Europe, for whom a tanned skin was the ignominious mark of the lowest class, that of the rural worker. Times have changed – it would be fascinating to know why. City-dwellers expose themselves to the sun at great expense against the categorical advice of their doctors. In Nordic countries, a winter tan is the ultimate in chic. At the same time, a rehabilitation of blackness has begun: black is beautiful. In this whole matter of skin, tattooing has an enigmatic and paradoxical place. And the distinction between Western and Polynesian tattooing is absolute and instructive.

In the West of our own time, the revelation that someone of our acquaintance is tattooed elicits a variety of feelings. A first observation: Western custom provides that tattoos may remain secret. Neither face nor hands are tattooed. The tattooed reveal themselves because they choose to, by stripping to the skin. The intimacy thus conferred imparts an almost erotic aspect to the tattoo. Western tattoos therefore evoke the private life: affairs, declarations of love or hate, vengeance sated or sought. Three other traits belong to this secretive, emotional aspect of Western tattooing. They reveal its shady, indeed sordid, origins. You come by a tattoo in the navy,

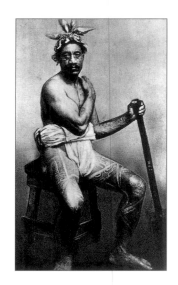

the Foreign Legion, above all in prison, preferably in forced labour. This necessarily evokes the branding of the convict. Secondly, the tattoo is acquired through suffering. And finally, it cannot be effaced. These characteristics have a singular coherence. They can be expressed in a single sentence: the bodies of those who have suffered in an abject milieu shall forever bear the painful mark of it.

This is the typology of the Western tattoo. We might add the moving and enigmatic statement made by the actor Michel Simon when asked why he was tattooed. He replied: 'My friends are tattooed, as I am. The tattooed never betray'.

This definition might serve as a starting point for an attempt to decipher 'in Western fashion' the phenomenon of tattooing such as it exists in the Polynesian islands. Clearly, there is nothing secretive about the Polynesian tattoo. On the contrary, it ostentatiously covers a scantily dressed body. It is there to be seen. It is the opposite of stigmatizing. It might be said to replace garments, to clothe the Polynesian body. At which point we should note that Western clothing quite exceeds its utilitarian function. True, we dress to protect ourselves from cold and hurt. But our clothes are also a sign of coquetry (or negligence), wealth (or poverty), power (or impotence); of function, grade and so on. Our clothes are a language, but it is a language superimposed on the body and supplementary to clothes' utilitarian function.

Polynesian tattoos are also language, but primary, primordial, original language. Tattooed, the body becomes a body-sign. It

 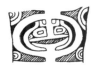

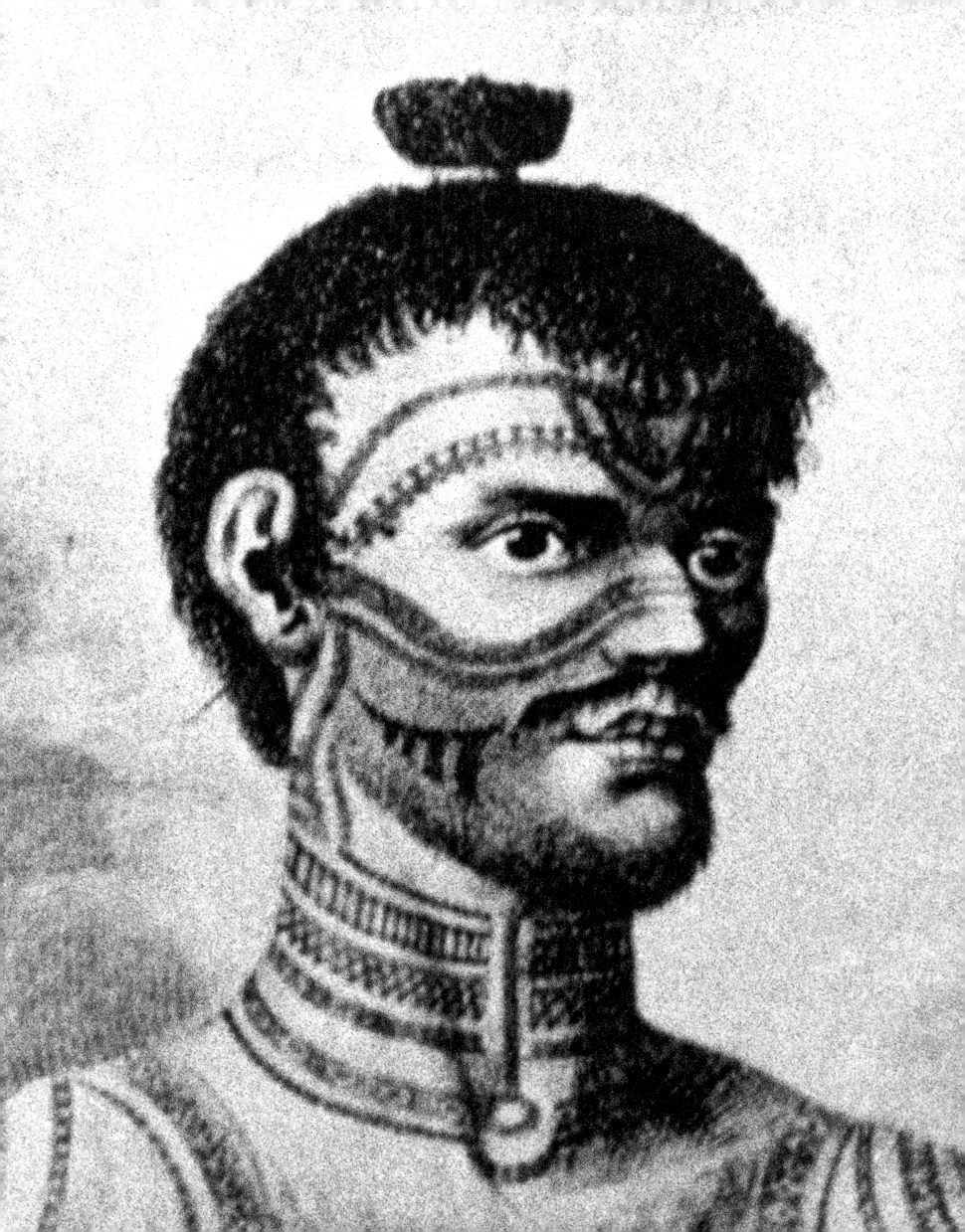

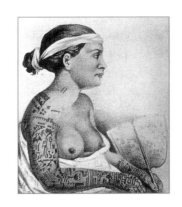

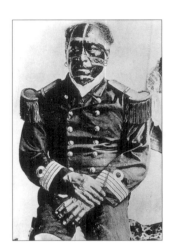

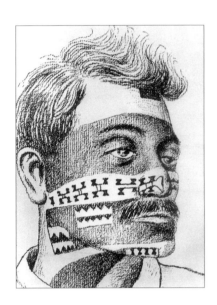

is a book of spells scrawled on the skin, it is knowledge and initiation. And in this way suffering and indelibility take on a sense quite different from that which they assume in Western countries. Putting on a Western garment is not painful, and it can always be changed. This gratuitousness and facility invalidate it. But in the Polynesian tattoo, suffering and indelibility entirely lack the sense of misery and filth implicit in the Western tattoo. They simply impart an incomparable gravity to the sign cut forever into the body of the initiate. We note parenthetically the somewhat vain and cowardly flight of Westerners from the marks that life inscribes upon their flesh in their own despite. They stupidly seek to remain eternally young, fresh, innocent: babies. But life inexorably slashes furrows into face and body, and no rejuvenating diet or surgery can restore the smoothness of the past. And they are right, in a sense, to lament this ageing, for the wrinkled, sagging, disfiguring skin has no other meaning than decrepitude.

This horror of ageing is unknown to the Polynesian, whose tattoos make of face and body – of what was, and in the Western-er remains, insignificant flesh – works of art apt to inspire love: jewelled body, diamantine face. The Polynesian tattoo is intended primarily as a declaration of love. But this sign is not devoid of meaning. The word it brings must be harmonious. It is a body-poem. And this word must also be veracity and fidelity: body-signature. Here Michel Simon's words come into their own. The tattooed never betray: they are word incarnate, the signature made flesh.

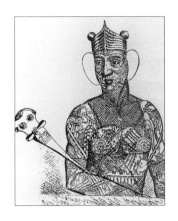

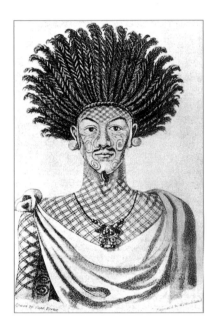

I once dreamt of a particular interpretation of the first lines of the Bible, which is relevant here. I imagined that, before original sin, Adam and Eve were not naked, but covered in signs, which were the word of God. They did not work, nor did they age, for their vocation was accomplished in this radiance of divine truth emanating from their skin, just as certain birds spontaneously hymn the glory of the Creator. Then came the Fall. Sin broke the divine pact. The cloak of words that covered Adam and Eve was torn from them. And they found themselves naked, ashamed of their white, insignificant skin. Their function changed. Where once they had proclaimed, in stillness and silence, the Word of God, they were now condemned to hard labour. On their bodies, calluses and scars formed.

In this sense, Polynesia is Paradise Regained.

Michel Tournier
from the Académie Goncourt

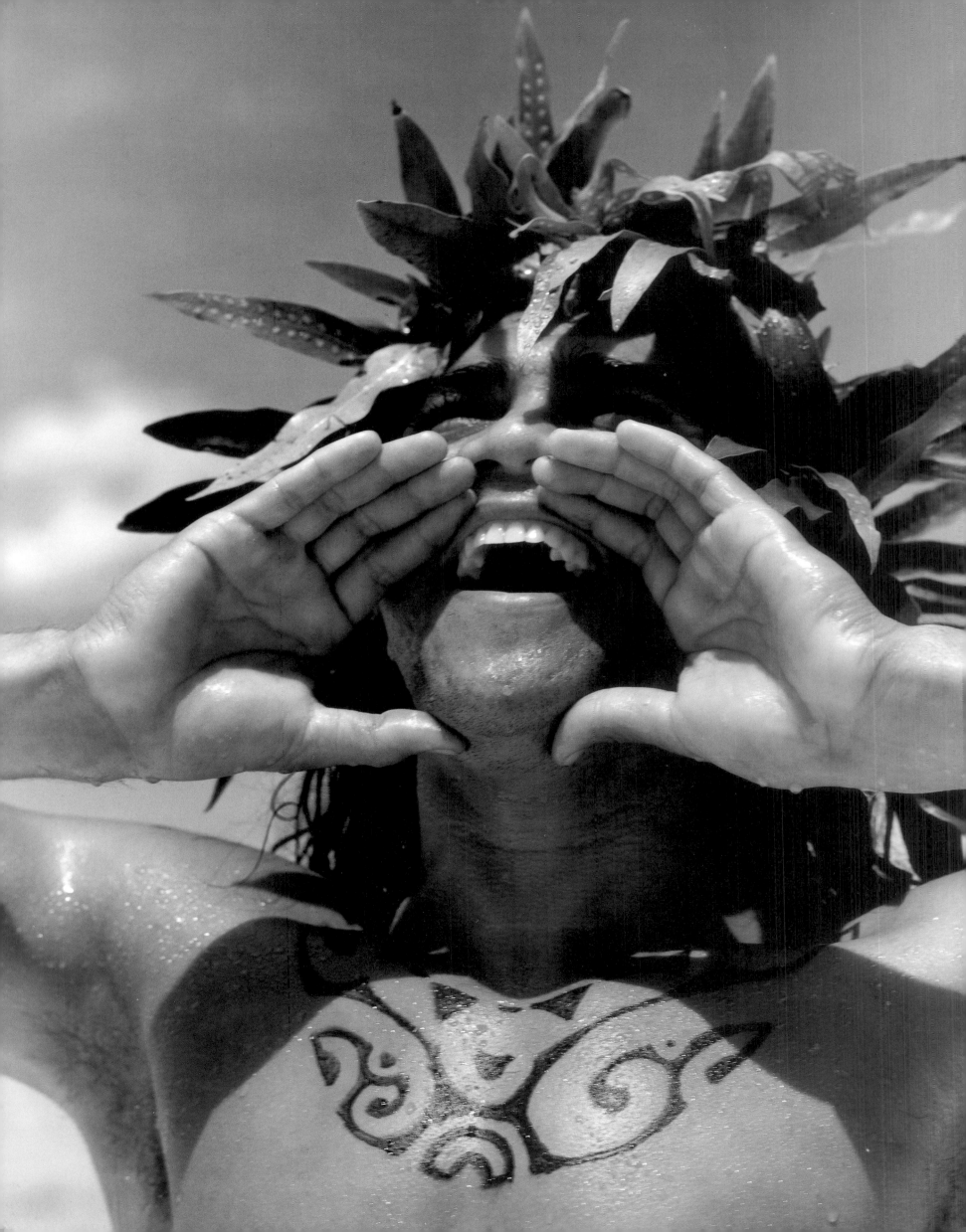

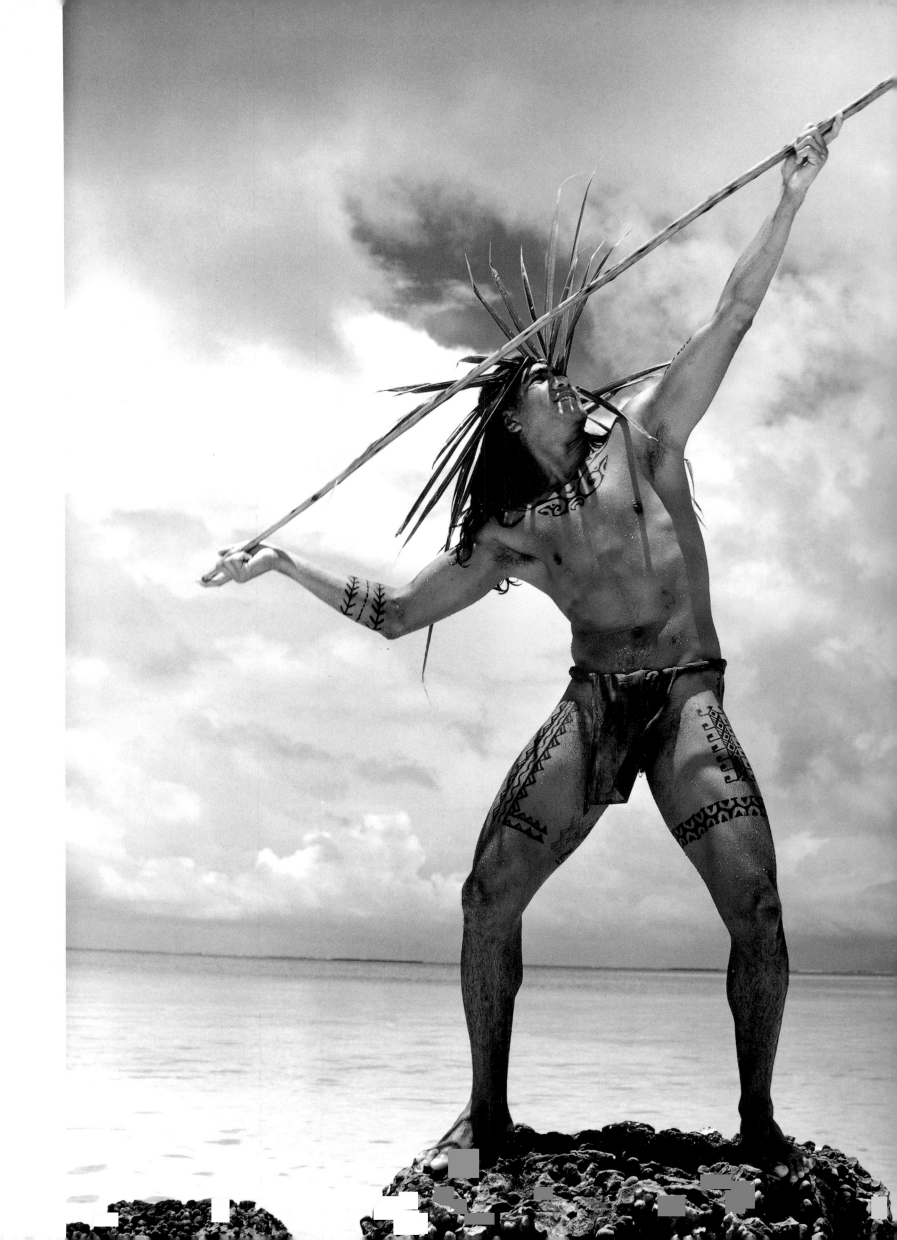

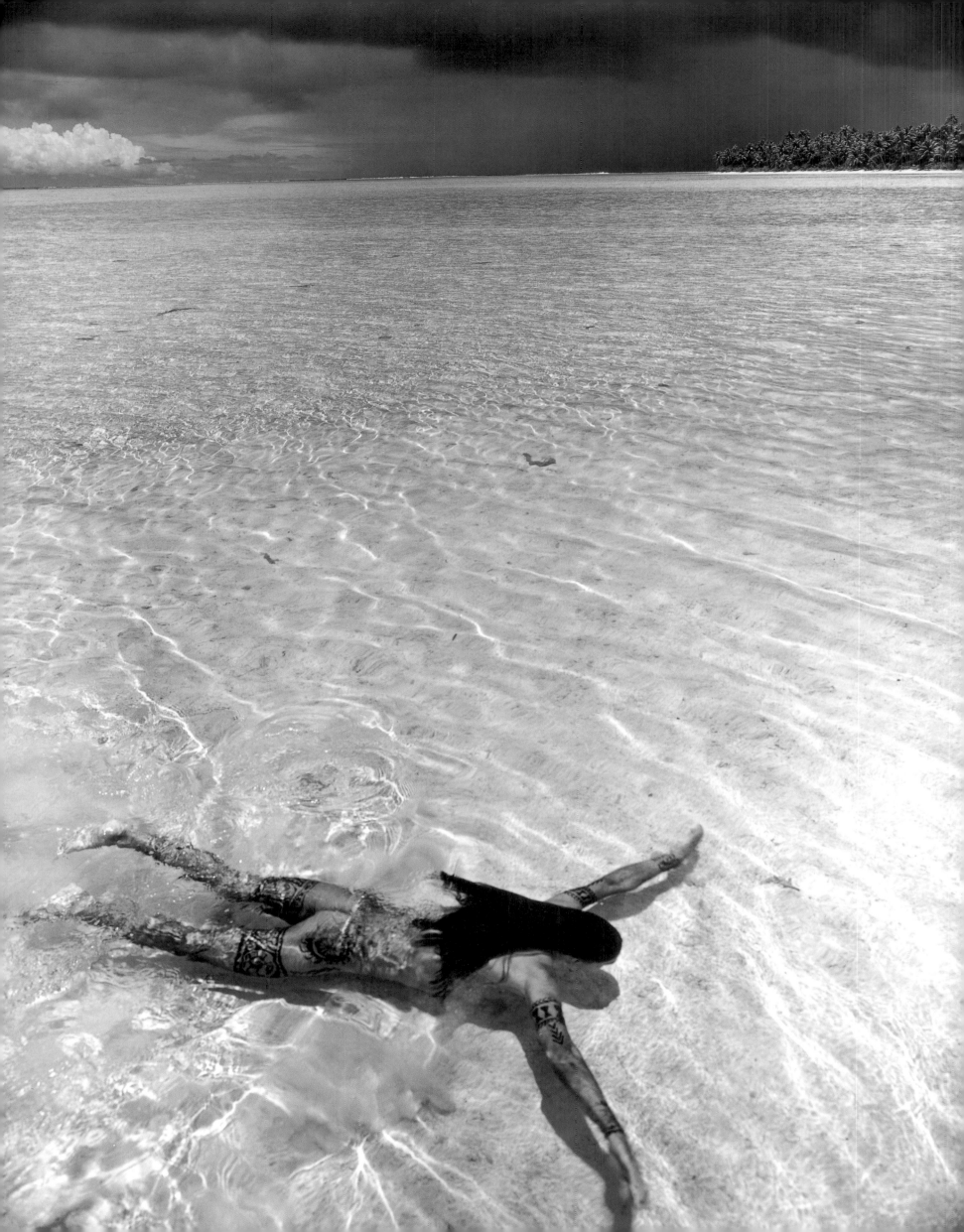

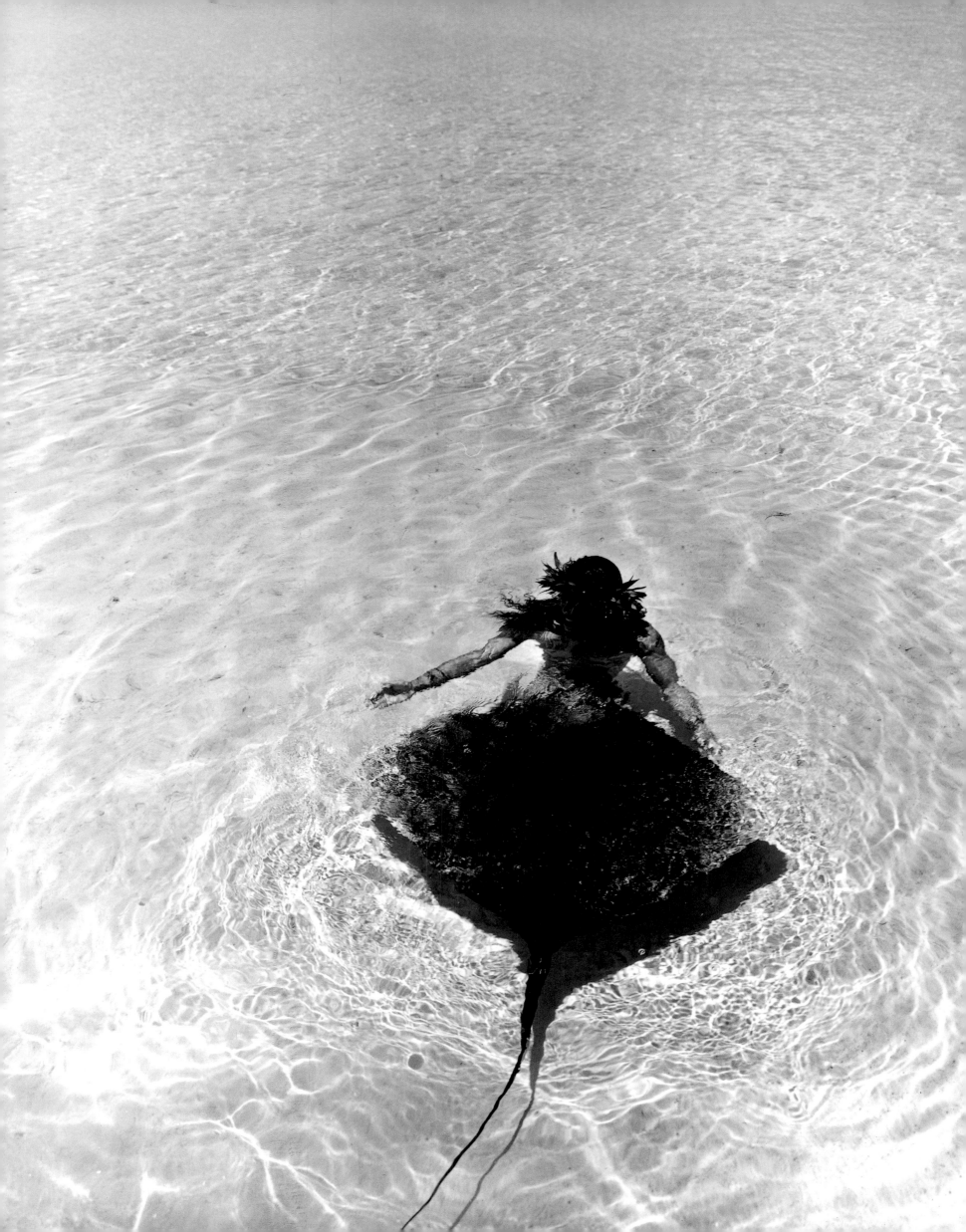

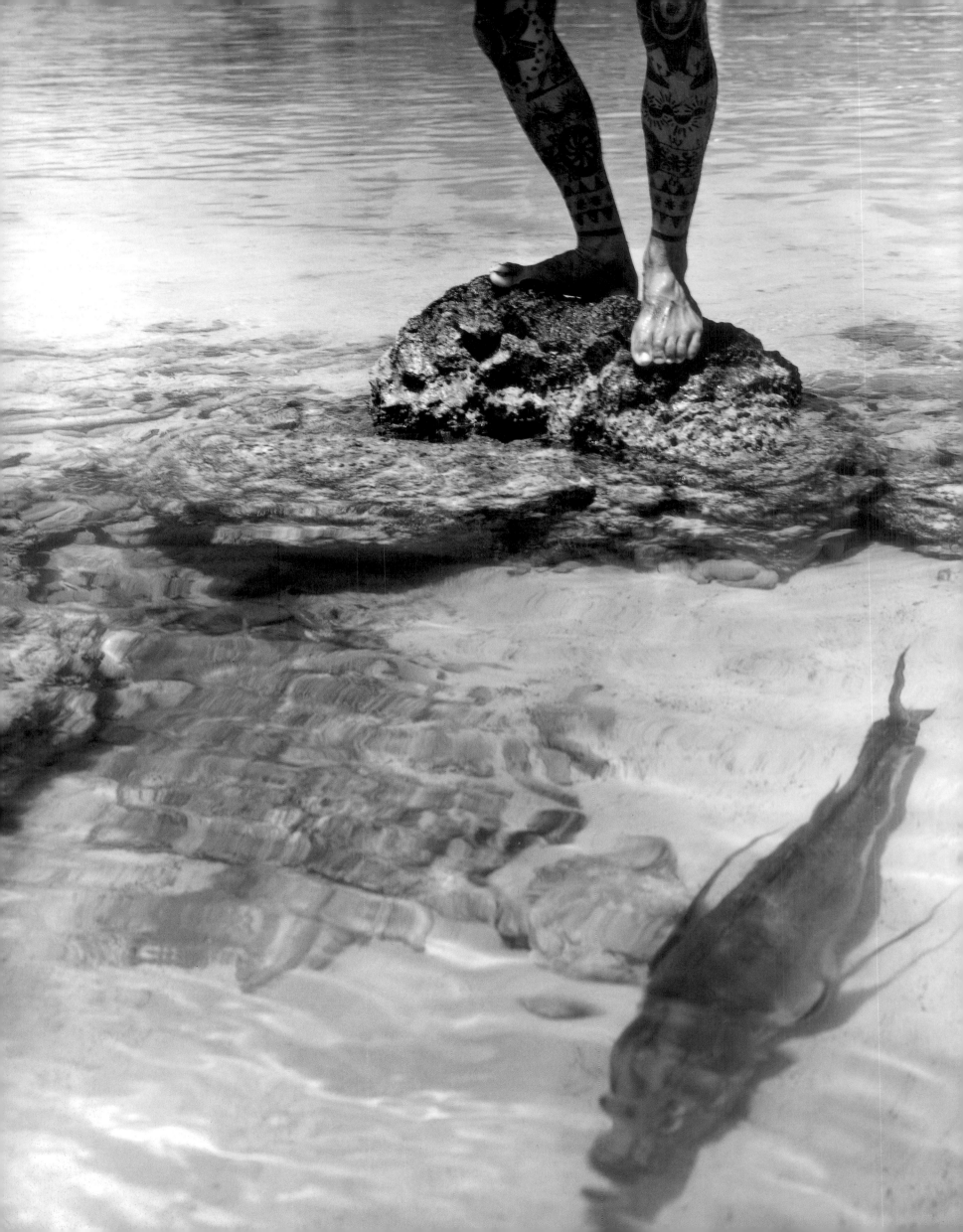

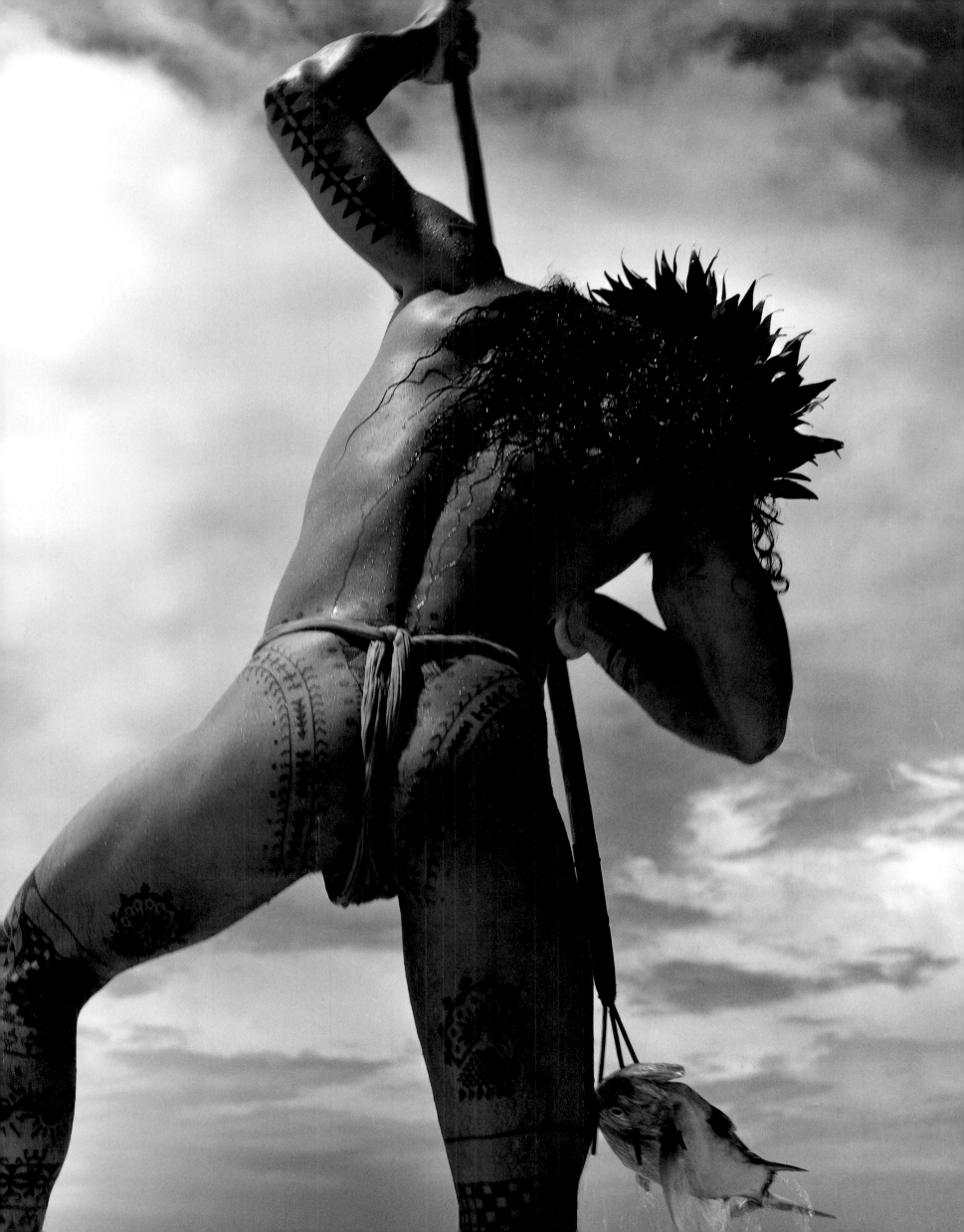

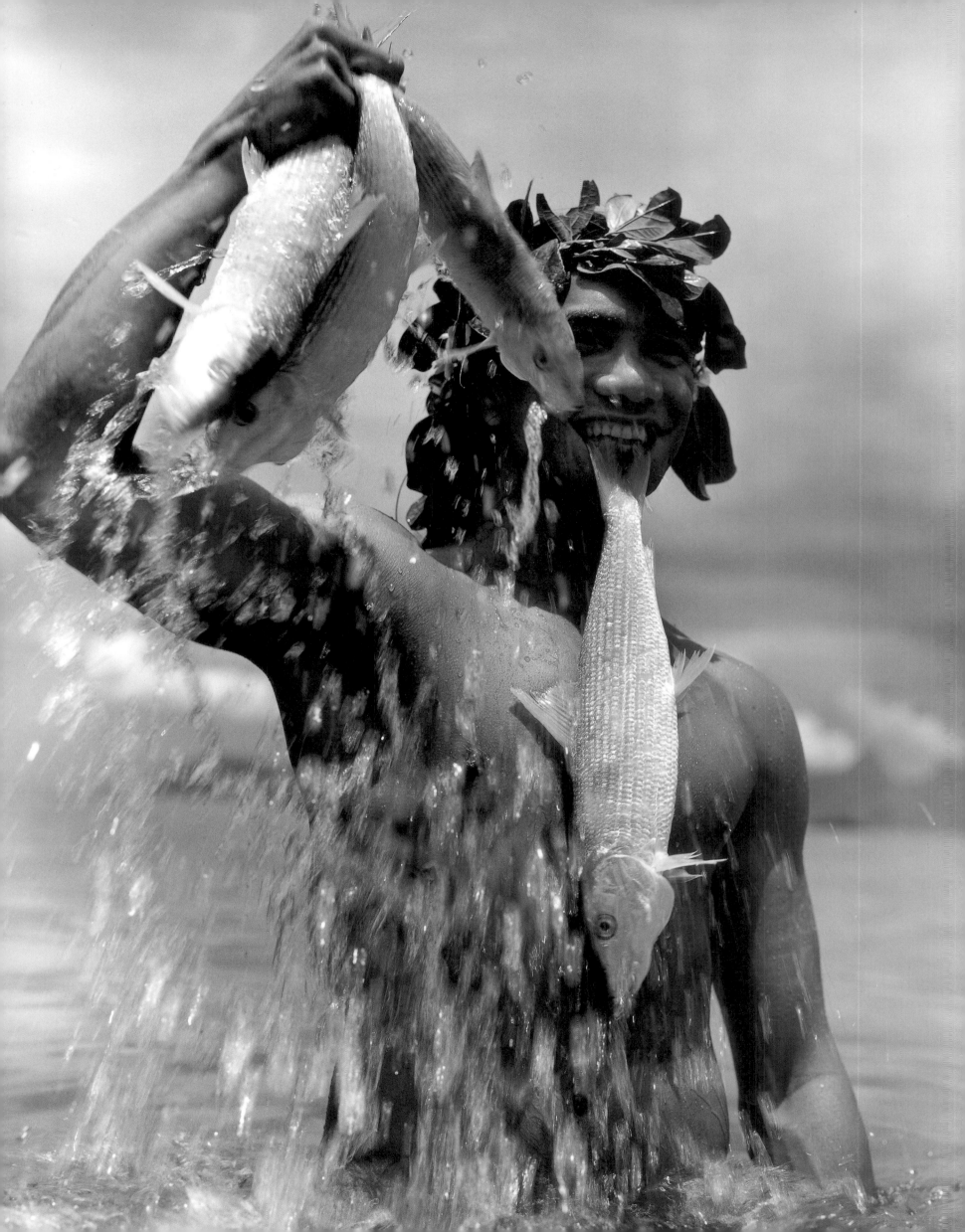

This time, we caught an enormous tunny fish. As the club smashed down on its head, the fish shuddered in its death-spasms, throwing itself around the canoe; its body became mirrored lightning, rippling with thousand-faceted flame.

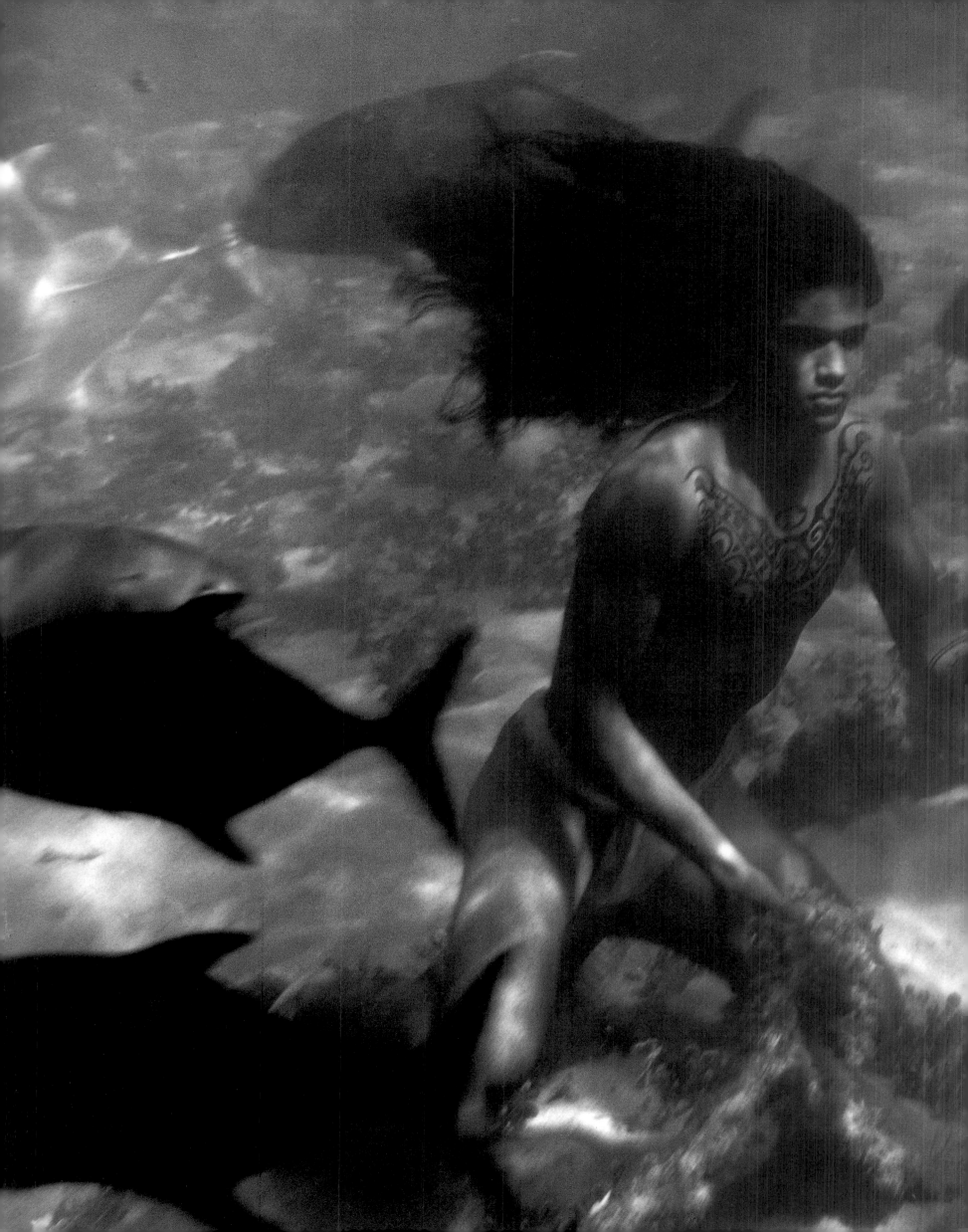

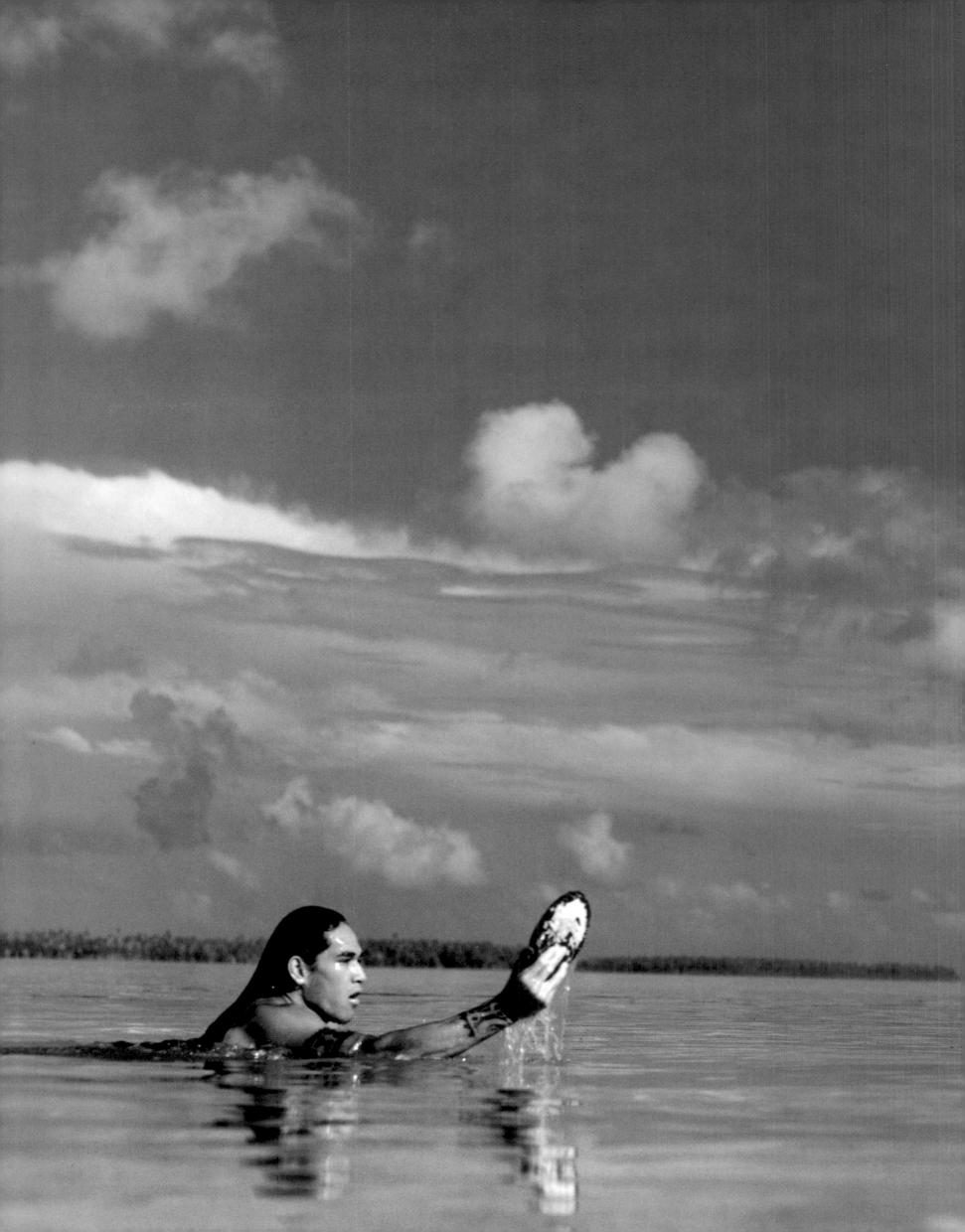

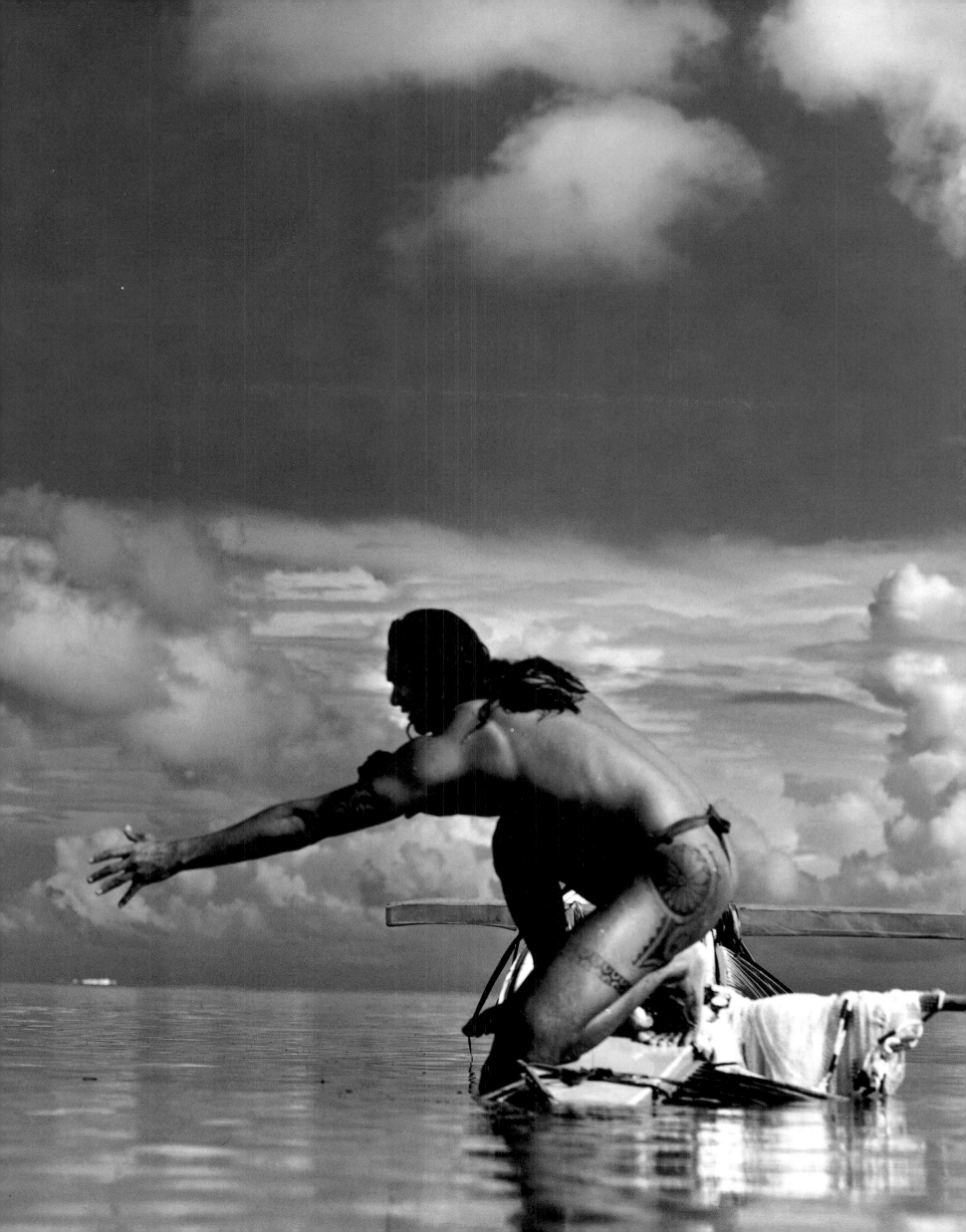

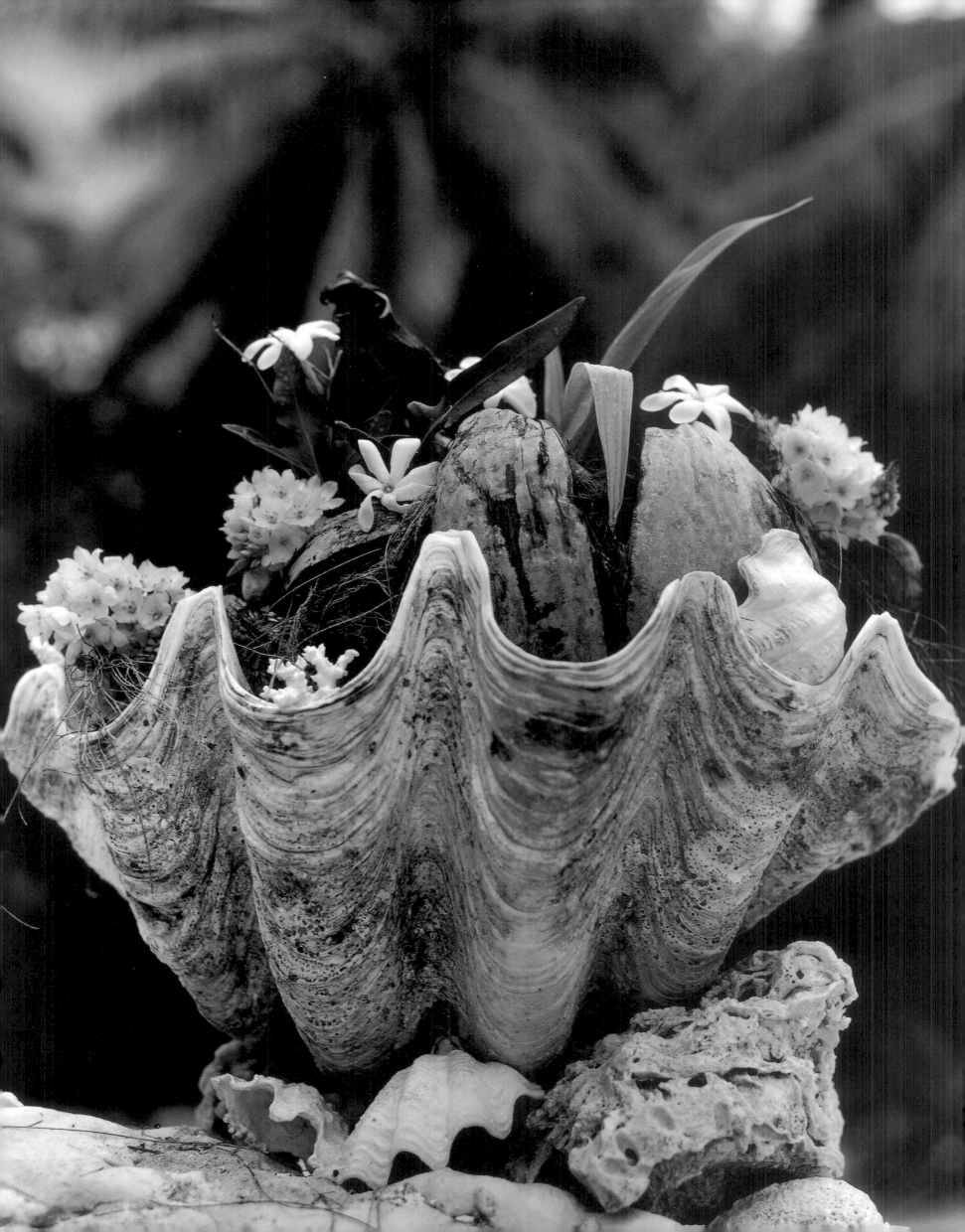

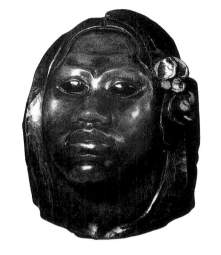

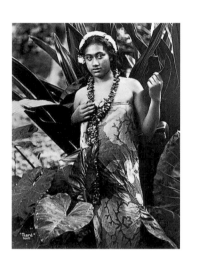

T hat day she had put on her most beautiful dress; a flower behind her ear in the Maori fashion, she wore a hat which she had woven from cane-fibre; on it was a band of straw flowers ornamented with delicately orange-tinted shells. With her black hair loose on her shoulders… she looked truly pretty.

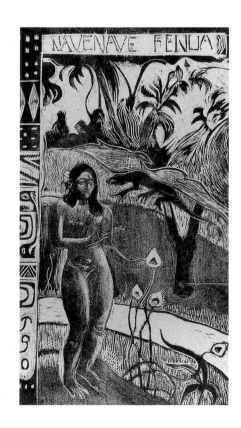

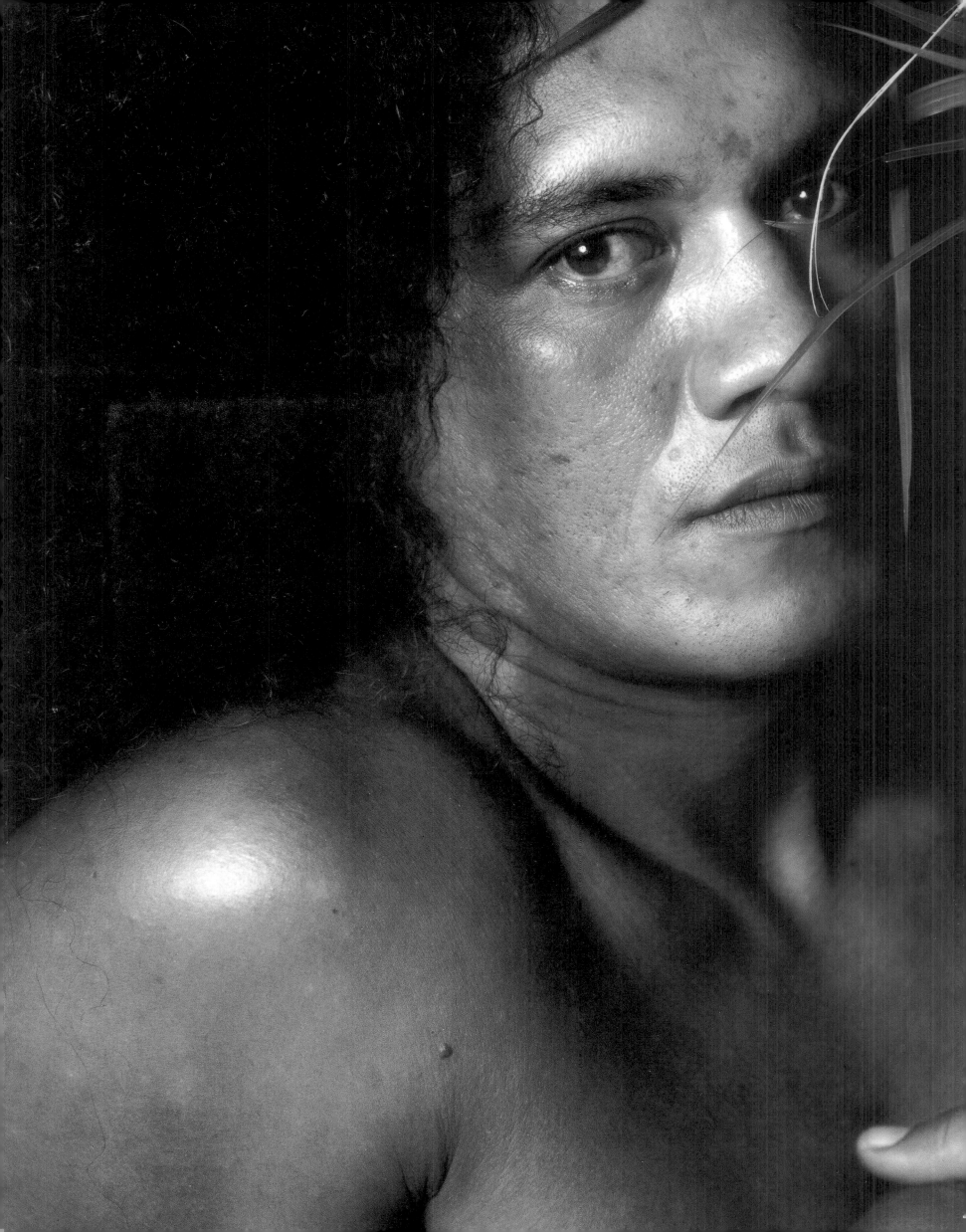

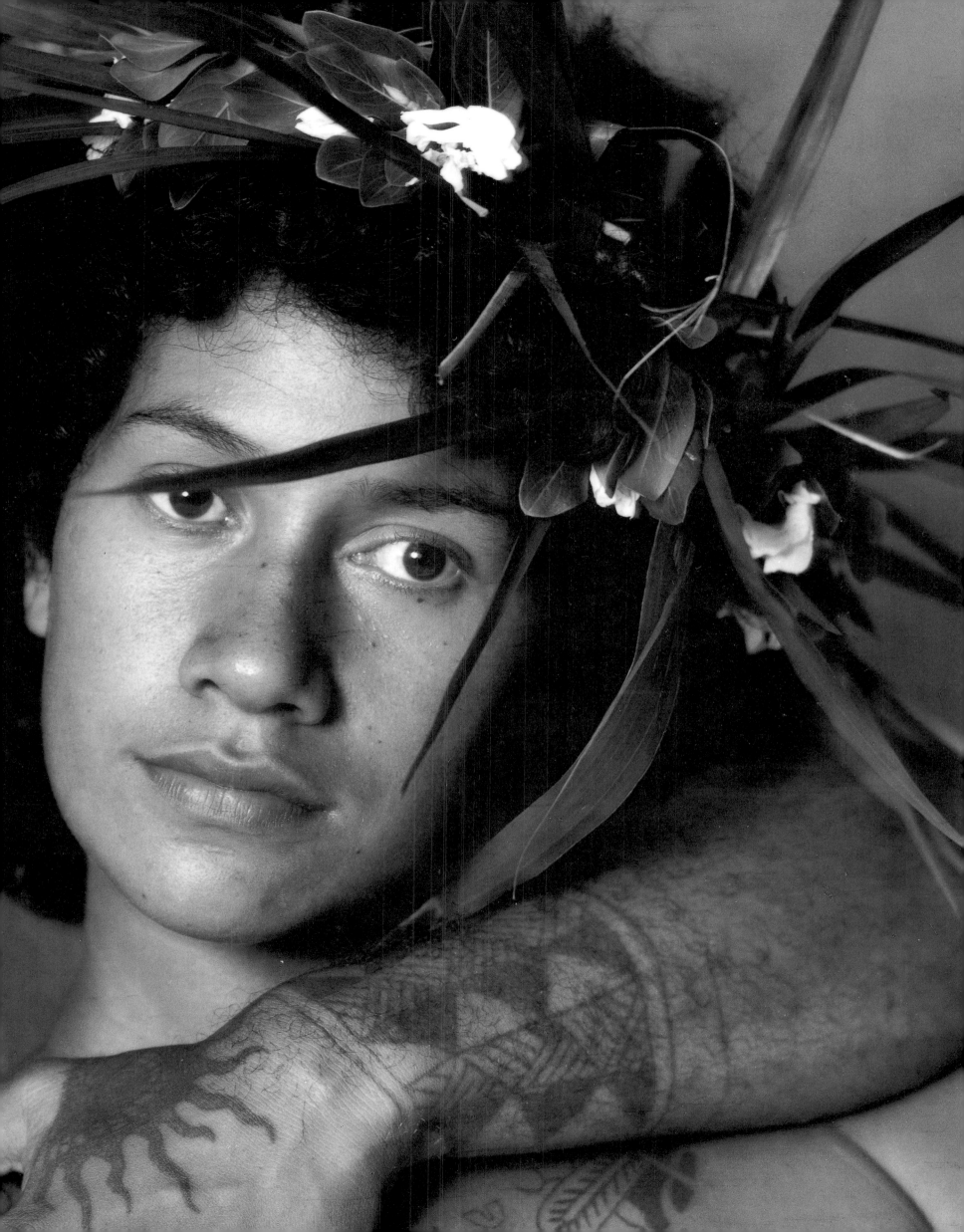

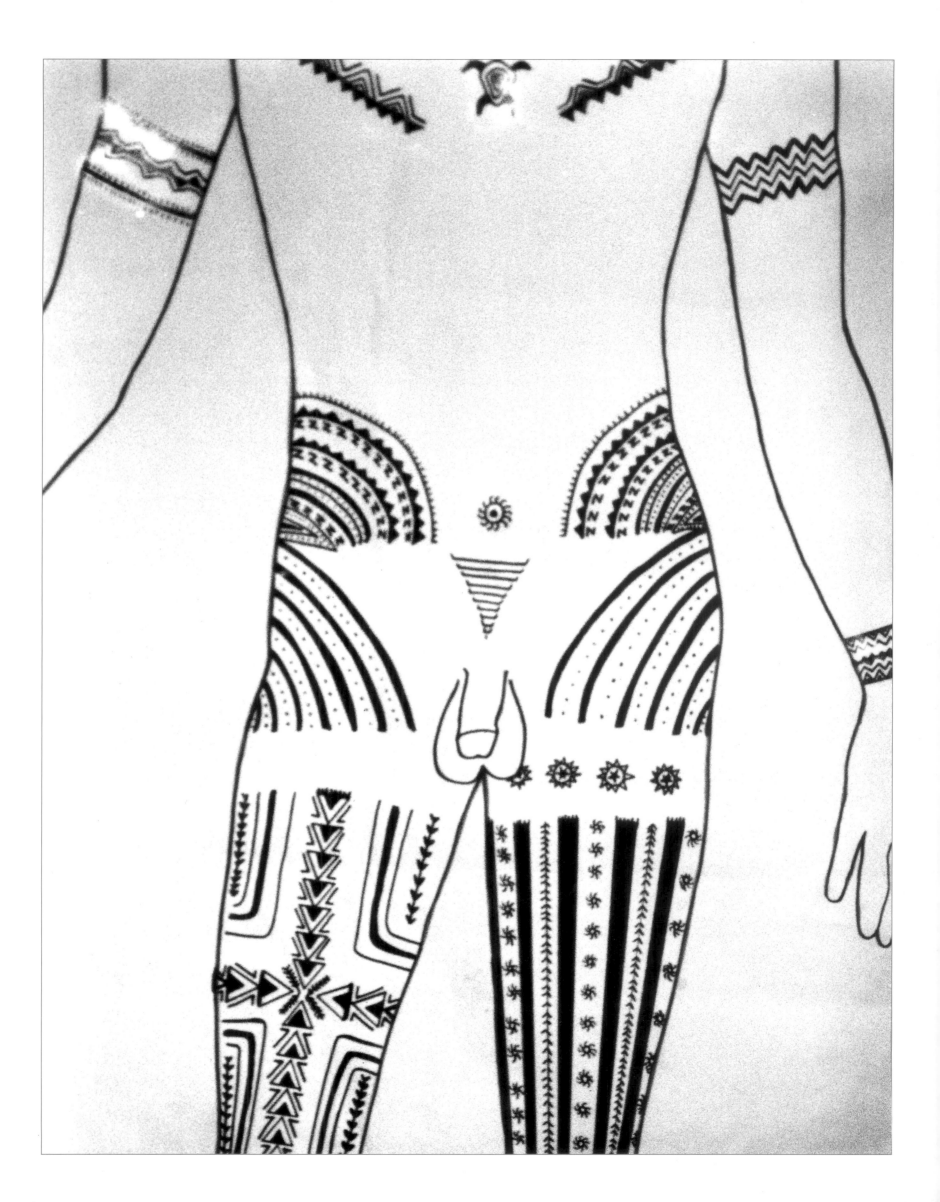

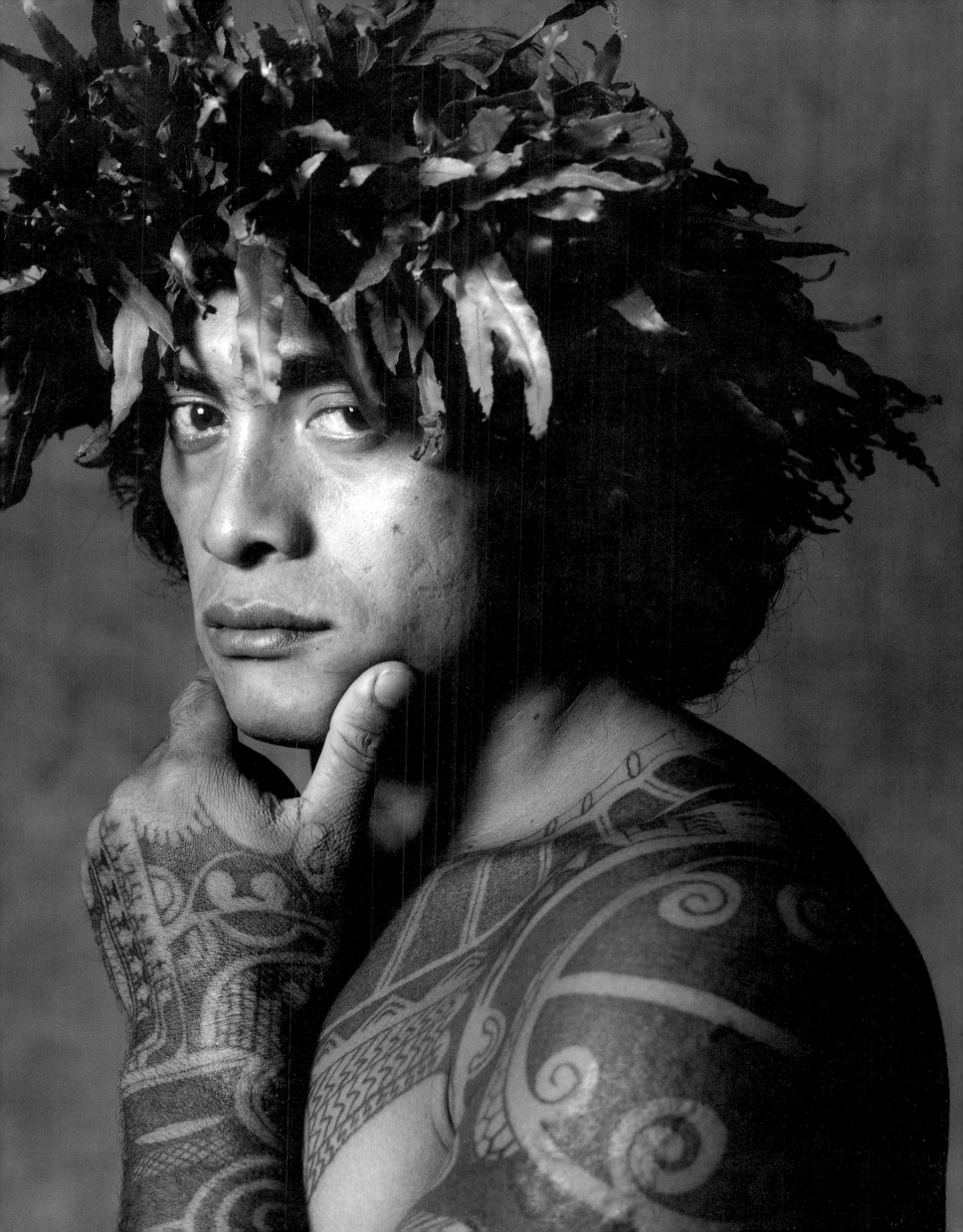

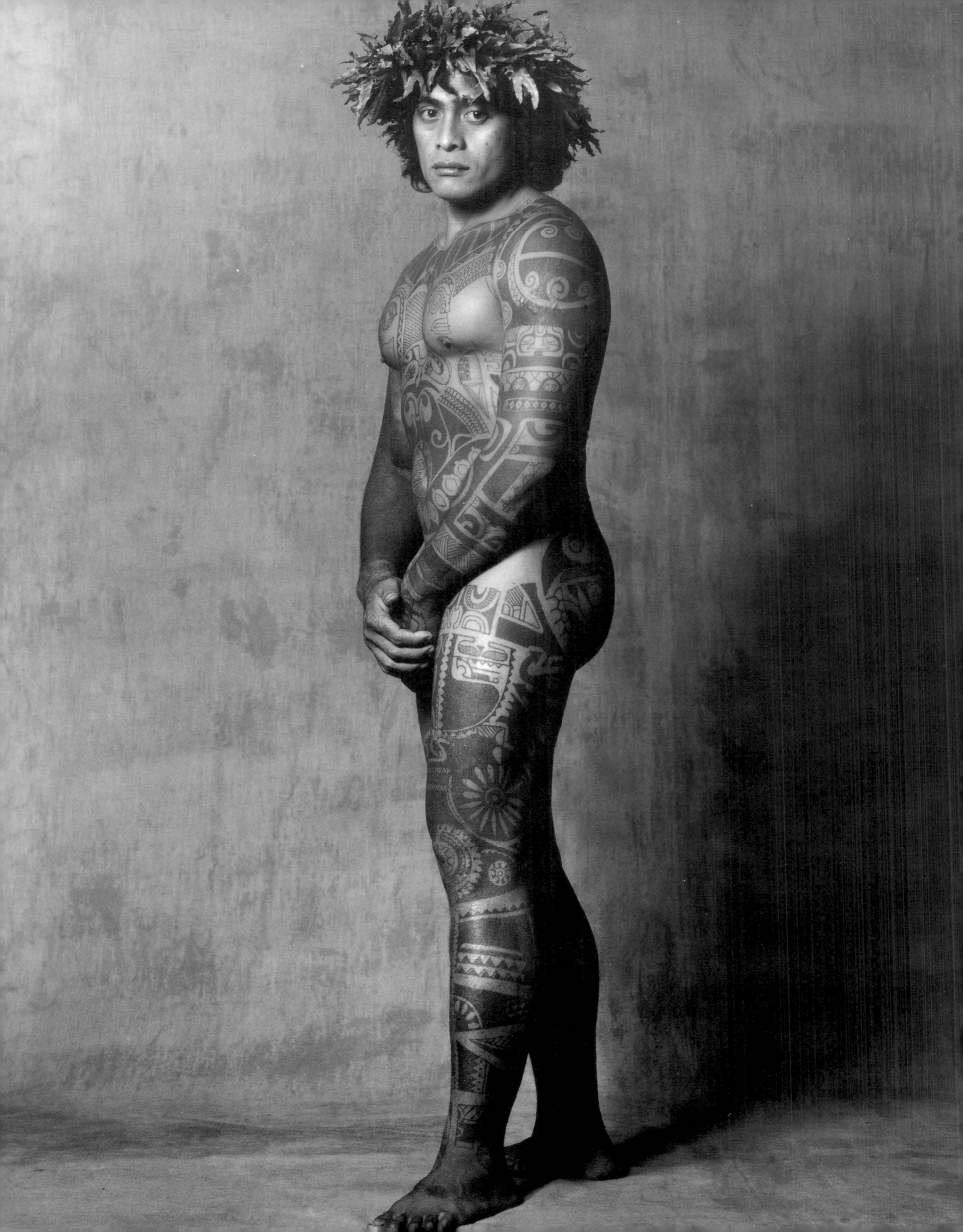

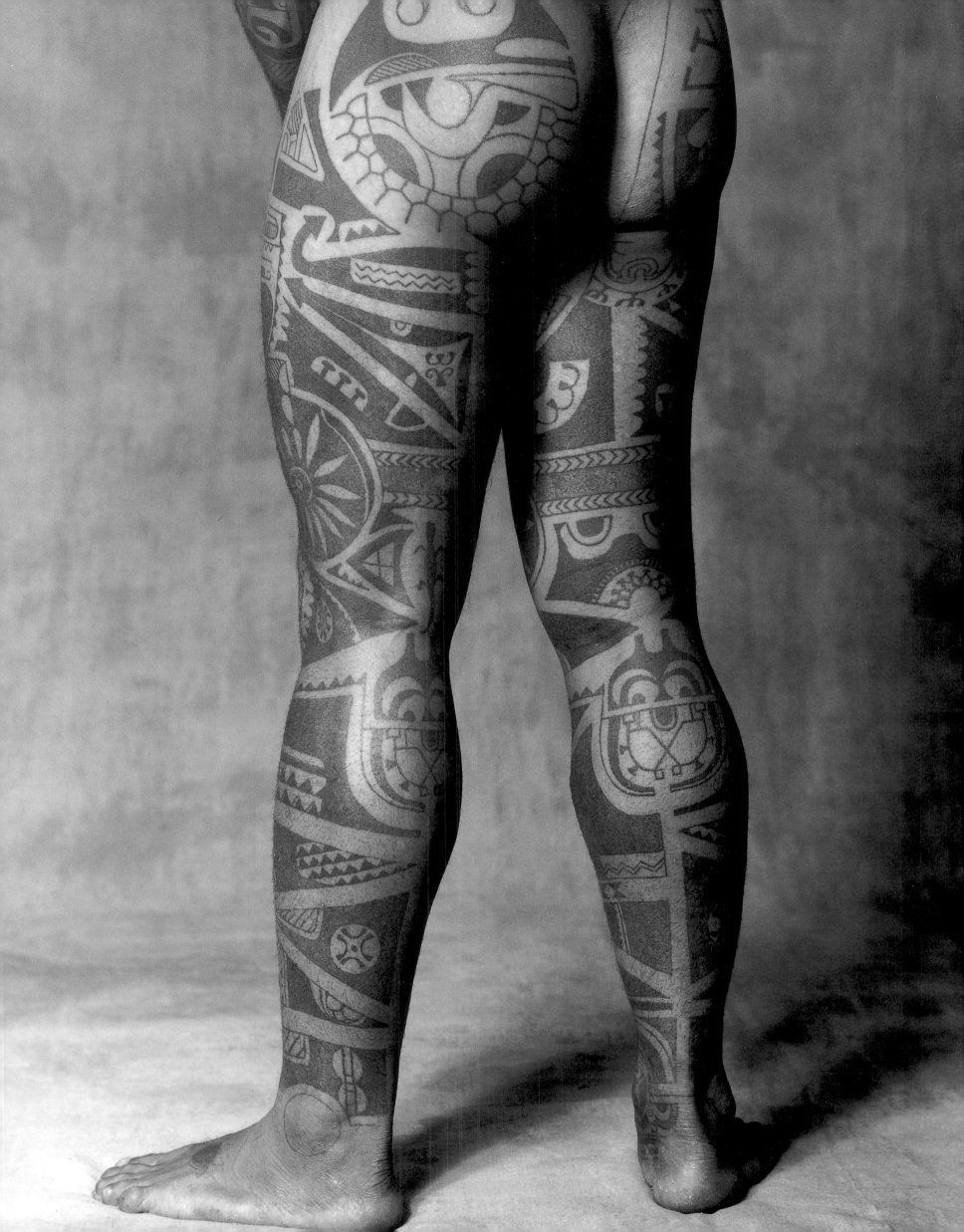

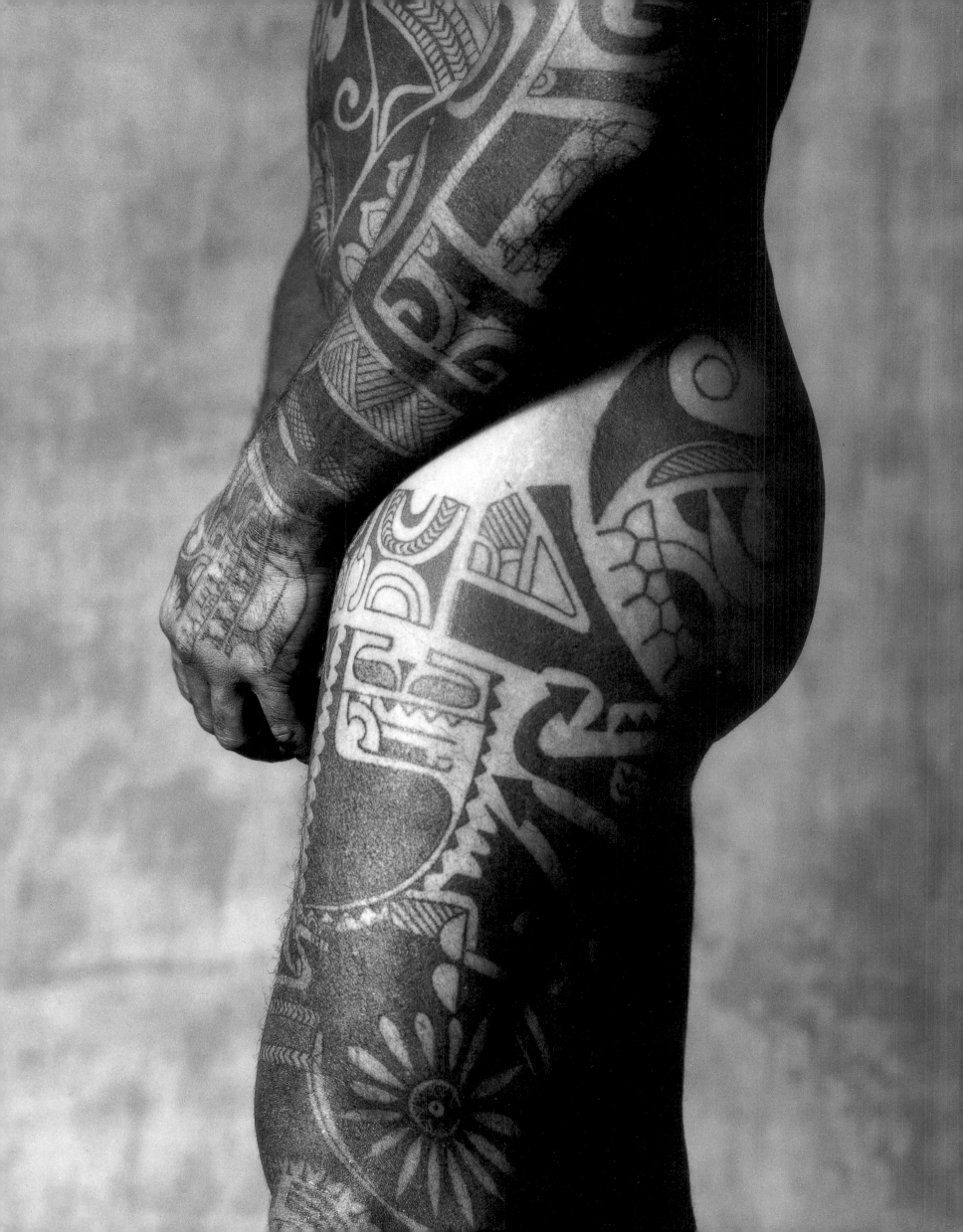

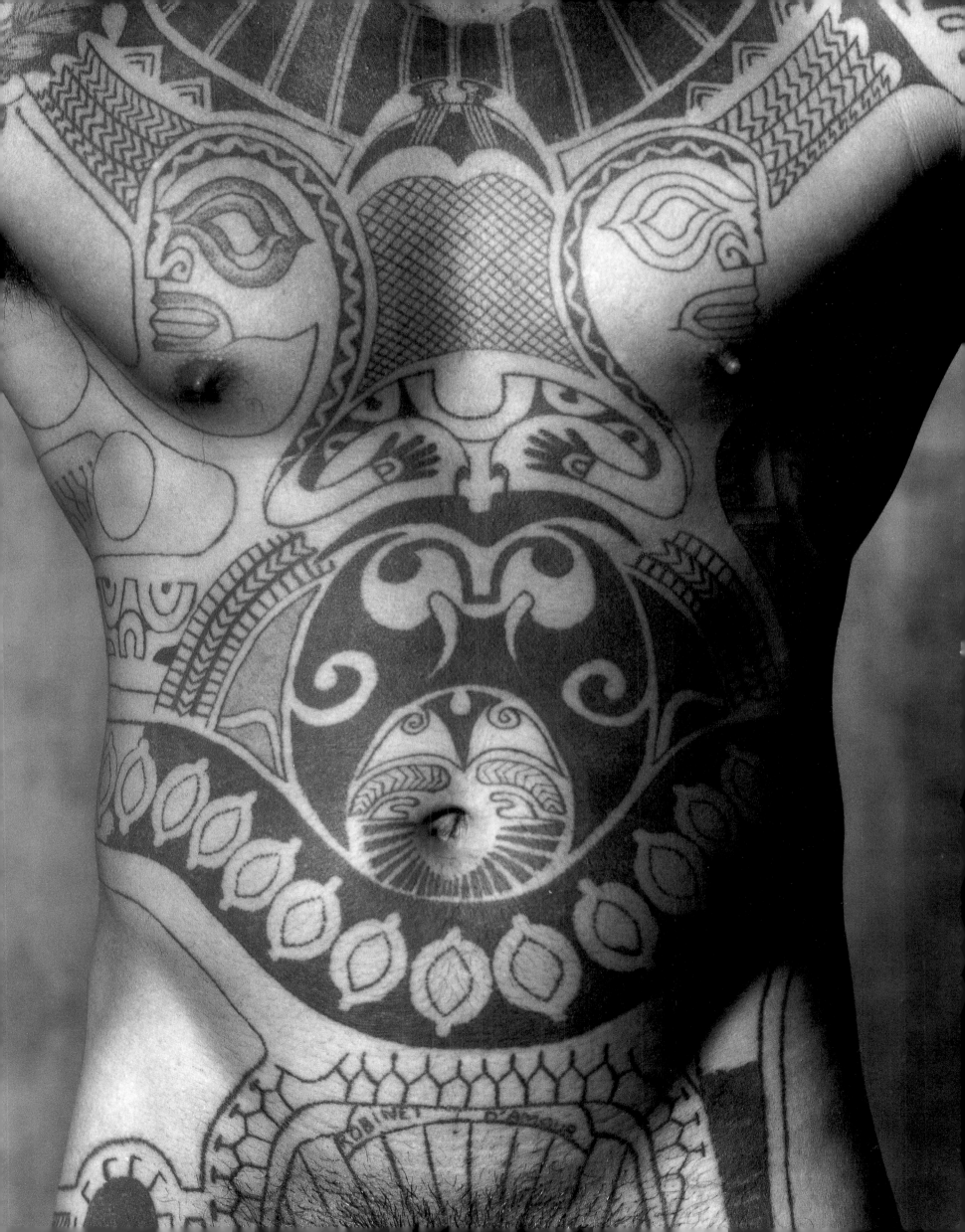

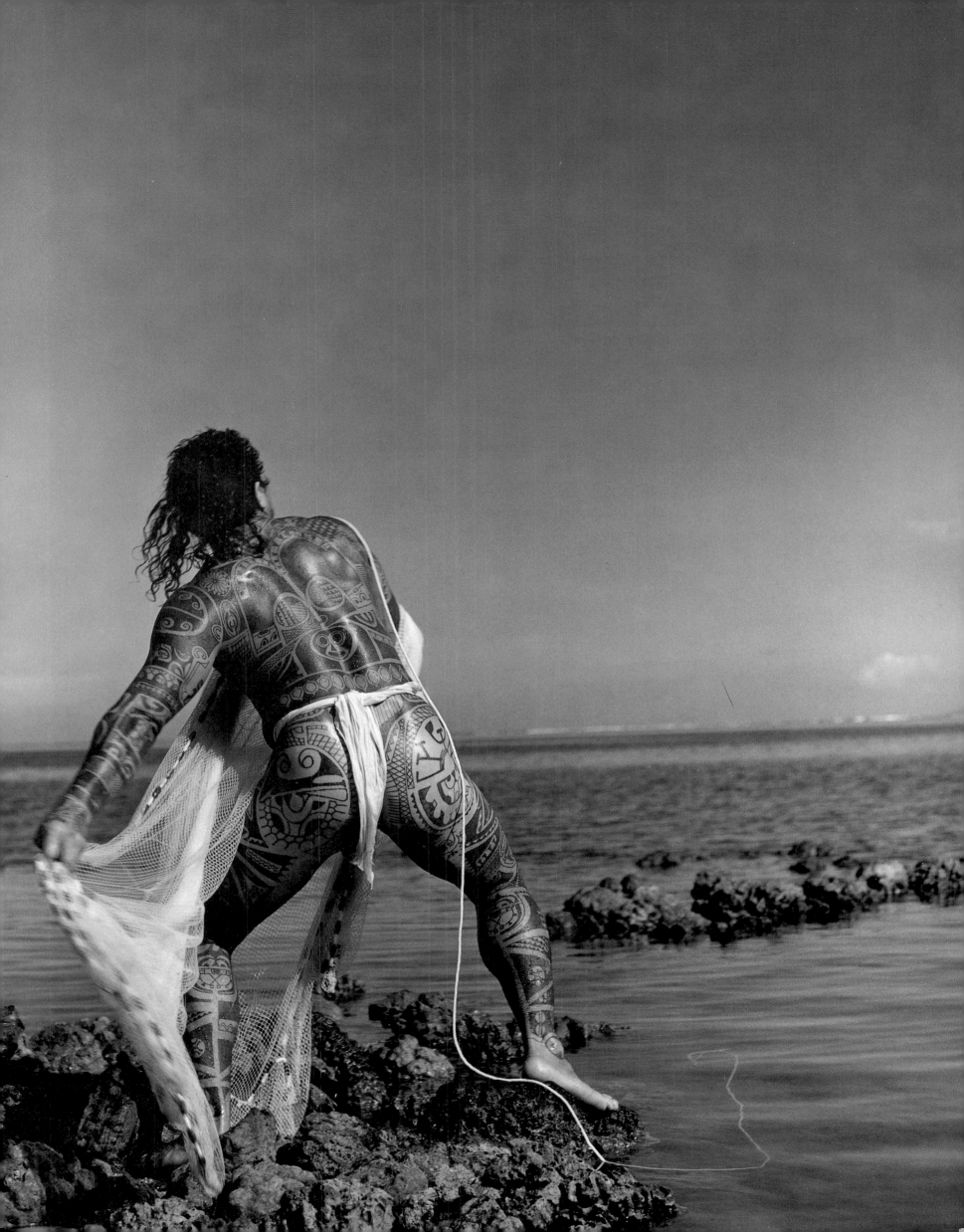

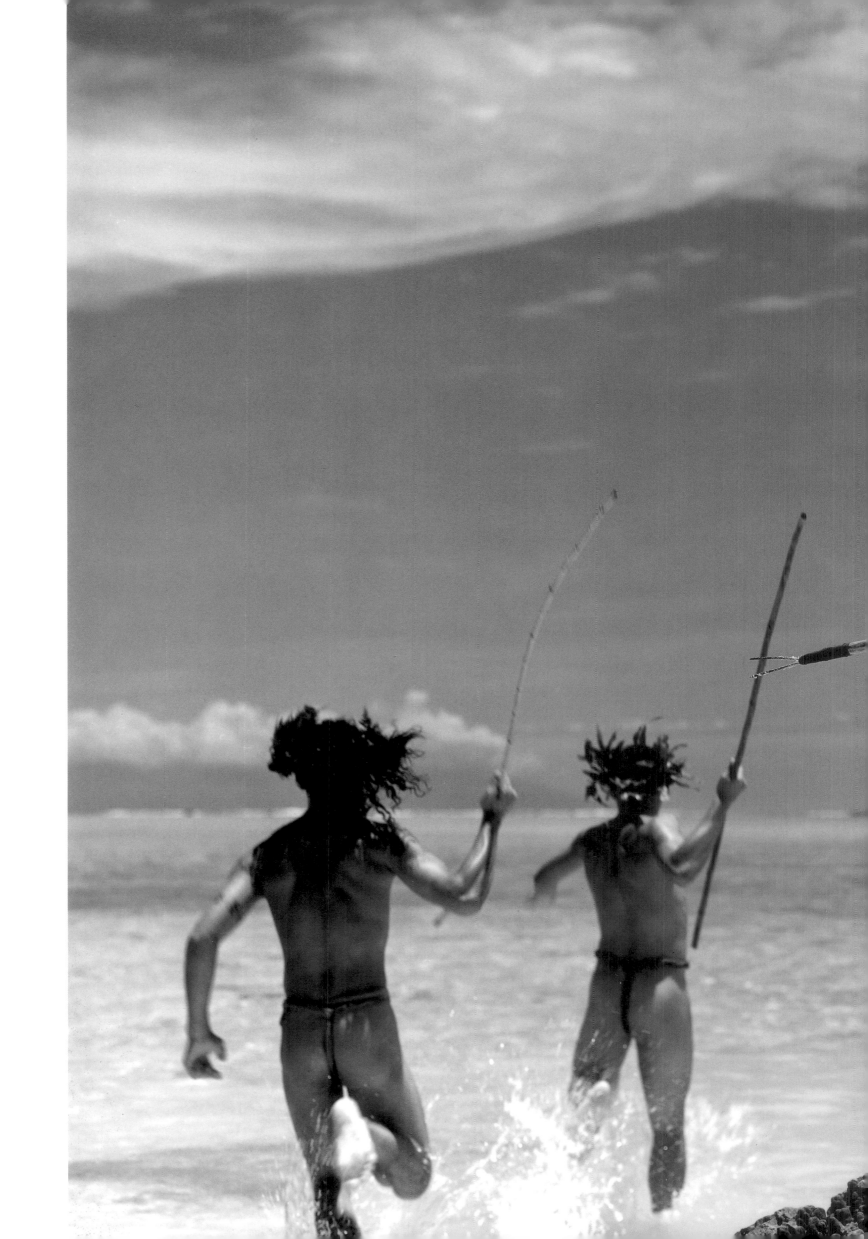

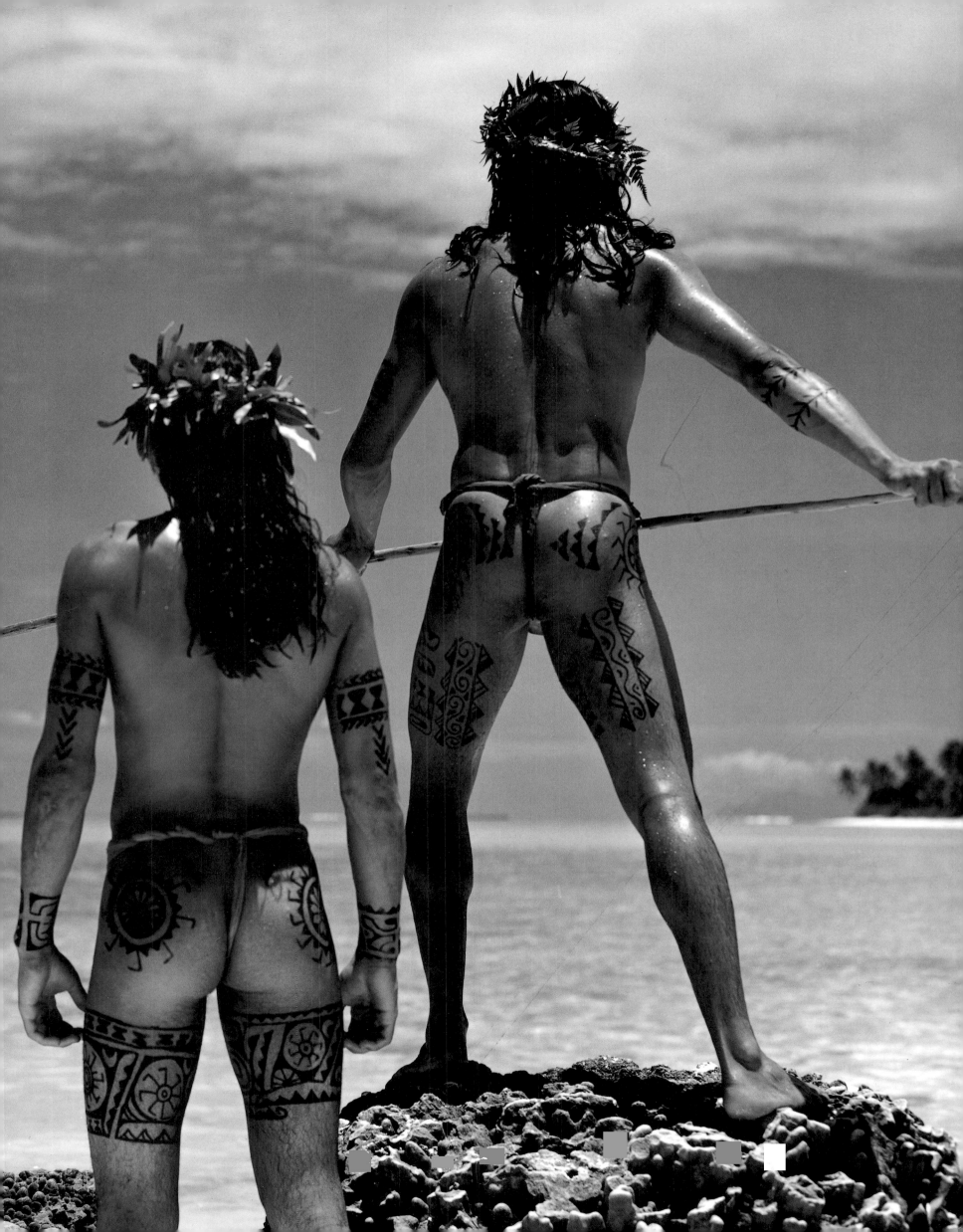

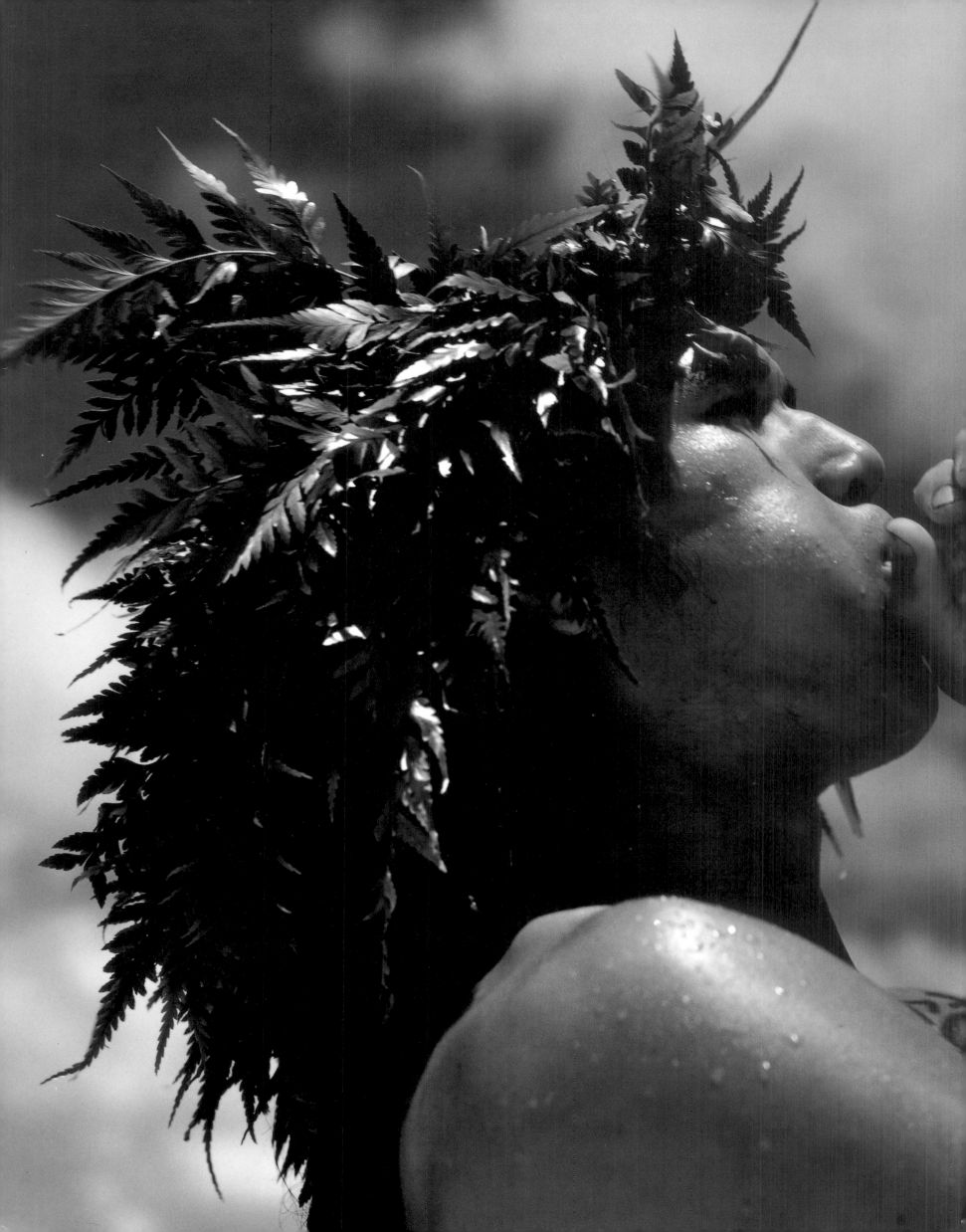

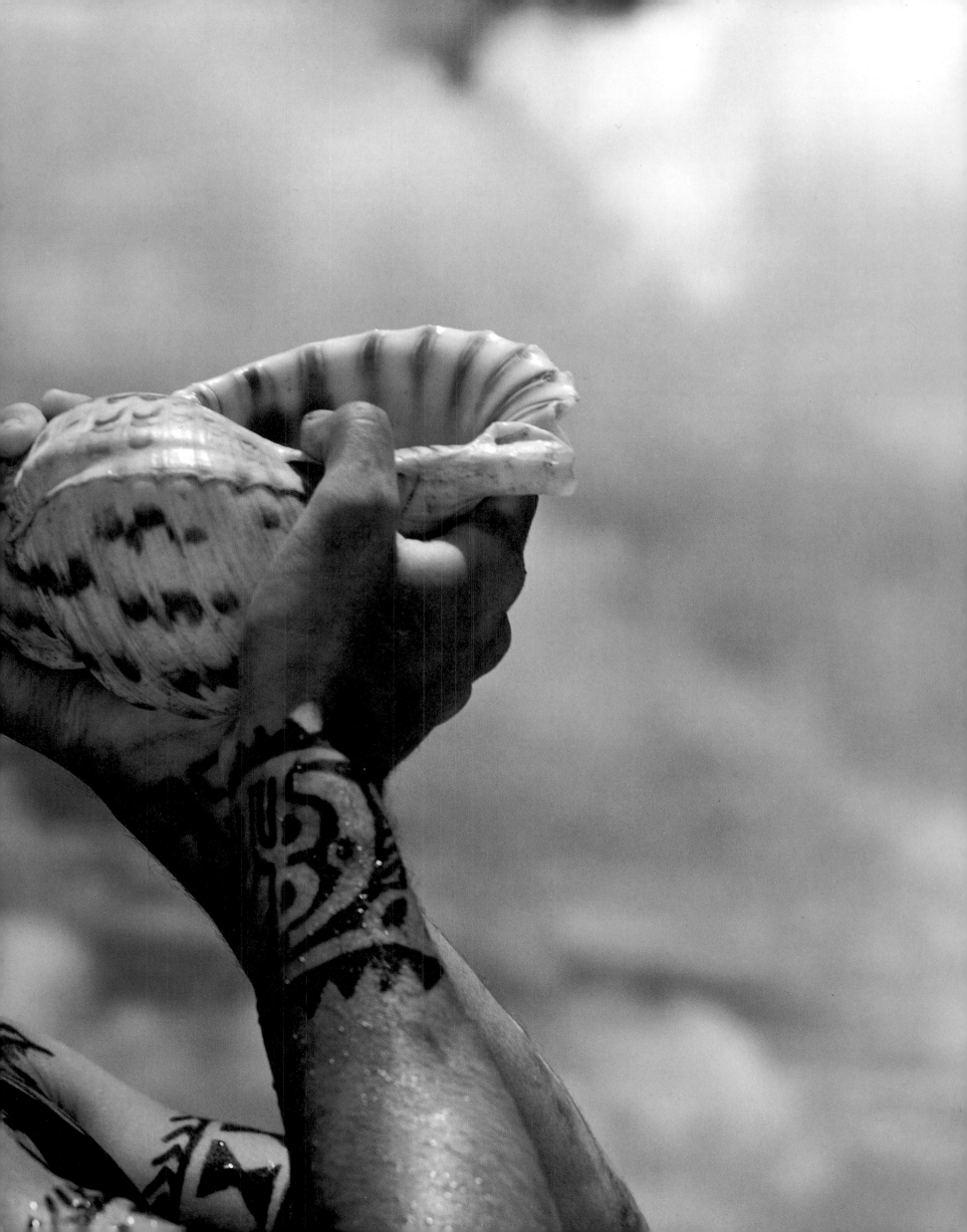

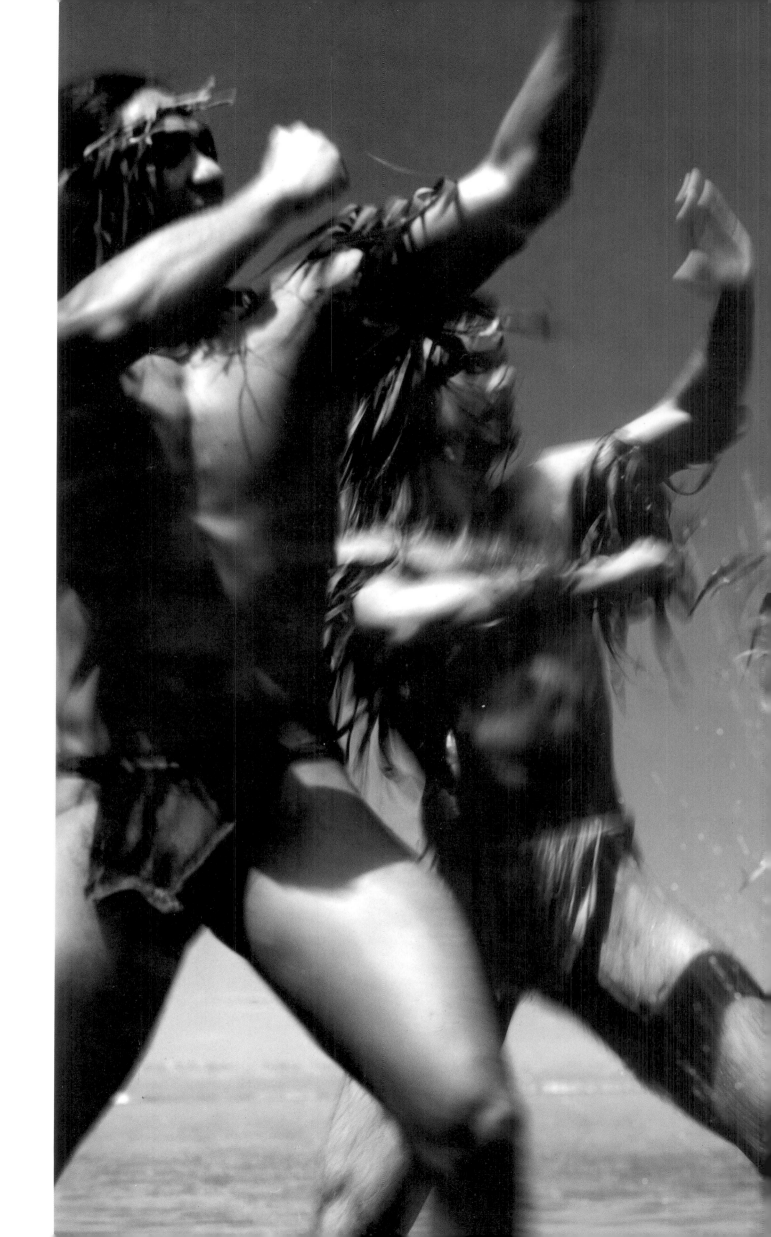

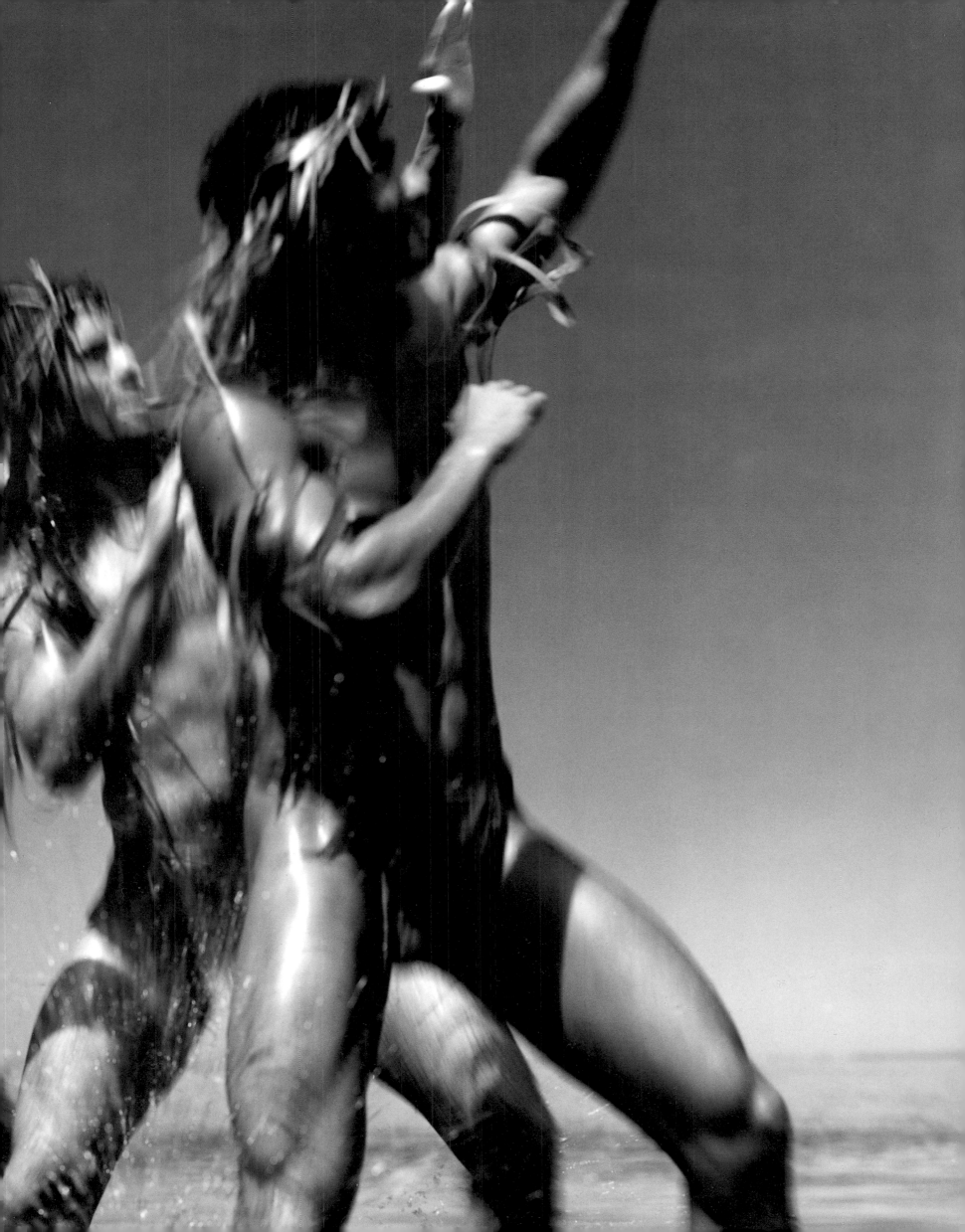

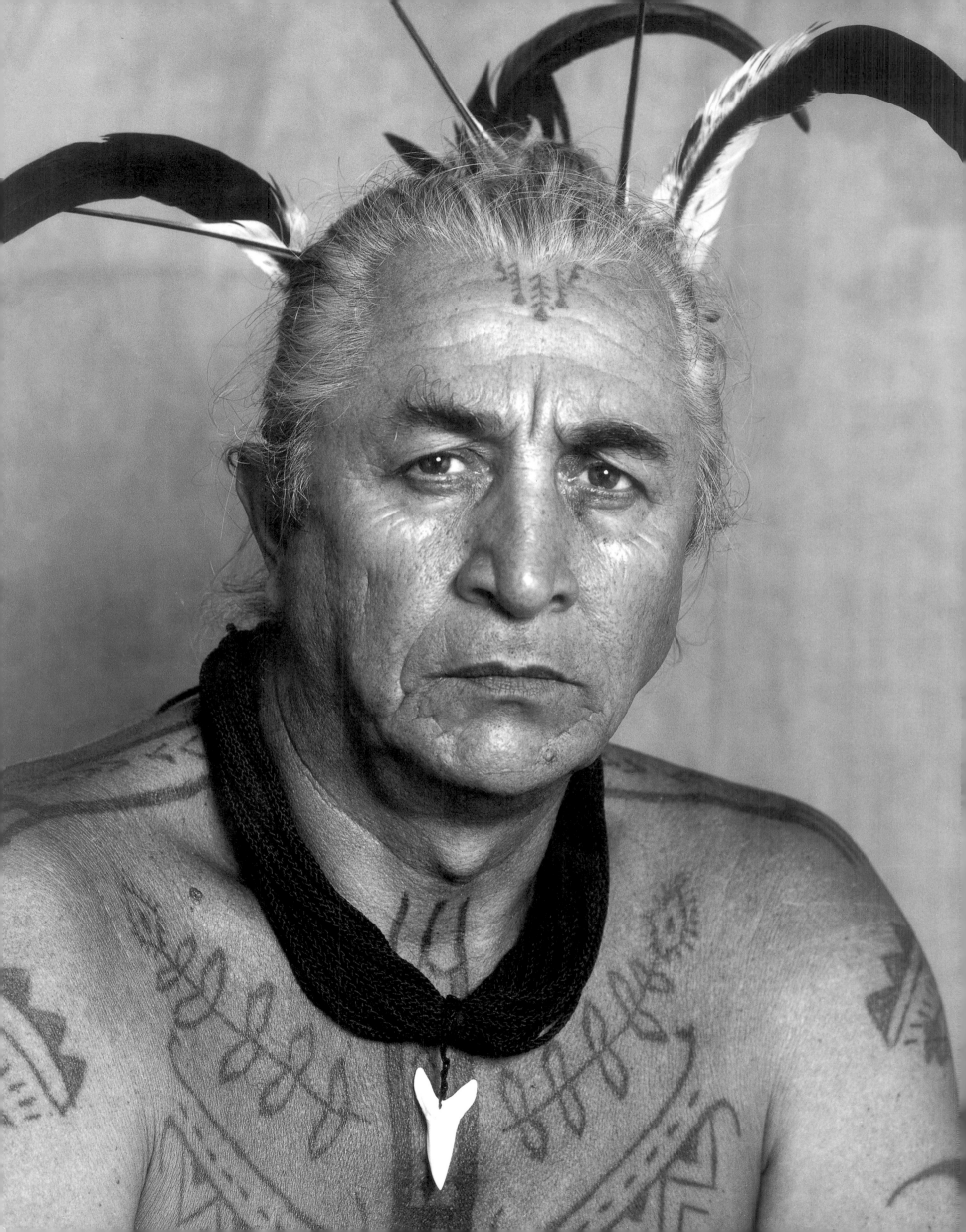

THE HISTORY OF
TATTOOING IN POLYNESIA

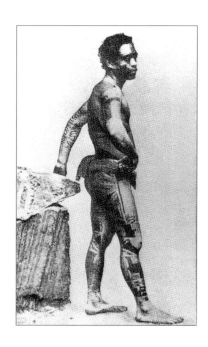

It is necessary to go right back to the dawn of Màohi civilization to trace the beginnings of tattooing in the Polynesian archipelago. The practice was originally widespread in the Society Islands, where it reached the greatest heights of artistic perfection, and was also favoured by the inhabitants of the Marquesas Islands and the Maoris. Actively discouraged by the religions which arrived from the Western world, tattooing became so little practised in Tahiti that the skill was forgotten. For that reason we had to turn to our neighbours in the Pacific, who had resisted the pressures of history, to relearn the lost art. The renaissance of tattooing took place in Tahiti, with the help of Samoan practitioners, at the Tiurai celebrations in 1982. It was an important occasion on which Tahitian culture rediscovered its roots and pledged itself to the conservation of Polynesian customs.

The origins of tattooing are unclear, for the origins of the custom go back beyond early Màohi culture to the fabulous age of the Polynesian creation myths. According to a local tradition, the practice of tattooing in Tahiti has a divine source. During the Po' (the dark age), tattooing was created by the two sons of the god Ta'aroa, Mata Mata Arahu (He Who Makes Marks with Charcoal) and Tu Ra'i Po' (He Who Lives in the Dark Sky). The two gods belonged to the same group of craftsmen as Taere, a highly skilled god, and Hina Ere Ere Manua (Hina of the Quick Temper), the eldest daughter of the first man, Ti'i, and the first woman, Hina. As she was growing up, Hina Ere Ere Manua became "Pahio", and was

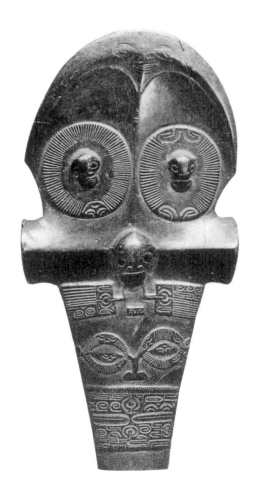

kept shut up under the watchful eye of her mother, who wished to preserve her virginity. But the two brothers were determined to seduce her. They invented the new art and tattooed themselves with the design known as "Tao Maro". Mata Mata Arahu and Tu Ra'i Po' were thus able to lure Hina Ere Ere Manua away from the place where she was being jealously guarded. She, too, wanted the new decoration so she eluded her mother's supervision and was finally able to get herself tattooed.

That was the supernatural origin of tattooing, first practised by the sons of the god Ta'aroa, the principal Tahitian divinity. They taught the art to mortals, who found it extremely attractive to be tattooed and used it widely. The two sons of the god Ta'aroa, Mata Mata Arahu and Tu Ra'i Po', became the patron spirits of the art. These illustrious forerunners were always invoked before a tattooing session began so that the operation would be successful, the scars would heal quickly, and the patterns would be pleasing to the eye. As a reminder of this legend, images of the two gods were conserved in the Marae of the Tahu'a, the skilled practitioners of the art. This particular form of traditional culture has been passed down uncontaminated from one generation to the next on our islands for no outside influence has been able to alter the methods used or the way in which designs are applied to the skin.

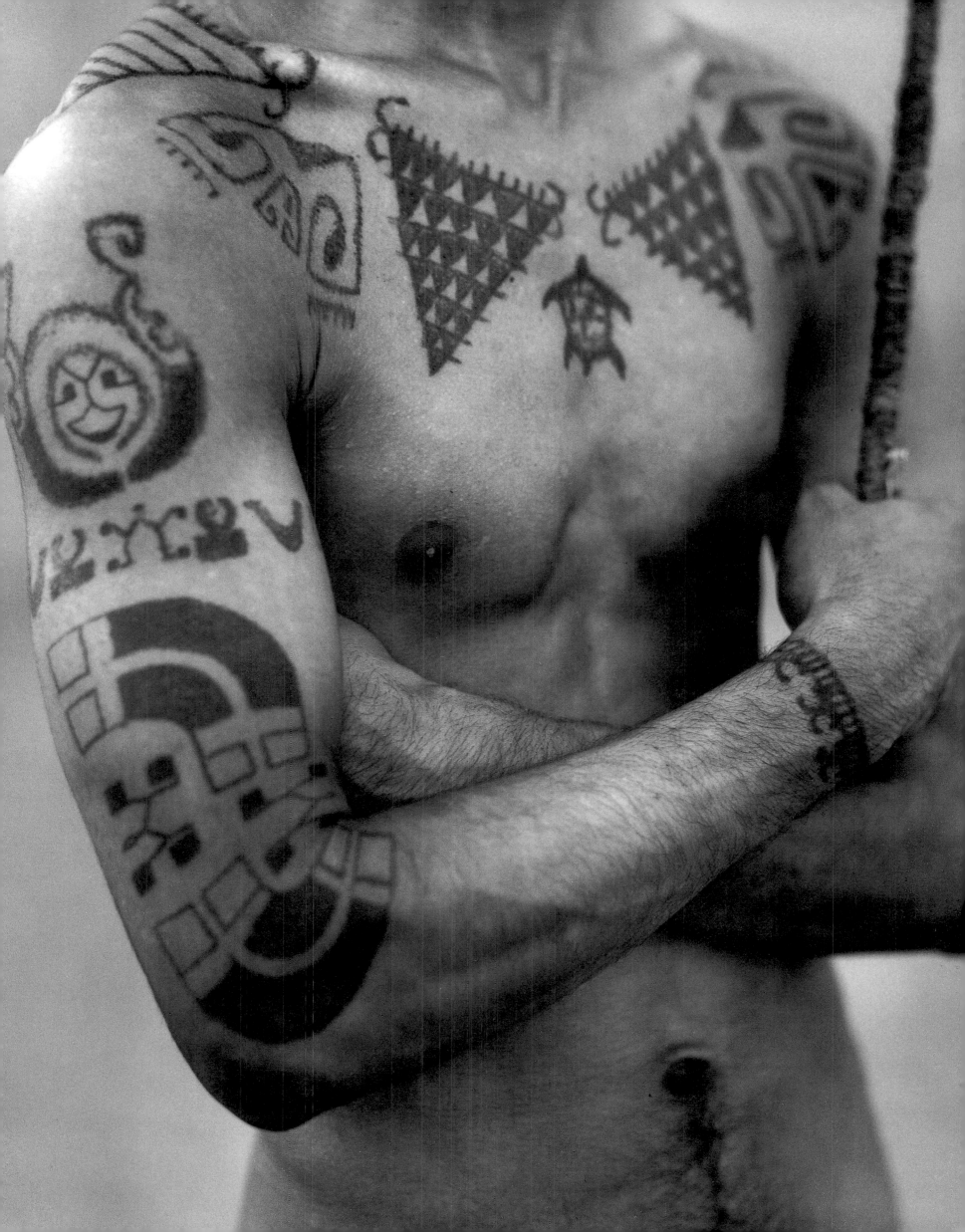

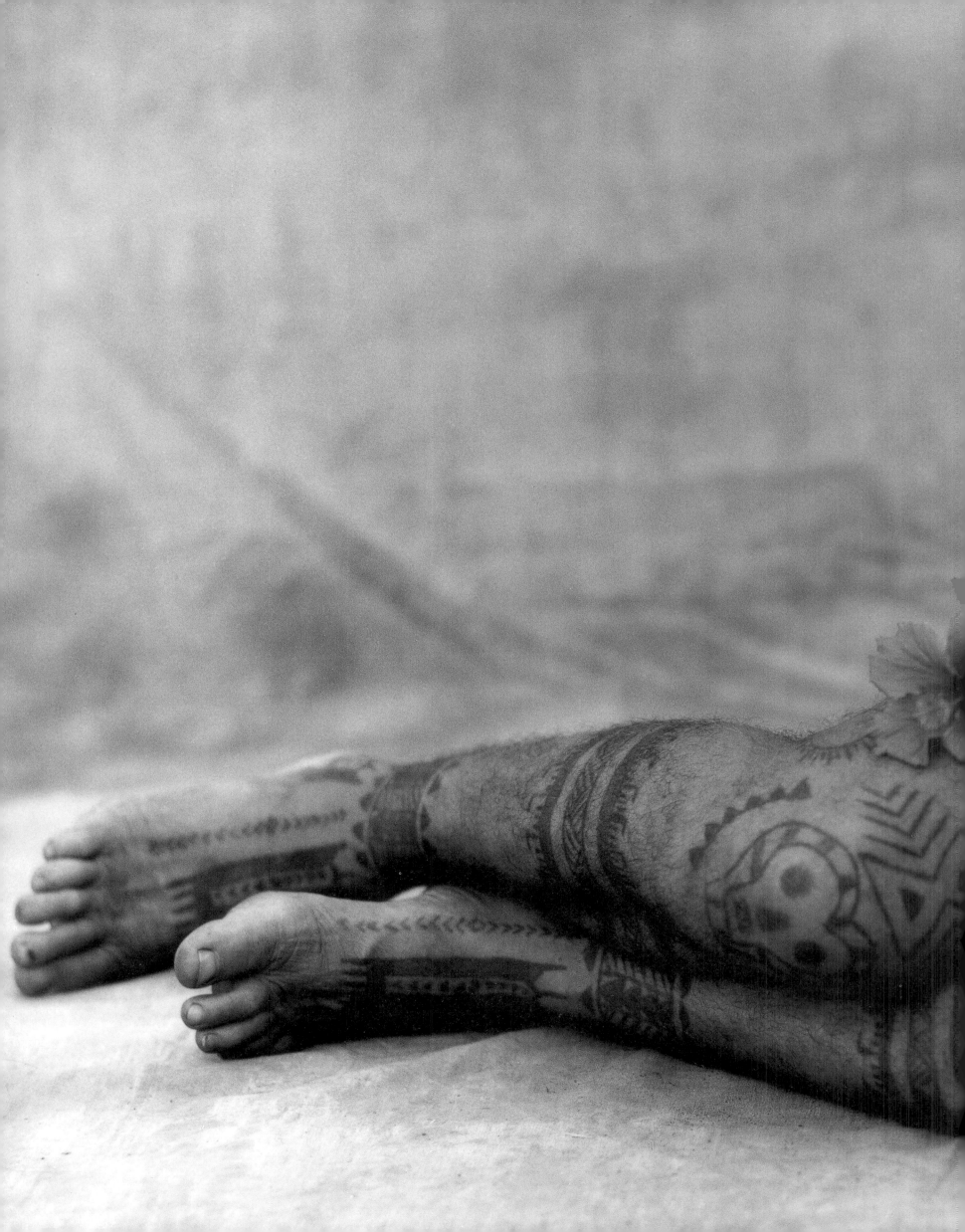

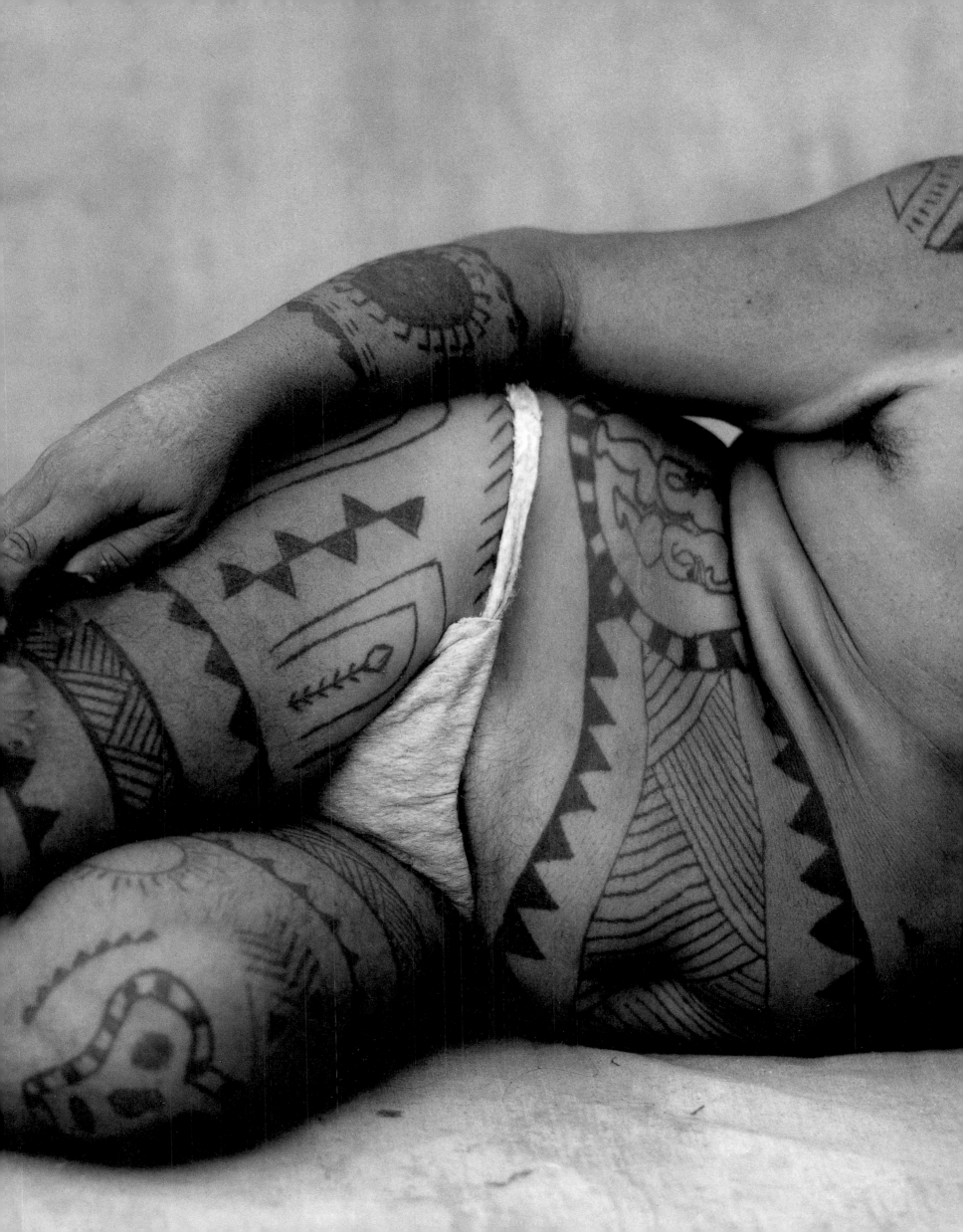

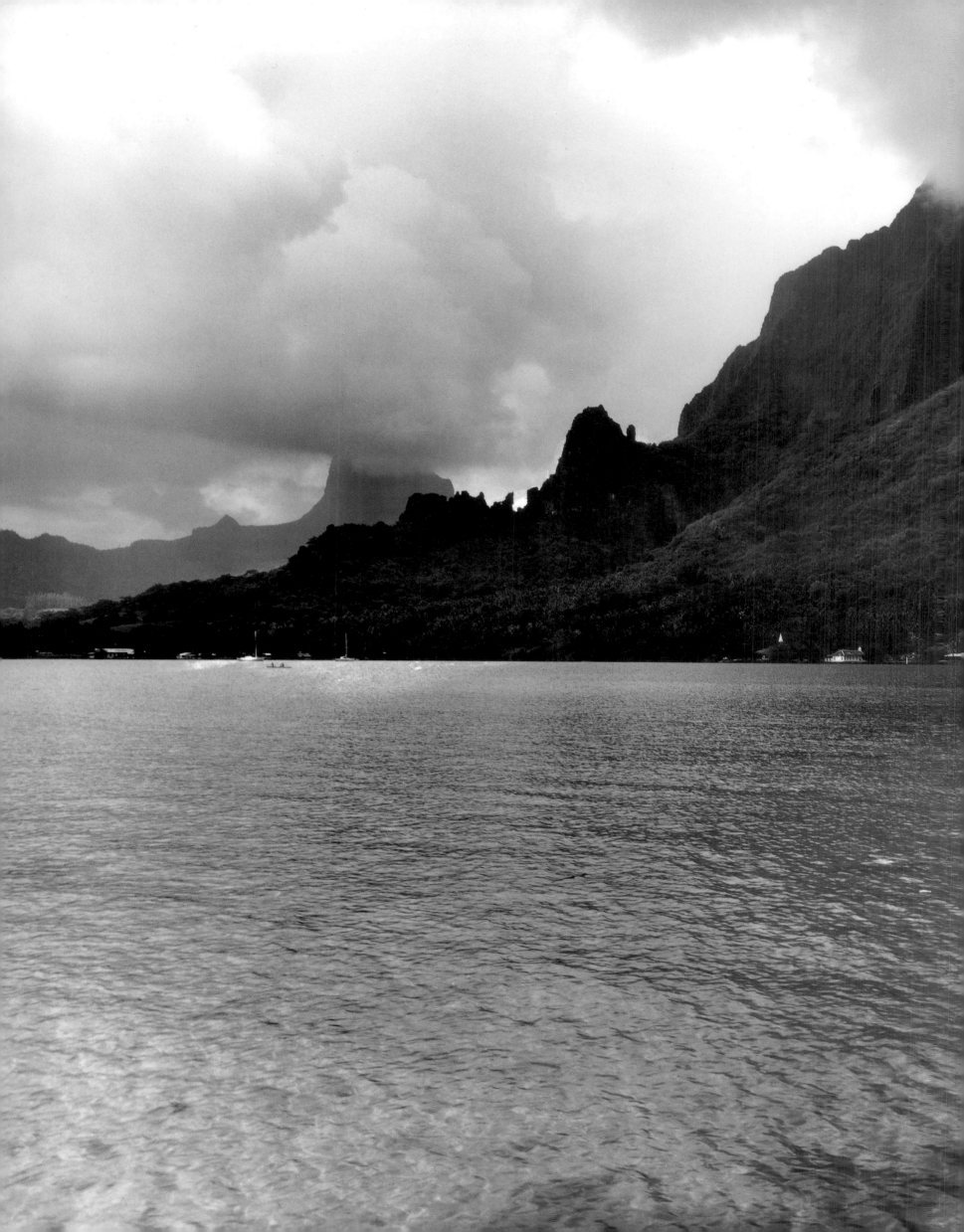

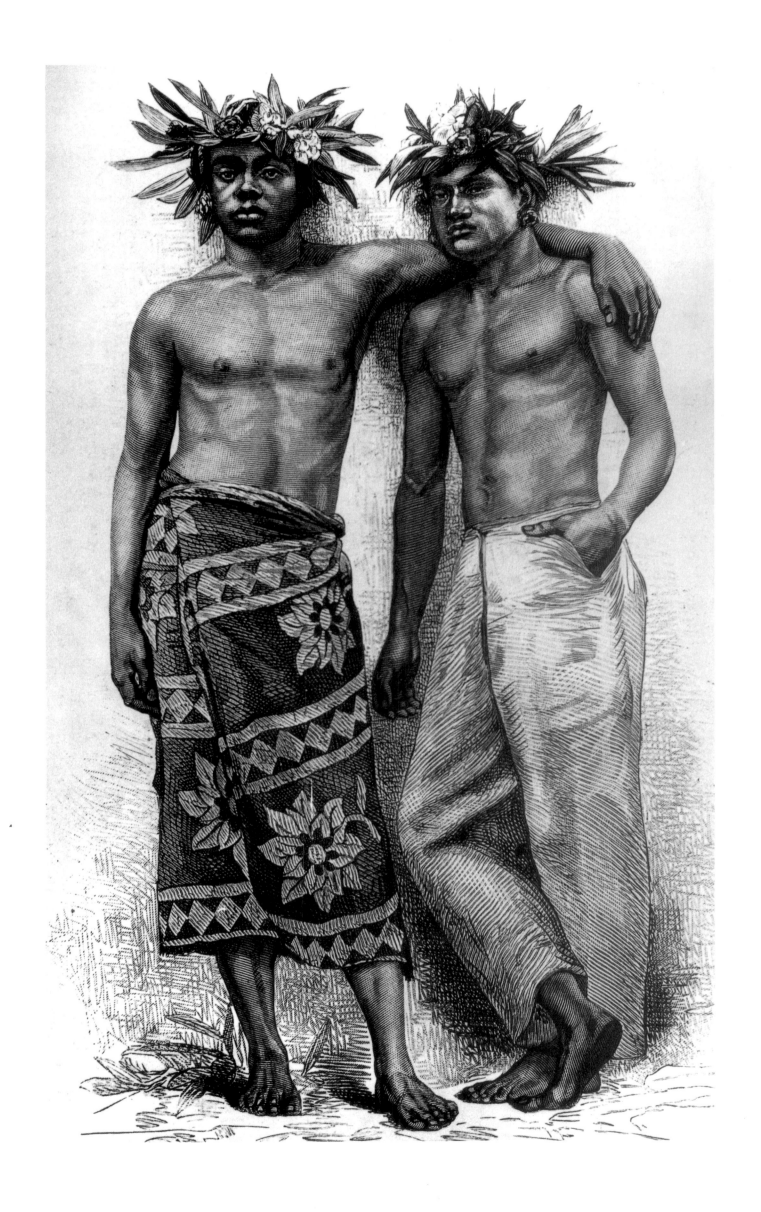

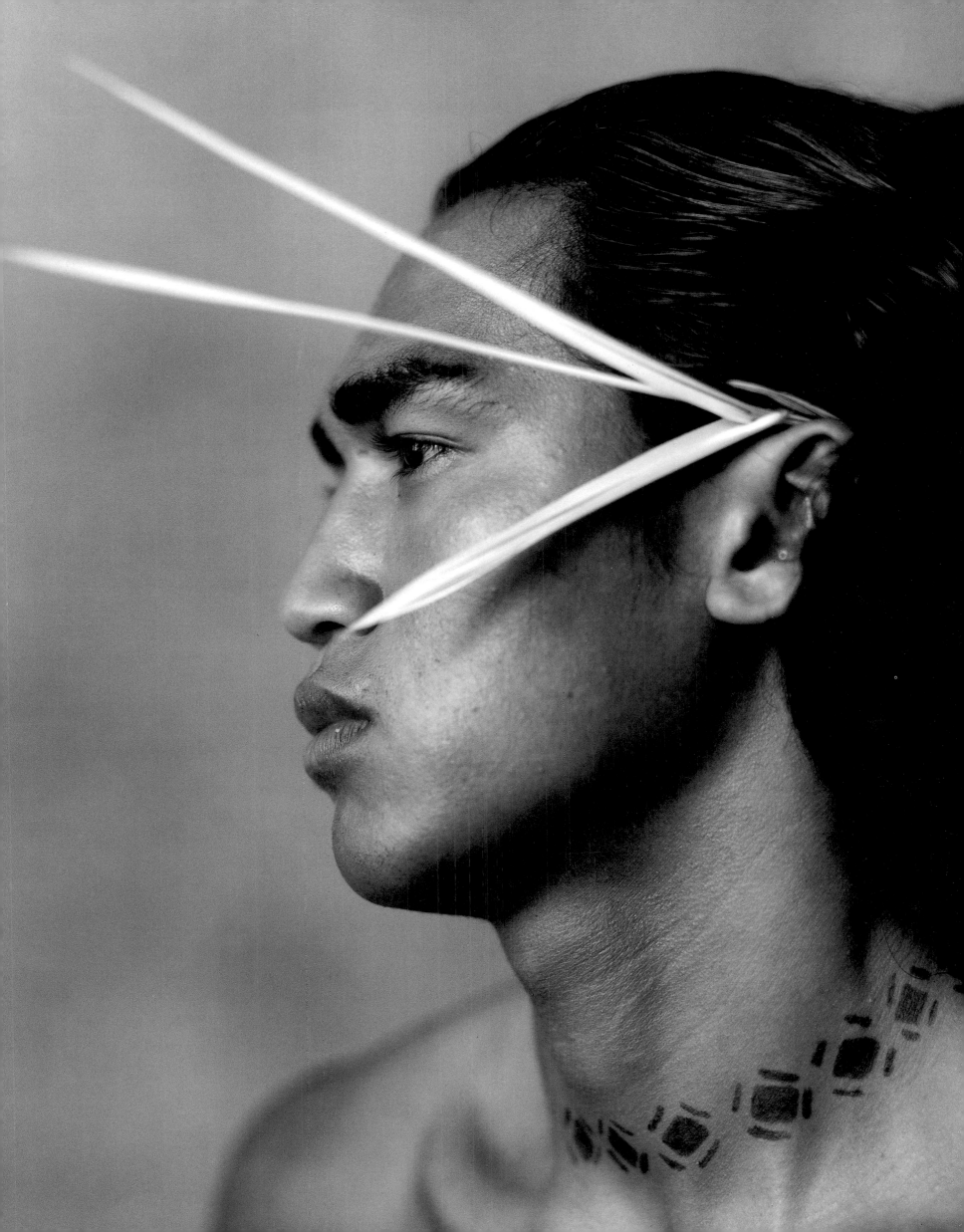

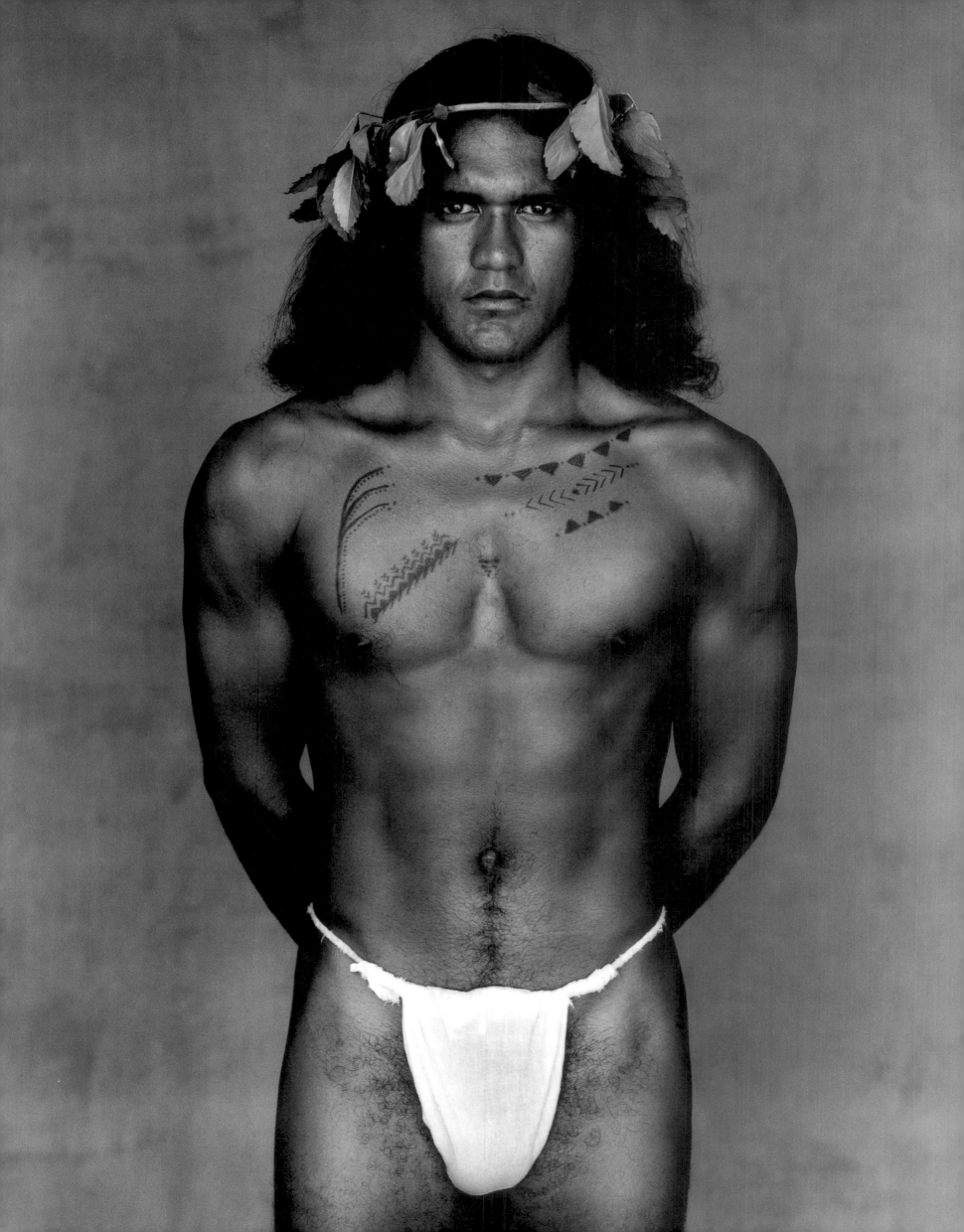

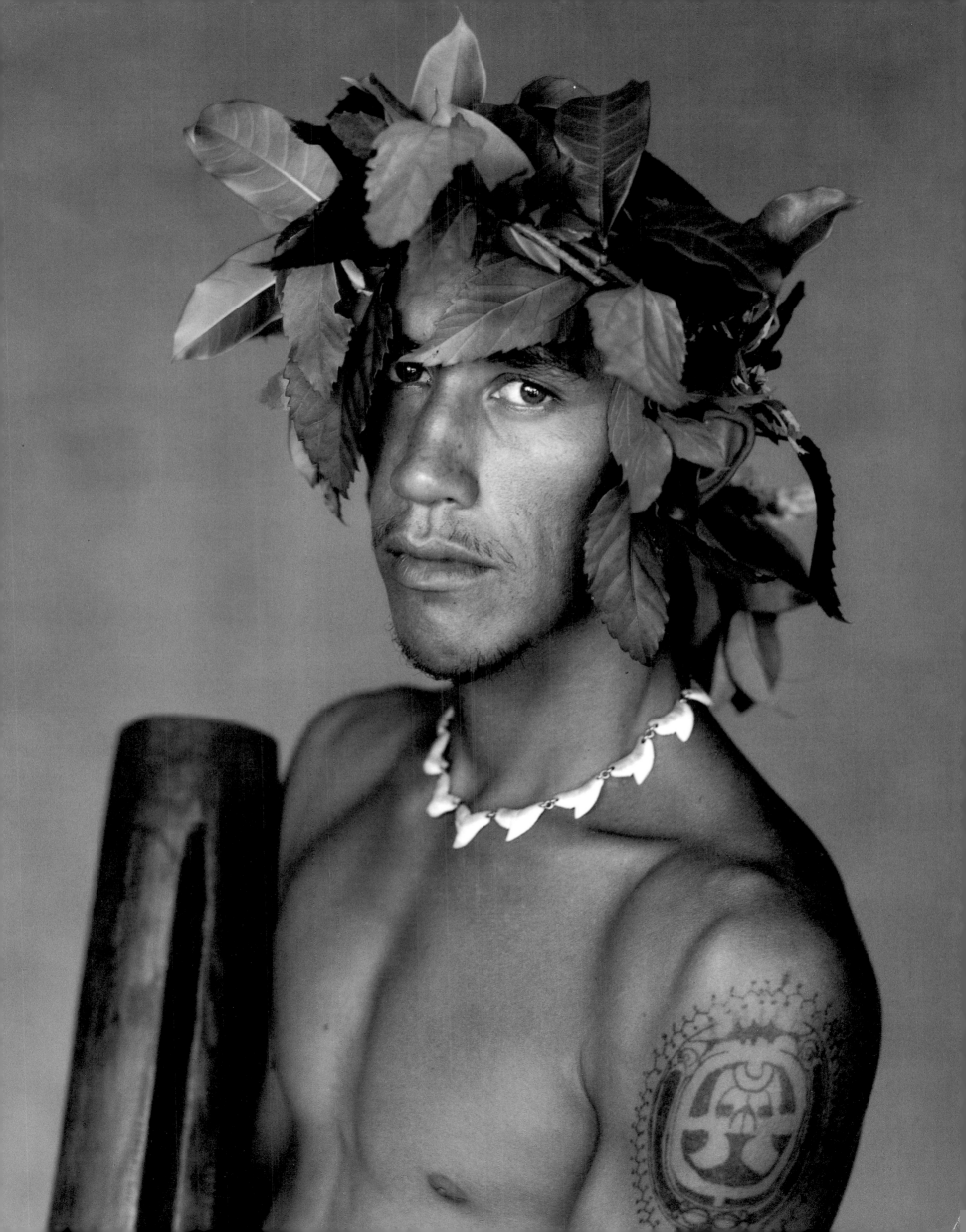

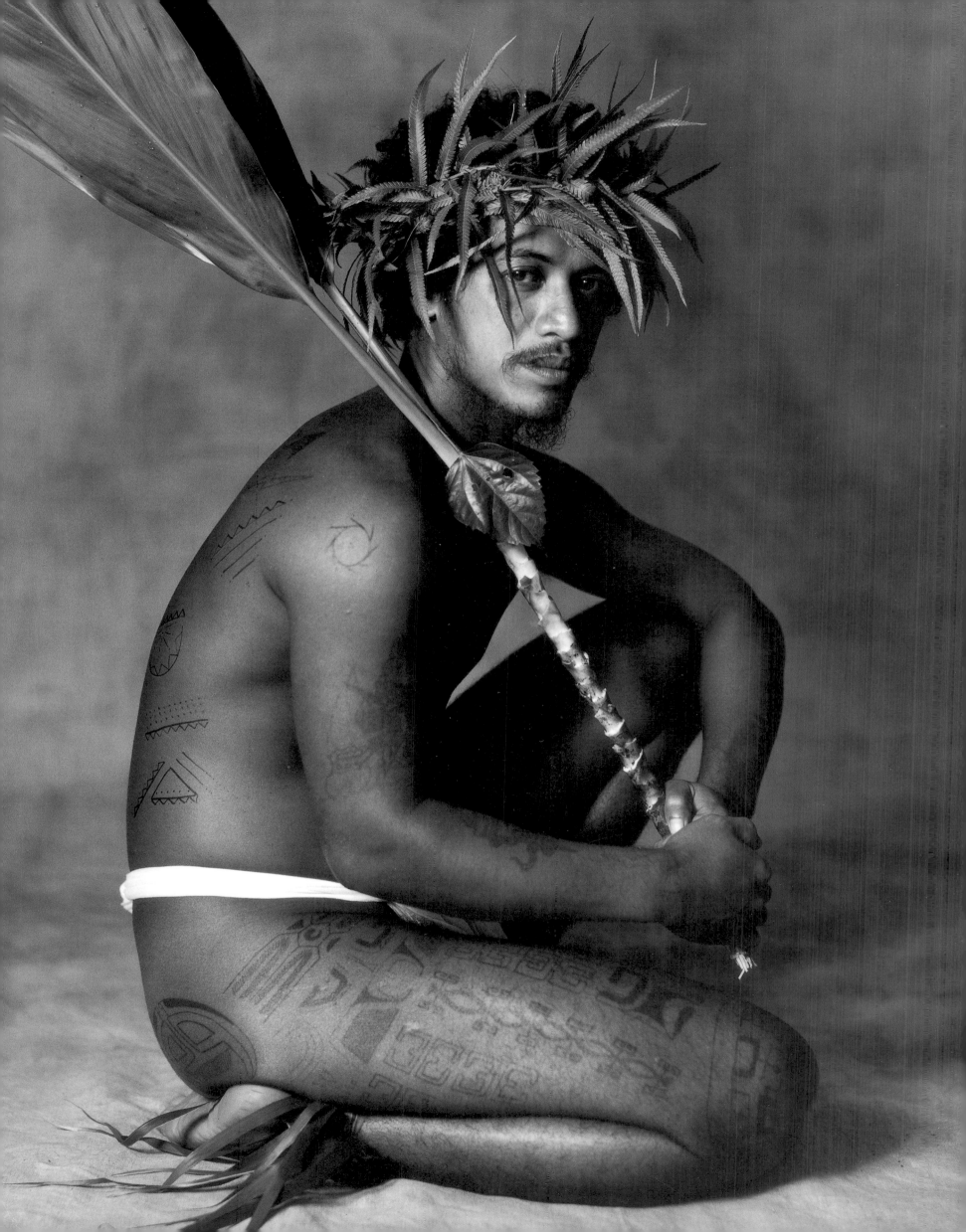

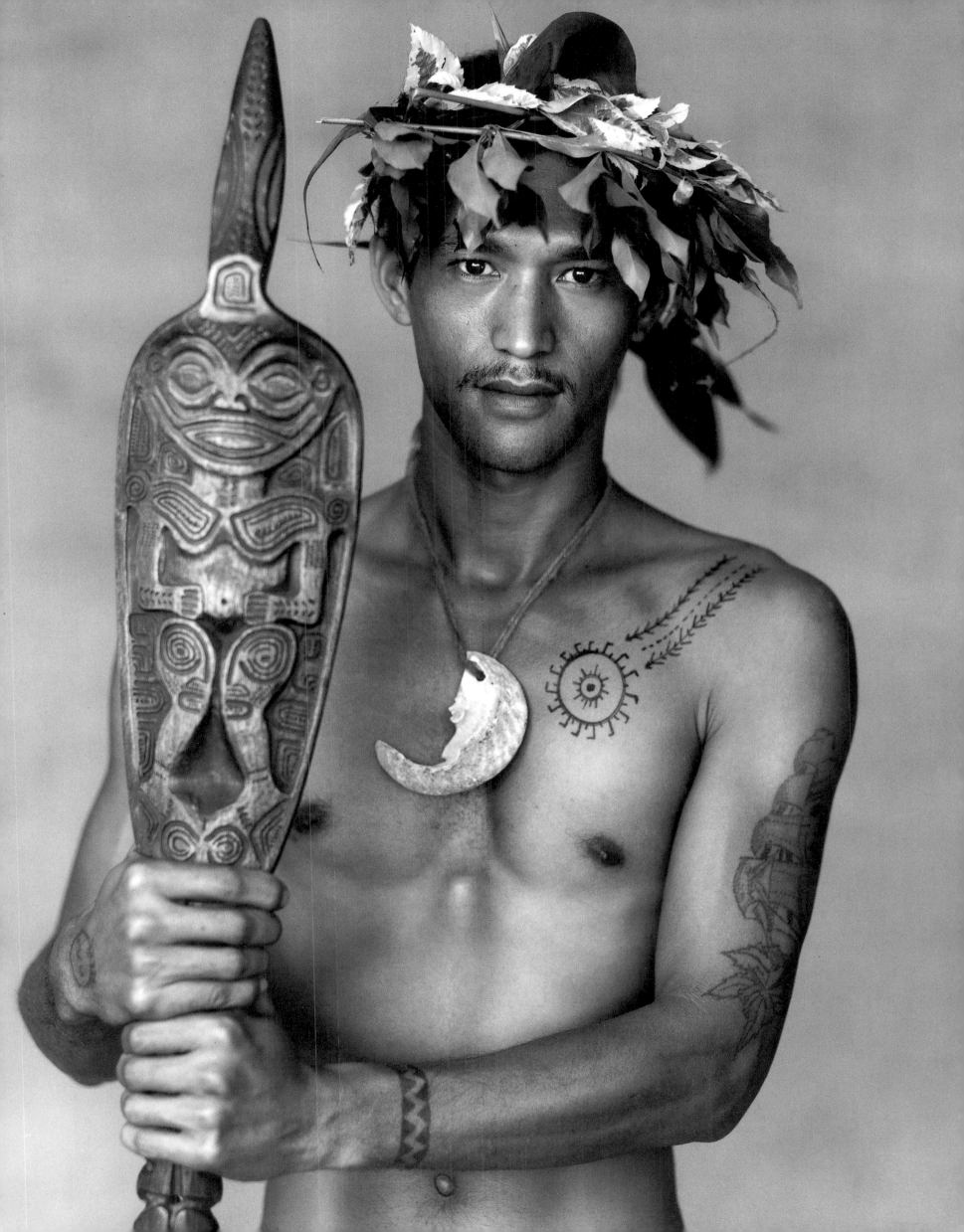

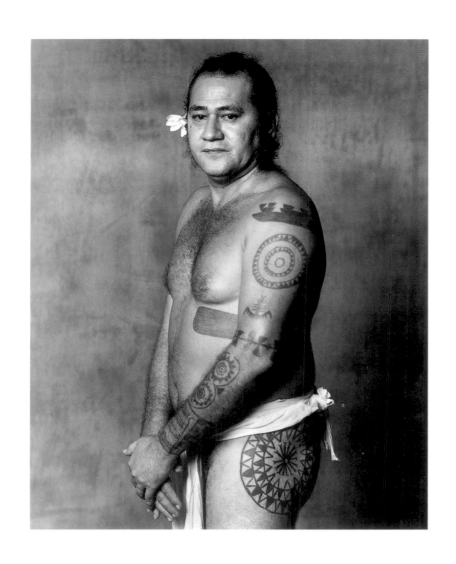
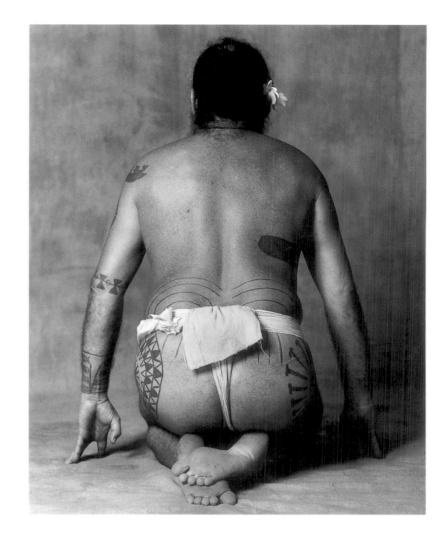

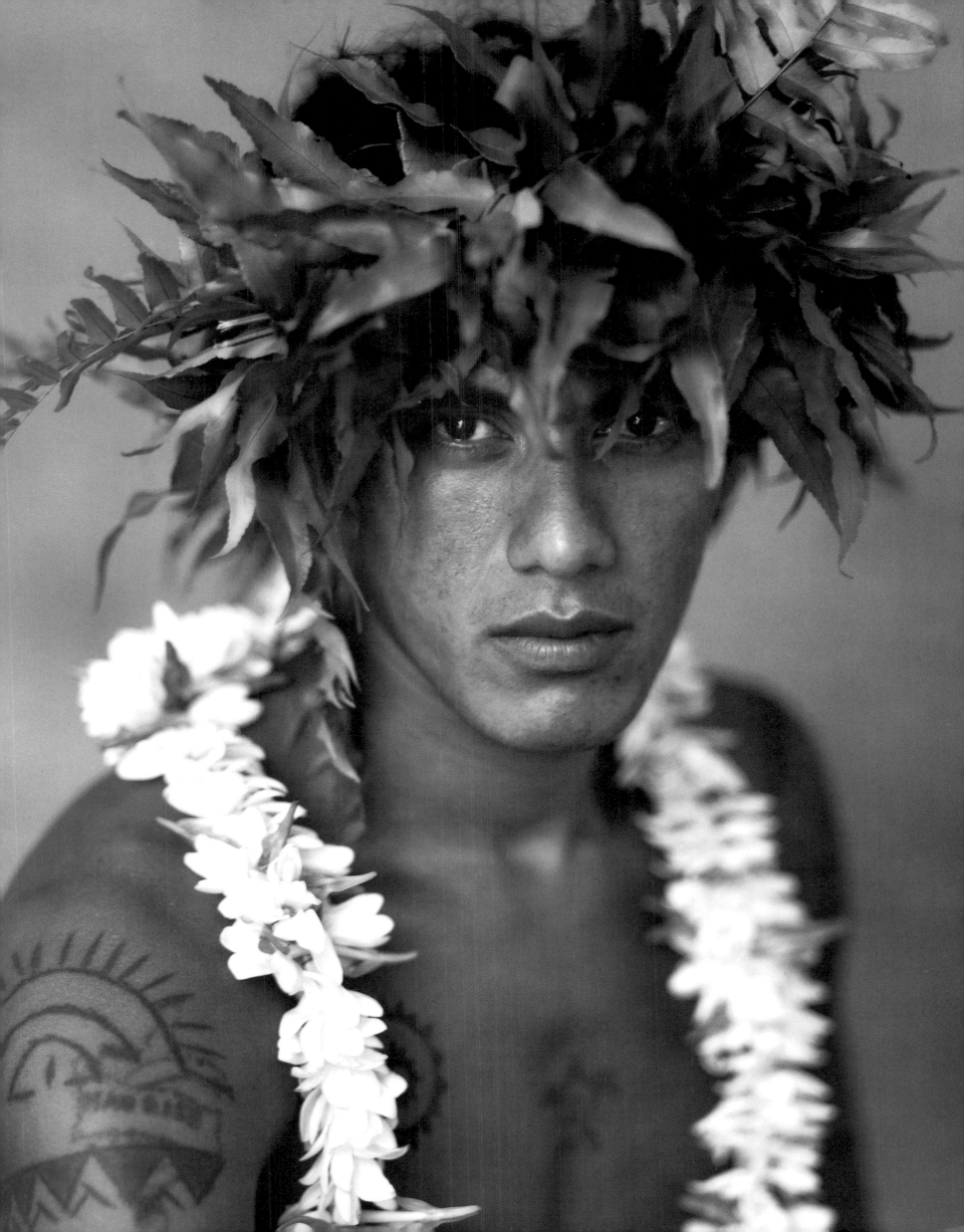

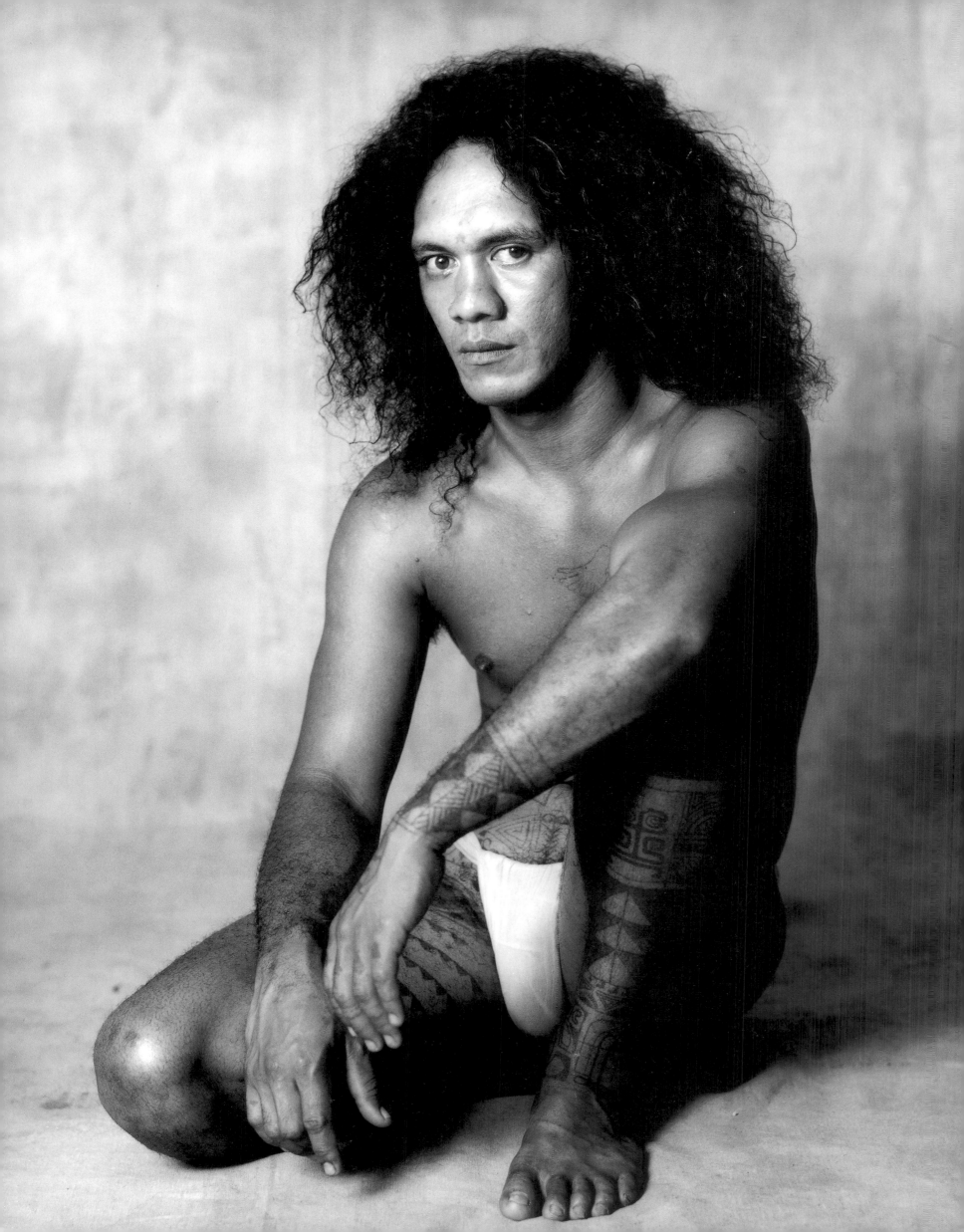

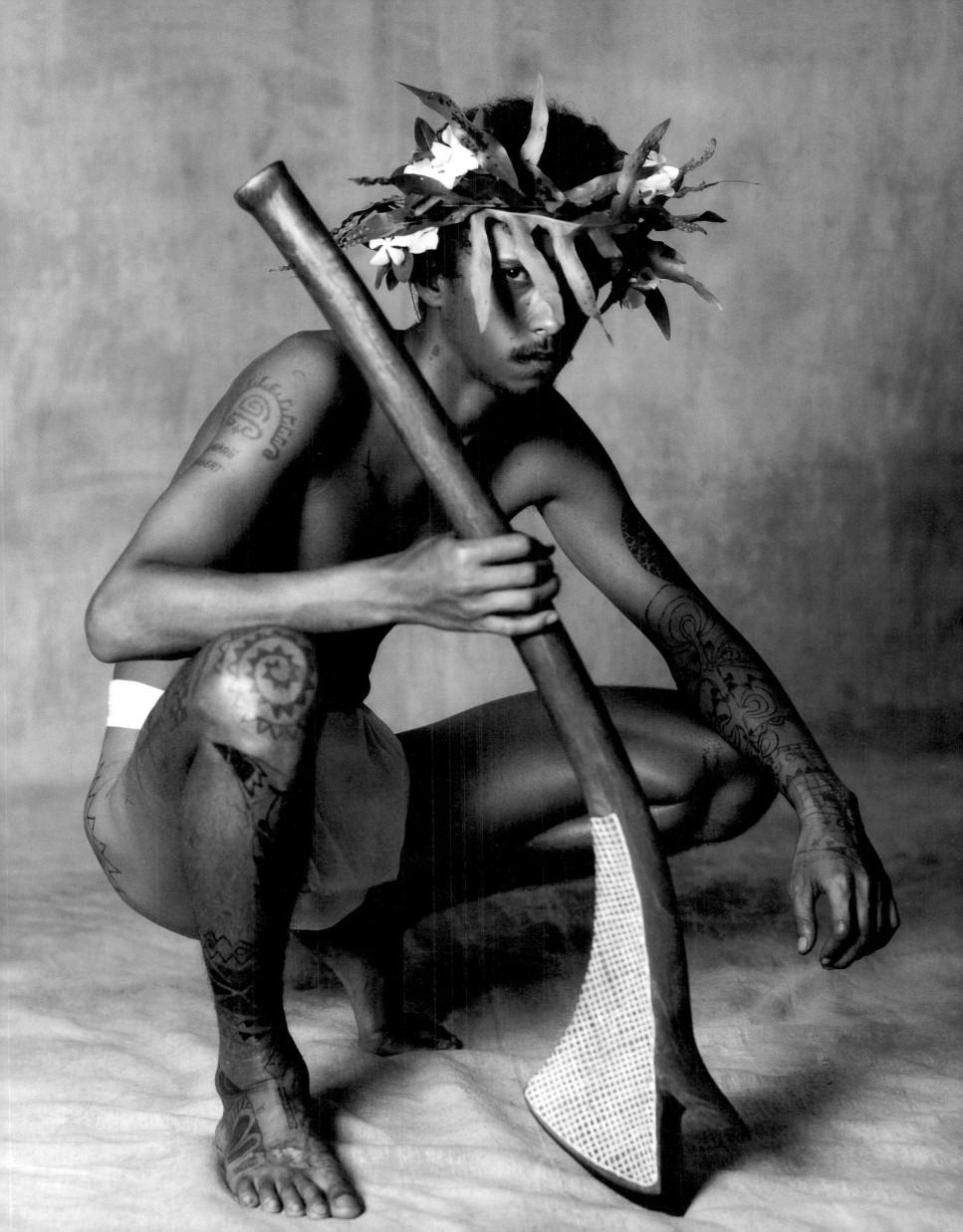

O gentle breezes from South
and East, who meet above my
head, ... go, hasten to the other
island; there you will find the
man who has abandoned me,
sitting in the shade of his
favourite tree. Tell him that
you found me in tears.

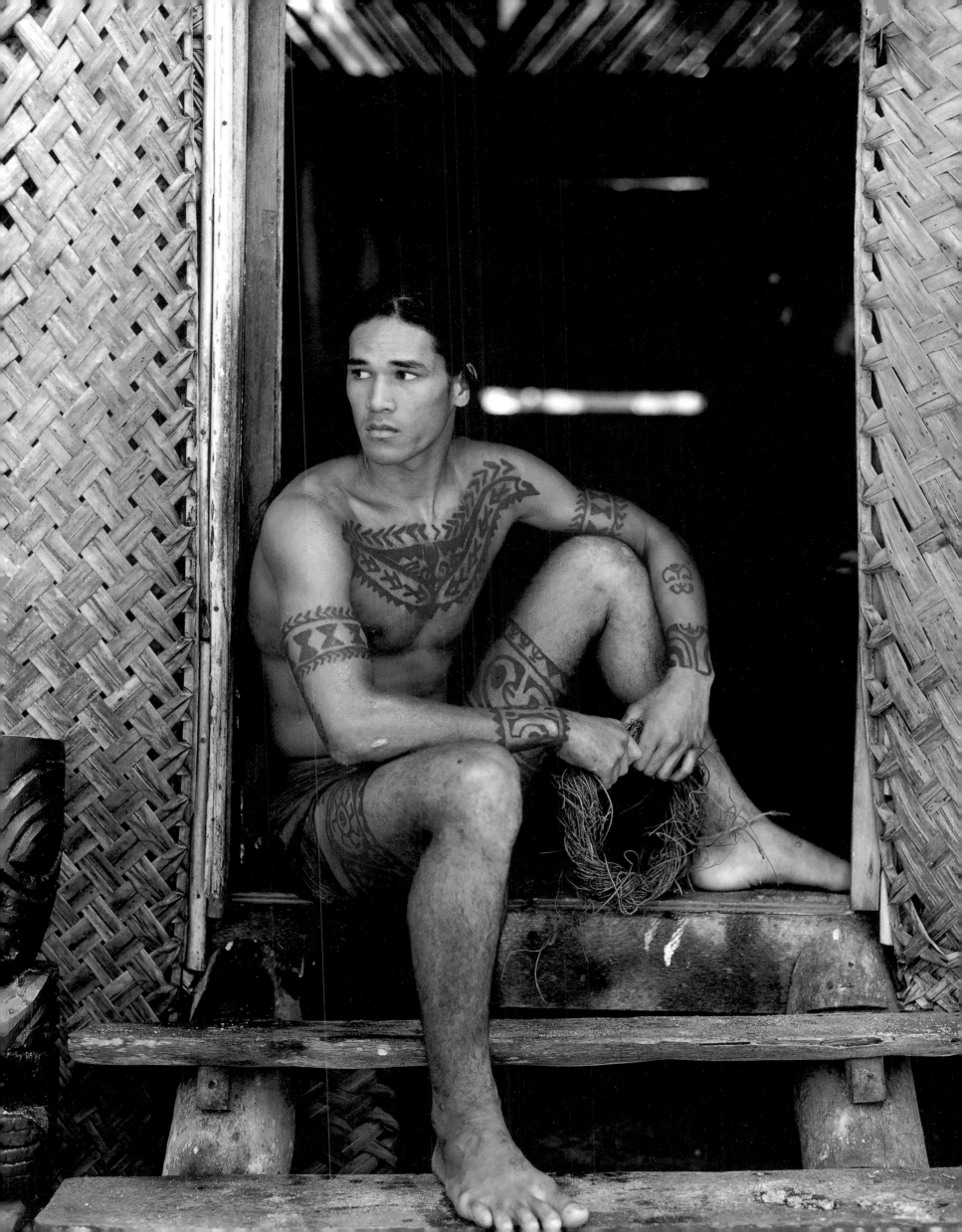

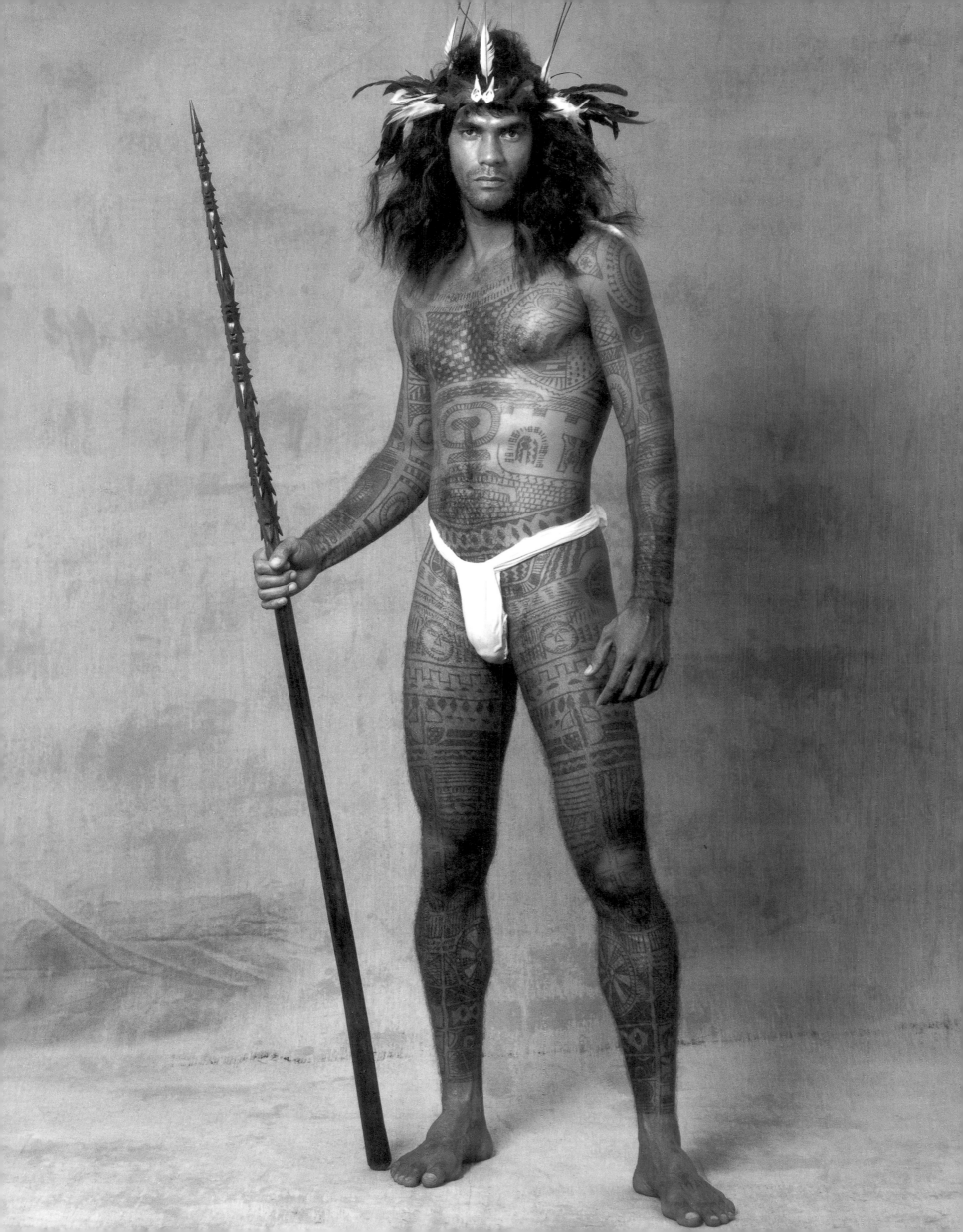

THE REASONS FOR TATTOOING

Traditionally, tattooing has always been a privilege of the more eminent social classes. The main purposes of decoration were to enhance sexual attraction, to exalt the life force and to give the wearer a godlike appearance. Social ranking was signalled by tattoos that corresponded to the wearer's position in the community under the supervision of the Ari'i. When initiates acquired greater prestige, they would get new tattoos.

Women had fewer tattoos than men, and only their hands, arms, hips, thighs and feet underwent the operation. Designs for women, being purely ornamental, were more elegant and better drawn.

Men often had tattoos all over their body, including on the neck and ears. Only the face was left untattooed, with the exception of the occasional warrior or priest who might wear a special emblem on his forehead or lips. Tribal chiefs would have a stunning array of body decoration. For men, tattoos were often a kind of medal, awarded for daring in war or to mark a special event, and were always an affirmation of cultural identity. Tattoos fall into four categories: those belonging to the social class of gods, priests and Ari'i, which were hereditary and restricted to their descendants; tattoos of the Hui Ari'i class, Arioi'i, exclusively for chiefs (male and female); tattoos of the Hui To'a, Hui Ra'atira, Ia To'ai class, reserved for leaders of war parties, warriors, dancers, rowers and so on; and Manahune class tattoos, for individuals with no pedigree or an unremarkable family history.

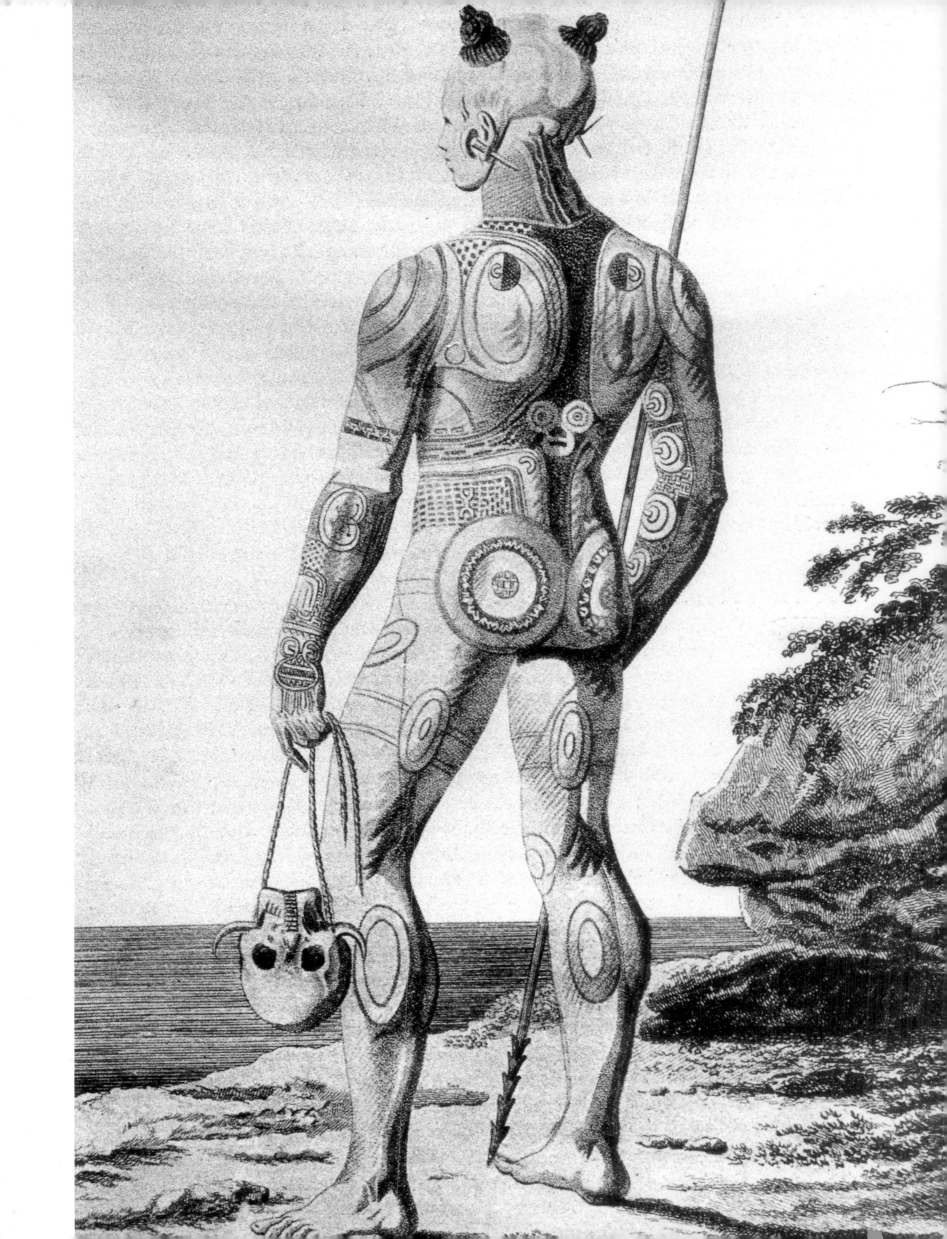

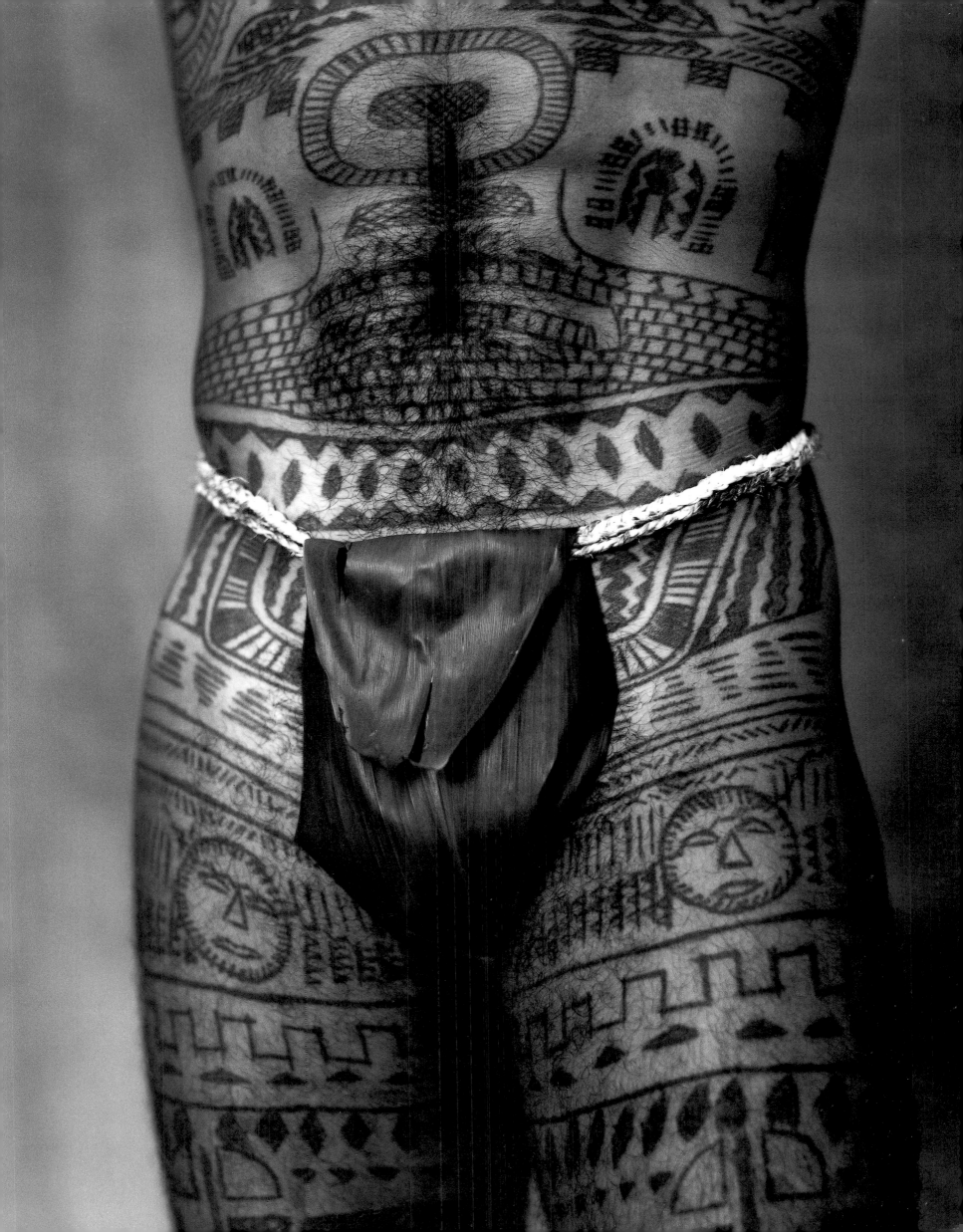

That day, I went to smoke a cigarette on the sandy shore.
The sun fell quickly to the horizon, where it was partly hidden by Moorea Island, to my right. The contrasts of light drew the silhouettes of the mountains ever more sharply and ominously black on the molten sky, their ridges forming crenellations of ancient castles.

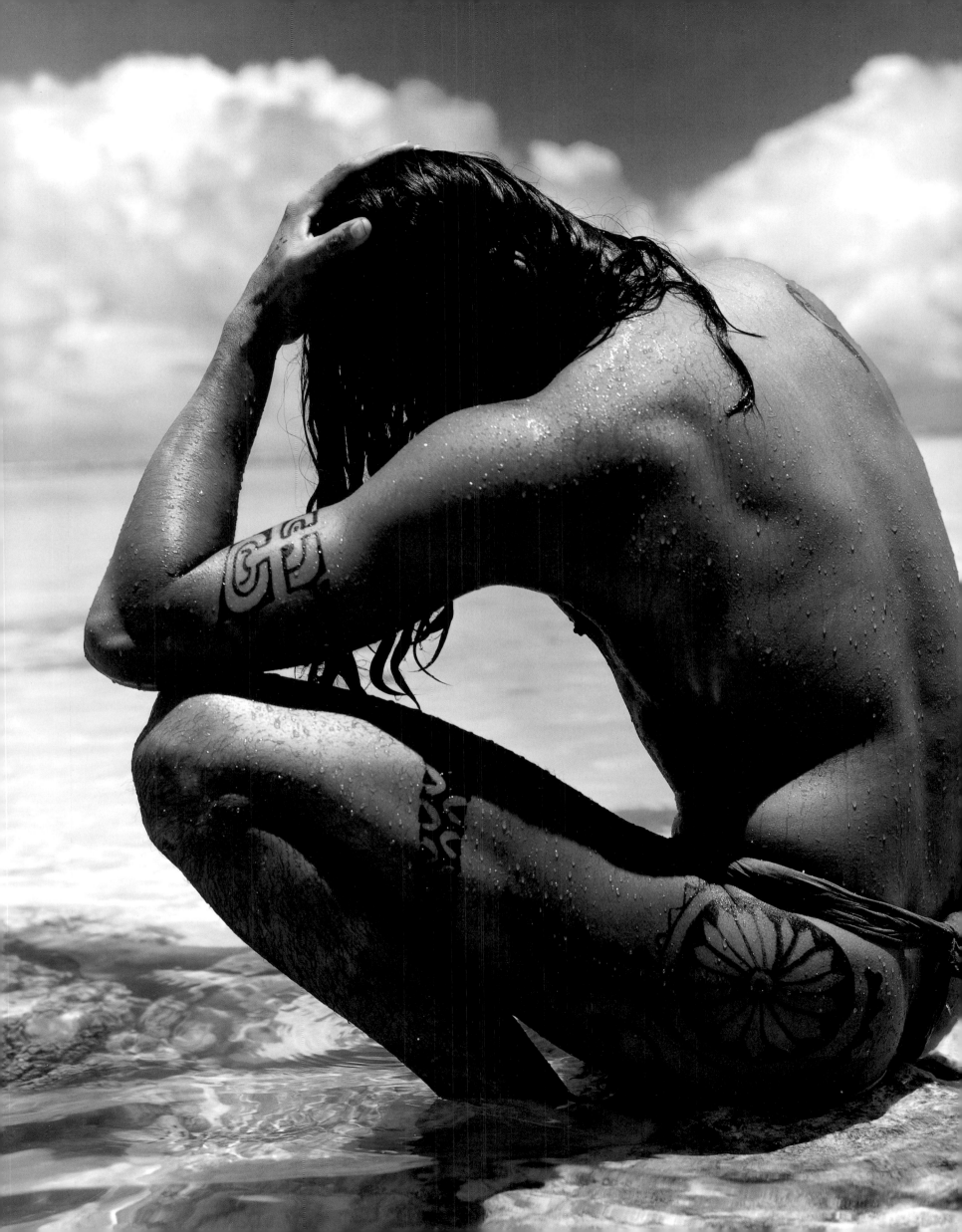

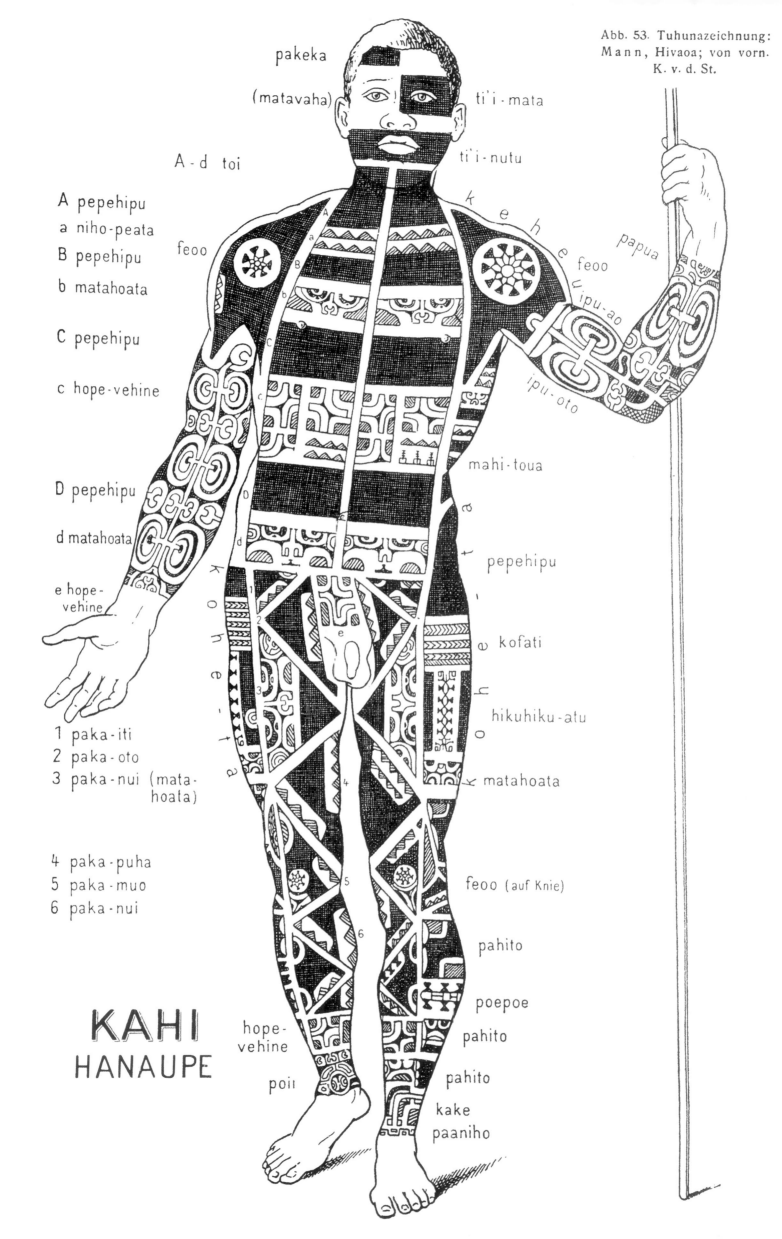

Abb. 53. Tuhunazeichnung:
Mann, Hivaoa; von vorn.
K. v. d. St.

pakeka

(matavaha)

ti'i-mata

ti'i-nutu

A-d toi

k e h e t i p u-a o

A pepehipu

feoo

feoo

niho-peata

papua

B pepehipu

ipu-ao

b matahoata

ipu-oto

C pepehipu

mahi-toua

c hope-vehine

pepehipu

D pepehipu

kofati

d matahoata

hikuhiku-atu

e hope-
vehine

matahoata

1 paka-iti

2 paka-oto

3 paka-nui (mata-
hoata)

feoo (auf Knie)

4 paka-puha

5 paka-muo

6 paka-nui

pahito

poepoe

KAHI

hope-
vehine

pahito

HANAUPE

pahito

poii

kake
paaniho

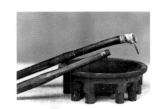

THE TATTOOING OPERATION

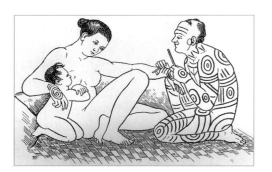

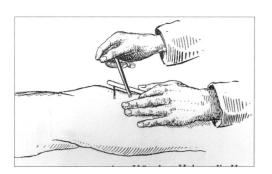

Tattooing is painful, but bearably so, and is only rarely carried out at a single sitting. The name "Tatatau" is a term that describes the tattooer's art, and means "making points or marks on the skin". It was practised on girls between eight and ten and on boys at the age of eleven or twelve, although in the case of males, decorations would continue to be added until they were about thirty. It was felt preferable for young girls to have been tattooed before their adolescence. The tattooing ceremony was a ritual in its own right, in which music had pride of place with drums, flutes and shell horns.

There were many different tattoos and they were applied to many parts of the body. Each design had its own special name, some of which are still known. For example, the tattoos applied to the back of the body are called Papai Taputua and Urupo'o, those on the ear lobes and buttocks are known as A'ie and tattoos on the face are named A'ie Aro. Some were stylized patterns of stars, circles, diamonds and so on while others reflected the way of life of a community: battles and weapons for the Uru, human sacrifices for the Marae. Finally tattooers also drew inspiration from dogs, other animals and fish. The tattooer priest who carried out this delicate operation was generously rewarded and enjoyed great standing in society.

The tools of the tattooer priest (Tahu'a Tatau), which are still used today, were two comb-like instruments, a punch and a stick. The punch had a wooden handle onto which a bird bone, or shard of

mother-of-pearl, or a tooth from a fish, pig, shark, whale or even a human being had been carefully attached and sharpened. Some combs had as many as 36 such points. To help this first tool to penetrate beneath the skin, the tattooer priest had a second instrument at his disposal. This was a stick that was used as a hammer on the punch.

The extremely black dye used came from the burnt and dried fruit of the "bancoule Tiairi". The resulting powder was mixed with water or *monoï*. The dye was injected under the skin and took on an absolutely indelible bluish coloration. A strongly scented plant, the Ahi tutu, was used to help the process of scarification.

The tattooer priest had an impressive range of models, and selection of the design, to which great care was devoted, was of crucial importance. Once the decision had been made, the motif was traced onto the wearer's body with a piece of charcoal, the artist often working freehand before using his tools to make the incisions into which the dye was injected. The Tahu'a Tatau, or tattooer priest, was and still is held to be the privileged repository of an art that must be passed on uncorrupted to future generations.

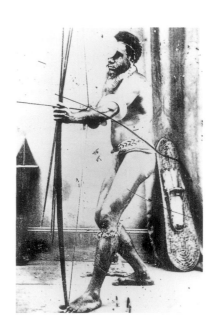

Raymond Graffe
High Priest of Marae and Tattoo

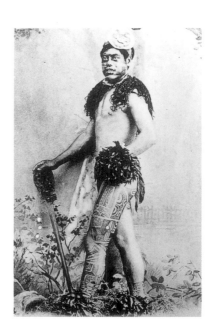

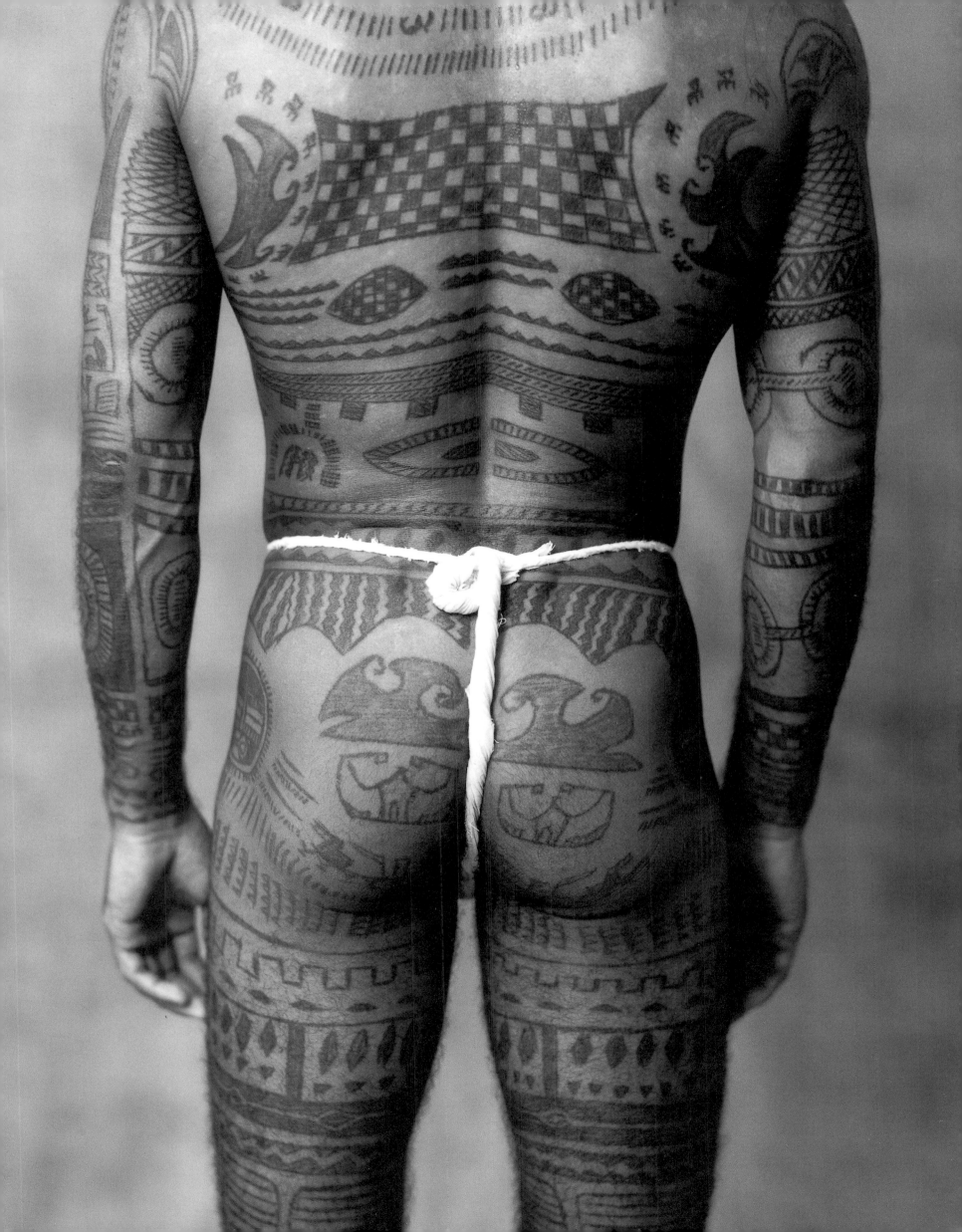

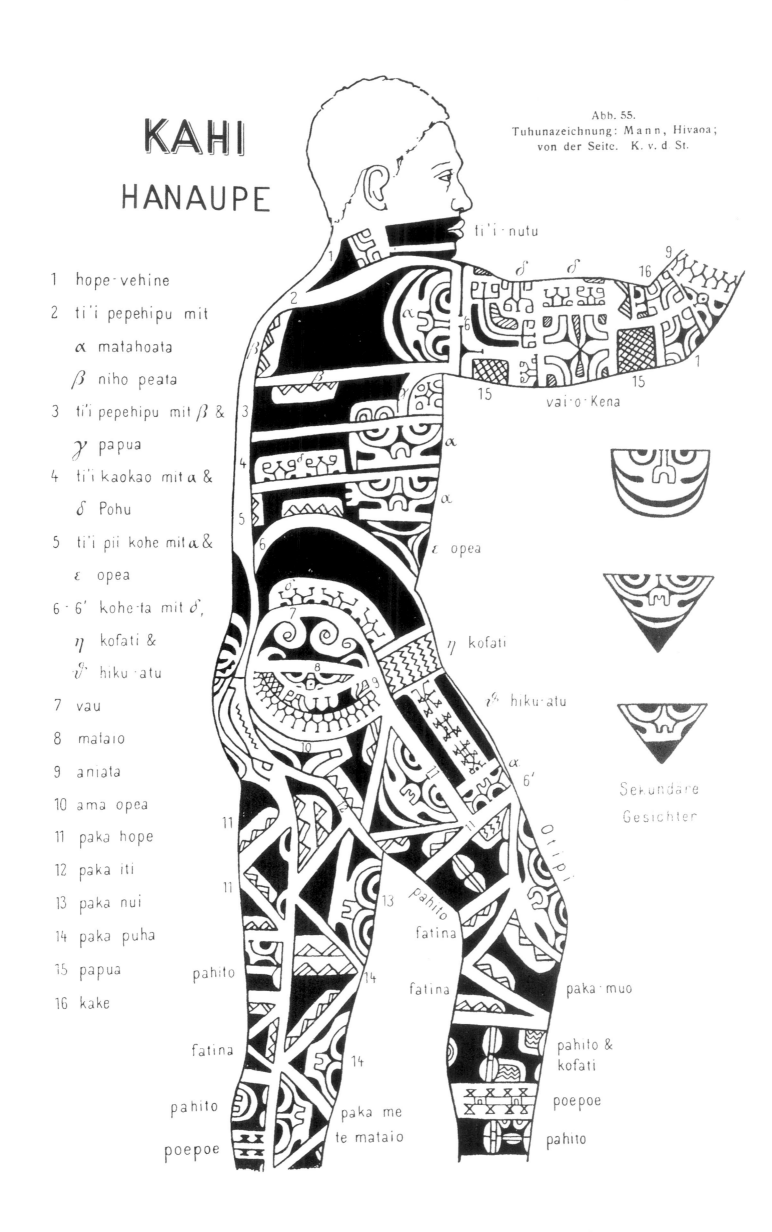

KAHI

HANAUPE

Abb. 55.
Tuhunazeichnung: Mann, Hivaoa;
von der Seite. K. v. d St.

1 hope·vehine
2 ti'i pepehipu mit
 α matahoata
 β niho peata
3 ti'i pepehipu mit β &
 γ papua
4 ti'i kaokao mit α &
 δ Pohu
5 ti'i pii kohe mit α &
 ε opea
6 · 6' kohe·ta mit ♂,
 η kofati &
 θ hiku·atu
7 vau
8 mataio
9 aniata
10 ama opea
11 paka hope
12 paka iti
13 paka nui
14 paka puha
15 papua
16 kake

ti'i·nutu

vai·o·Kena

α
α
ε opea

η kofati

θ hiku·atu

α
6'

Sekundäre
Gesichter

pahito
fatina

fatina

paka·muo

pahito
fatina

pahito &
kofati

pahito

paka me
te mataio

poepoe

poepoe

pahito

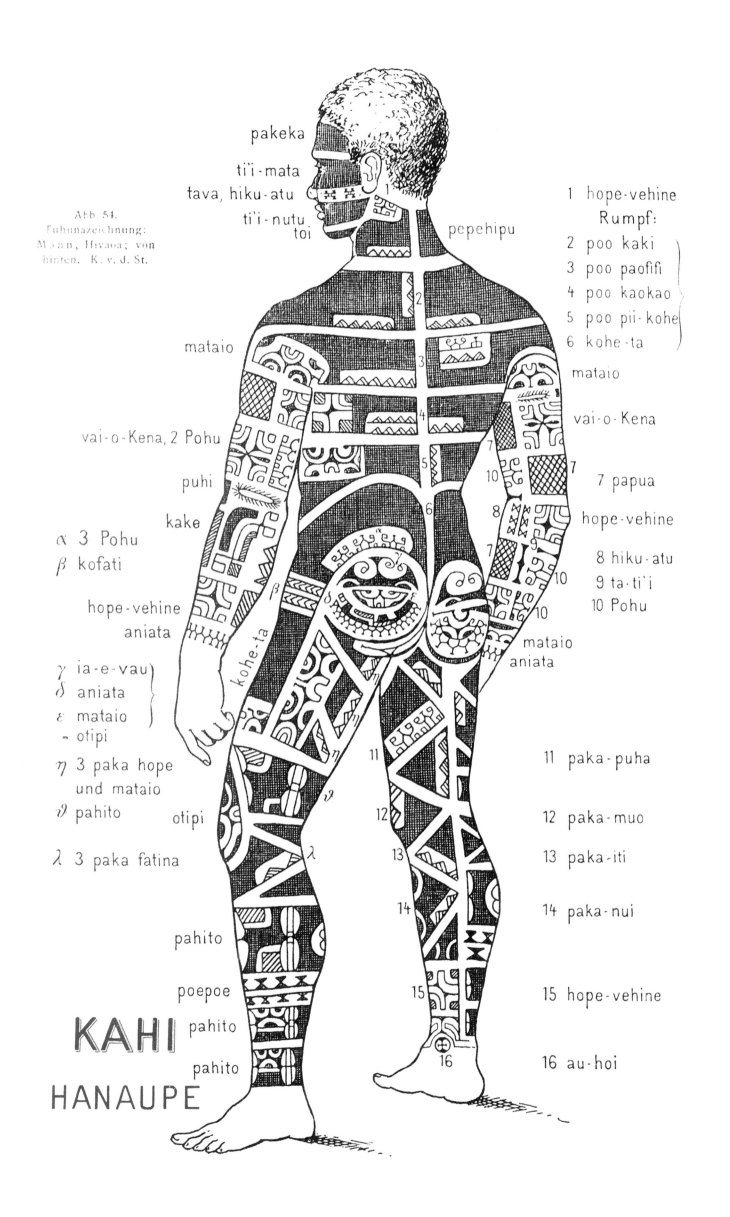

pakeka
tiï-mata
tava, hiku-atu
tiï-nutu
toi

Abb. 54.
Tuhunazeichnung:
Mann, Hivaoa; von
hinten. K. v. d. St.

mataio

vai-o-Kena, 2 Pohu

puhi

kake

α 3 Pohu
β kofati

hope-vehine
aniata

γ ia-e-vau
δ aniata
ε mataio
⌐ otipi

η 3 paka hope
und mataio
ϑ pahito

λ 3 paka fatina

pahito

poepoe

KAHI pahito

HANAUPE pahito

pepehipu

kohe-ta

otipi

λ

1 hope-vehine
 Rumpf:
2 poo kaki
3 poo paofifi
4 poo kaokao
5 poo pii-kohe
6 kohe-ta

mataio

vai-o-Kena

7 papua

hope-vehine

8 hiku-atu
9 ta-tiï
10 Pohu

mataio
aniata

11 paka-puha

12 paka-muo

13 paka-iti

14 paka-nui

15 hope-vehine

16 au-hoi

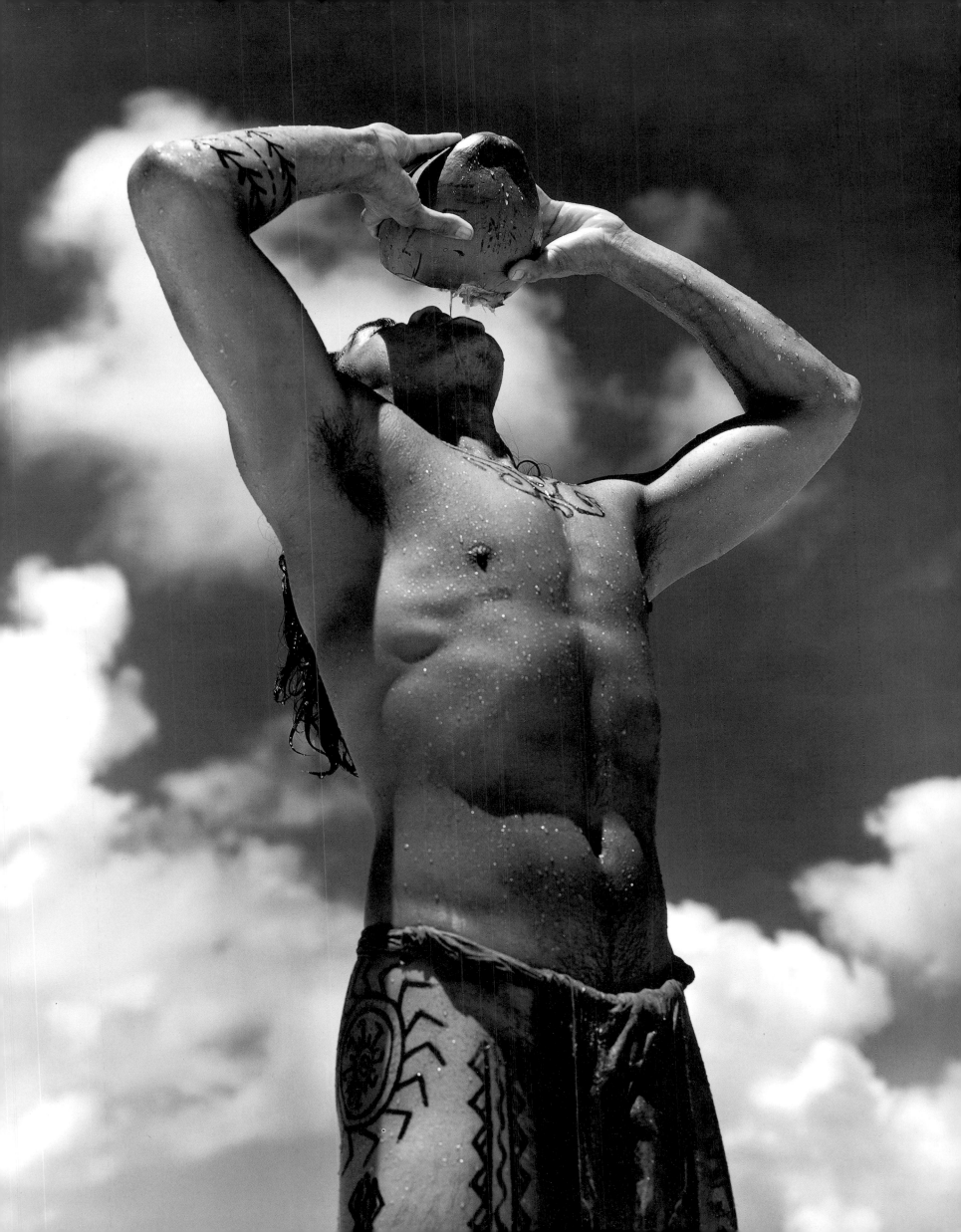

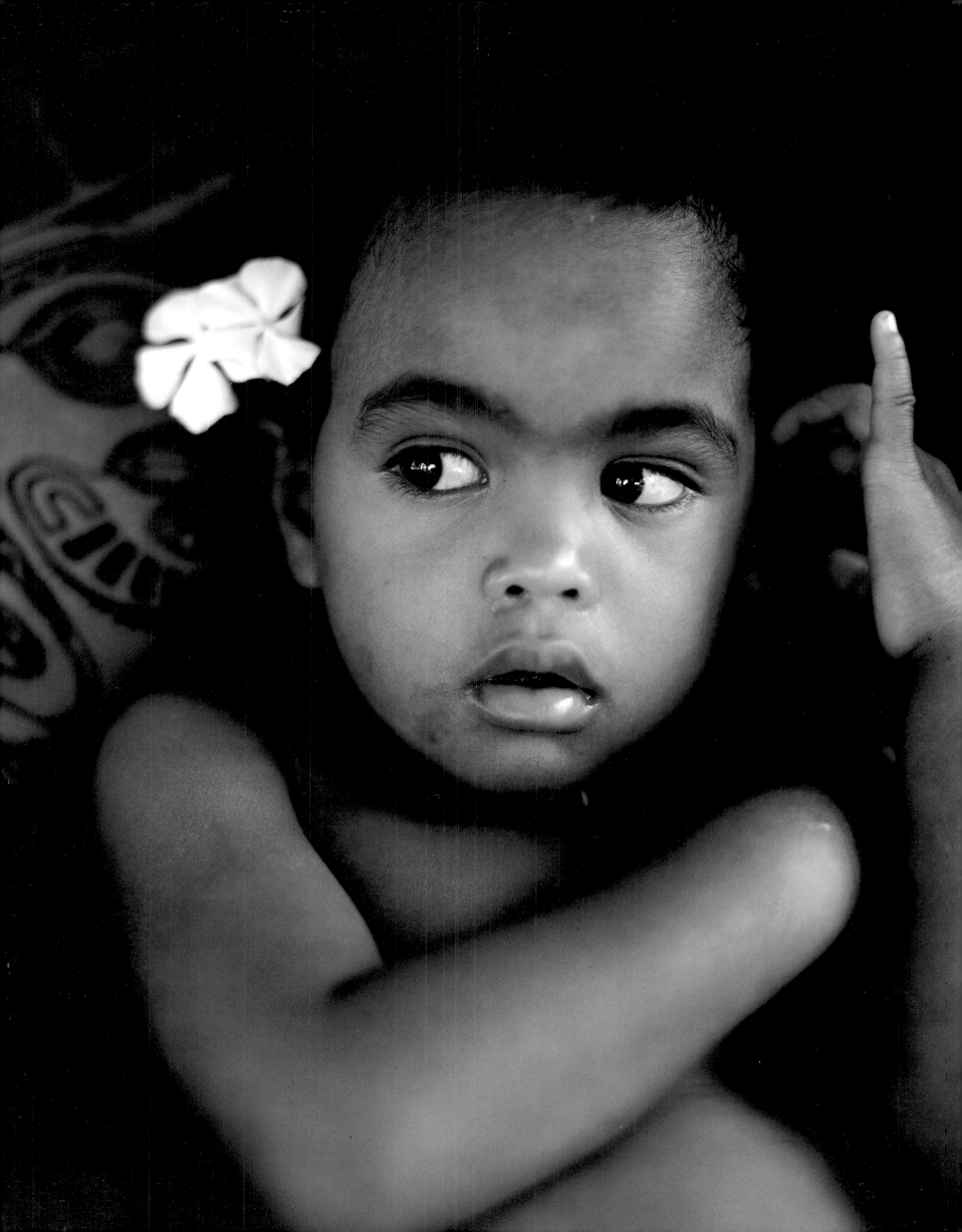

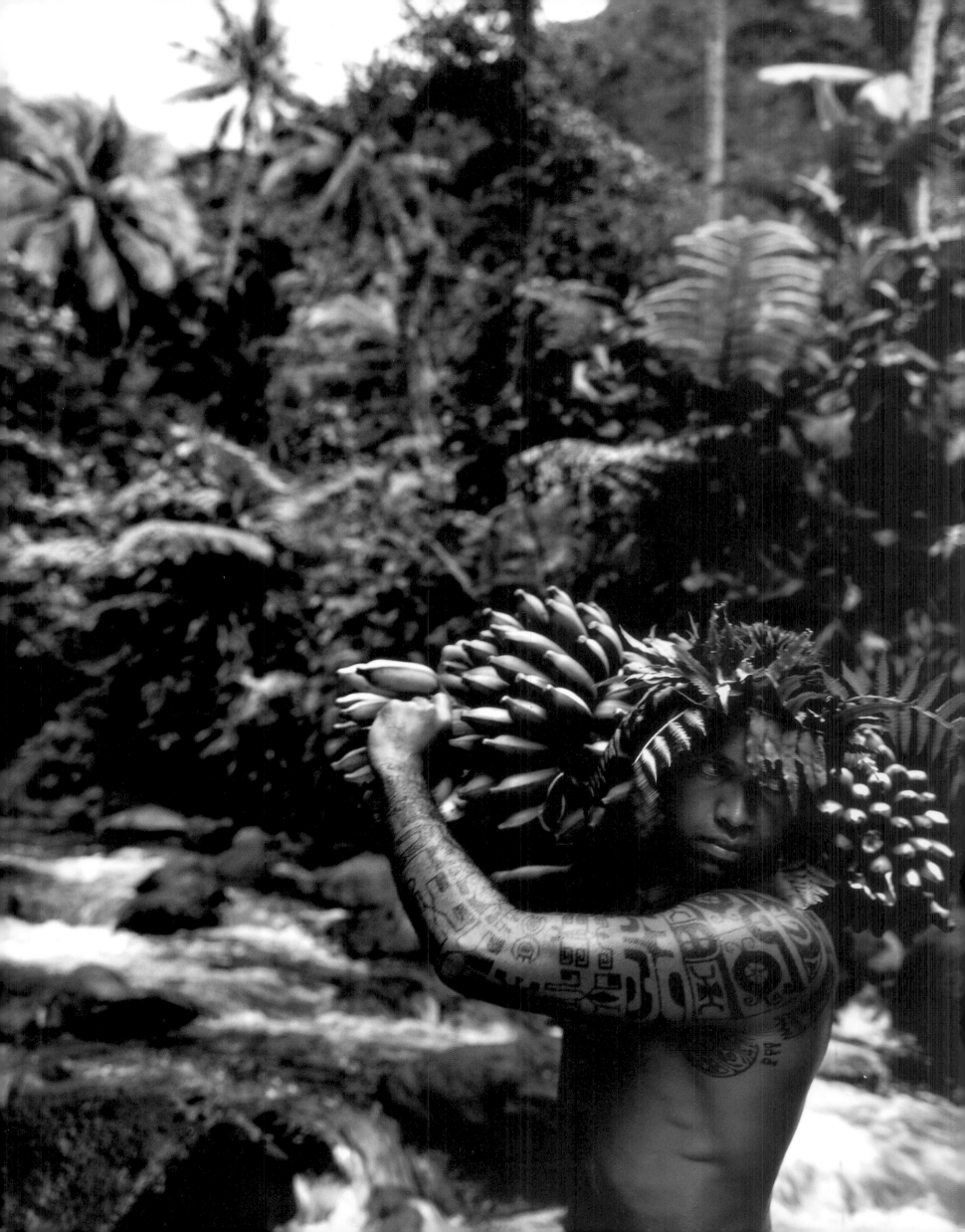

A friend has come to me, of his own accord. His motives are good, of that I am sure. He is… a young man, very unassuming and very good looking. My painted images and wooden carvings intrigue him, and my answers to his questions inform him. Every day he comes to watch me painting or sculpting.

In the evening, while I rested from my day's work, we talked; he asked me the questions a young savage asks when he is curious about things European, especially sexual matters, and often his questions embarrassed me.

It happened that I needed a rosewood tree for a sculpture that I was planning; I wanted a big, mature tree. 'You'll have to go up to the mountains,' he said. 'I know a place where there are fine trees. If you like, I'll take you there, we can cut down the tree you like and bring it back together'.

We left early in the morning. The Indian paths in Tahiti are quite difficult for a European. Between two mountains too steep to climb – two walls of basalt – a narrow crevice had formed in which the water wended its way through the boulders that it detached when in spate; it set them down a little further along its course, taking them up again after a while, and finally pushing and rolling them down to the sea.

On either side of the stream and its frequent waterfalls were traces of a path among the dense mass of trees:

83

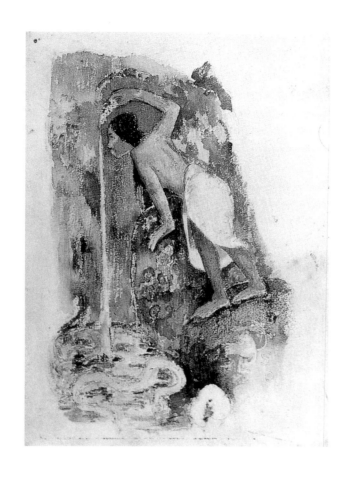

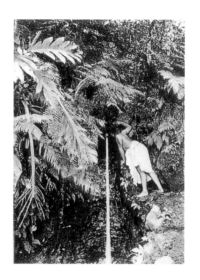

breadfruit, ironwood, pandanus, bouraos, coconut palms, giant ferns, a wilderness of plants which grew ever wilder and more impenetrable as we climbed towards the centre of the Island. Both naked, loin-cloth at the waist and axe in hand, we crossed and re-crossed the stream to follow the traces of path which my companion seemed to detect rather by smell than by sight, since the grass and leaves and flowers took up all the space, in splendid disorder. The silence was complete;

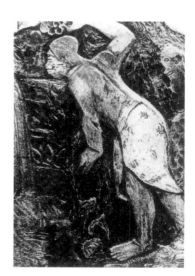

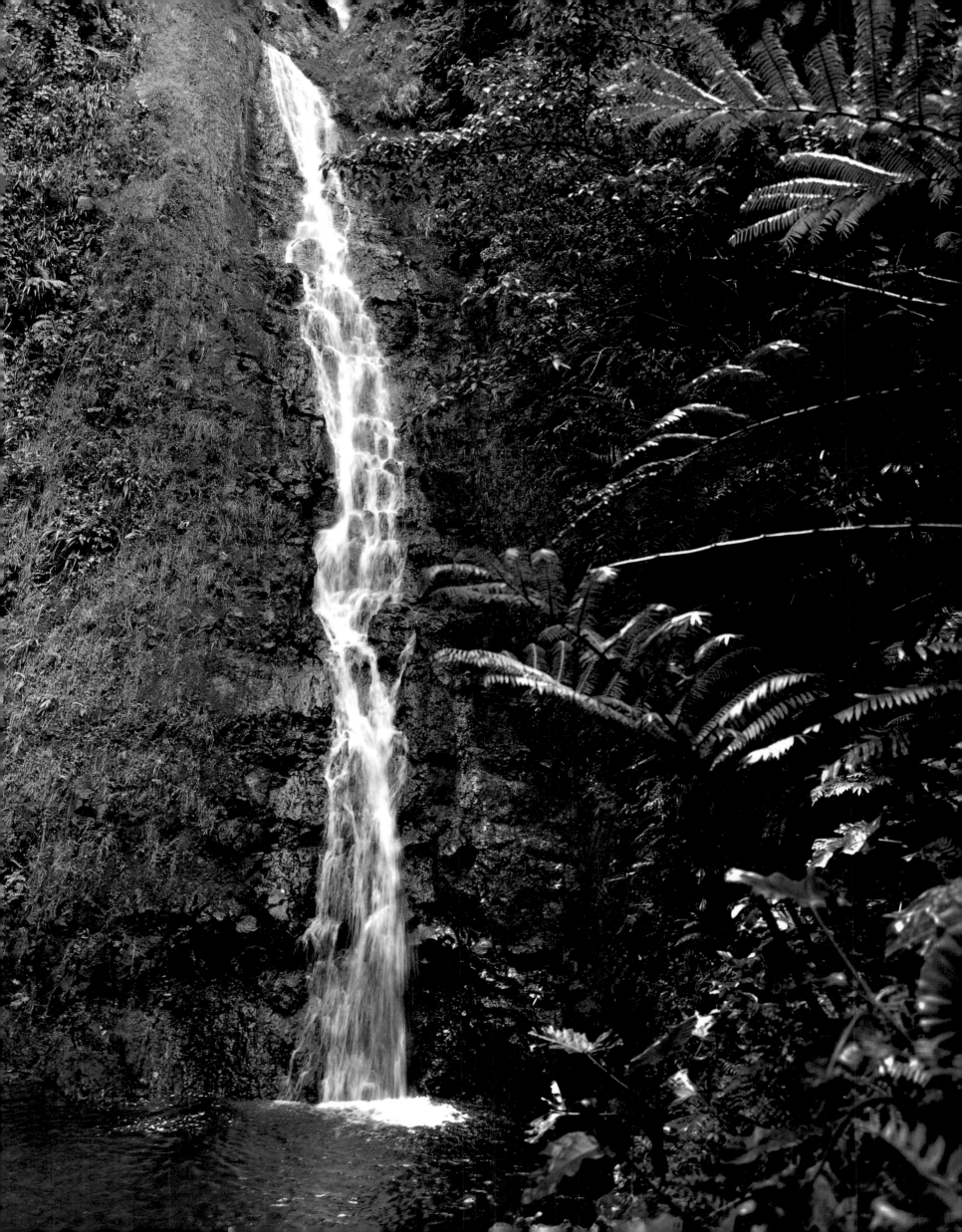

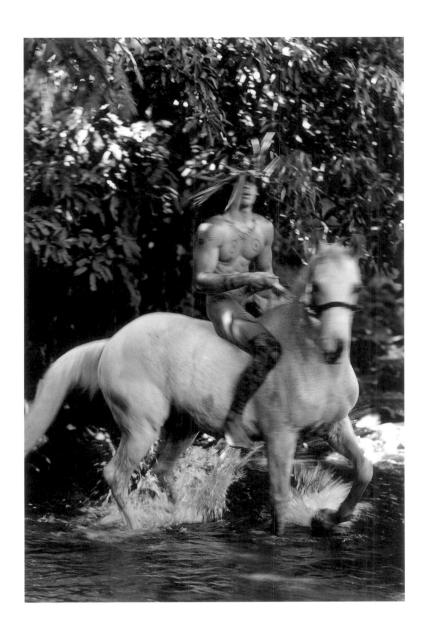
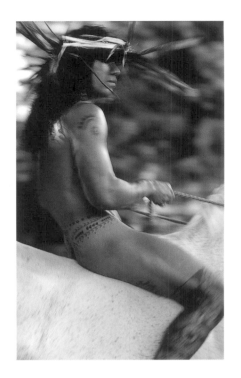
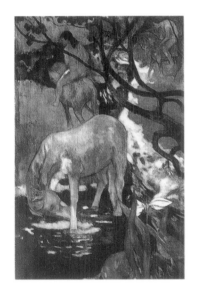

there was only the plaintive sound of the water among the rocks, a monotonous sound that accompanied the silence.

There were just the two of us: he, a very young man, and myself almost an old man, soul despoiled of so many illusions, body wearied by constant effort and the fatal heritage of the past – the vices of a society grown morally and physically ill. He walked in front, his gracious, androgynous form moving with animal suppleness, and I felt as if the breath in his body incarnated the splendour of the plant life that surrounded us. And from that splendour, into him and through him, there spread a

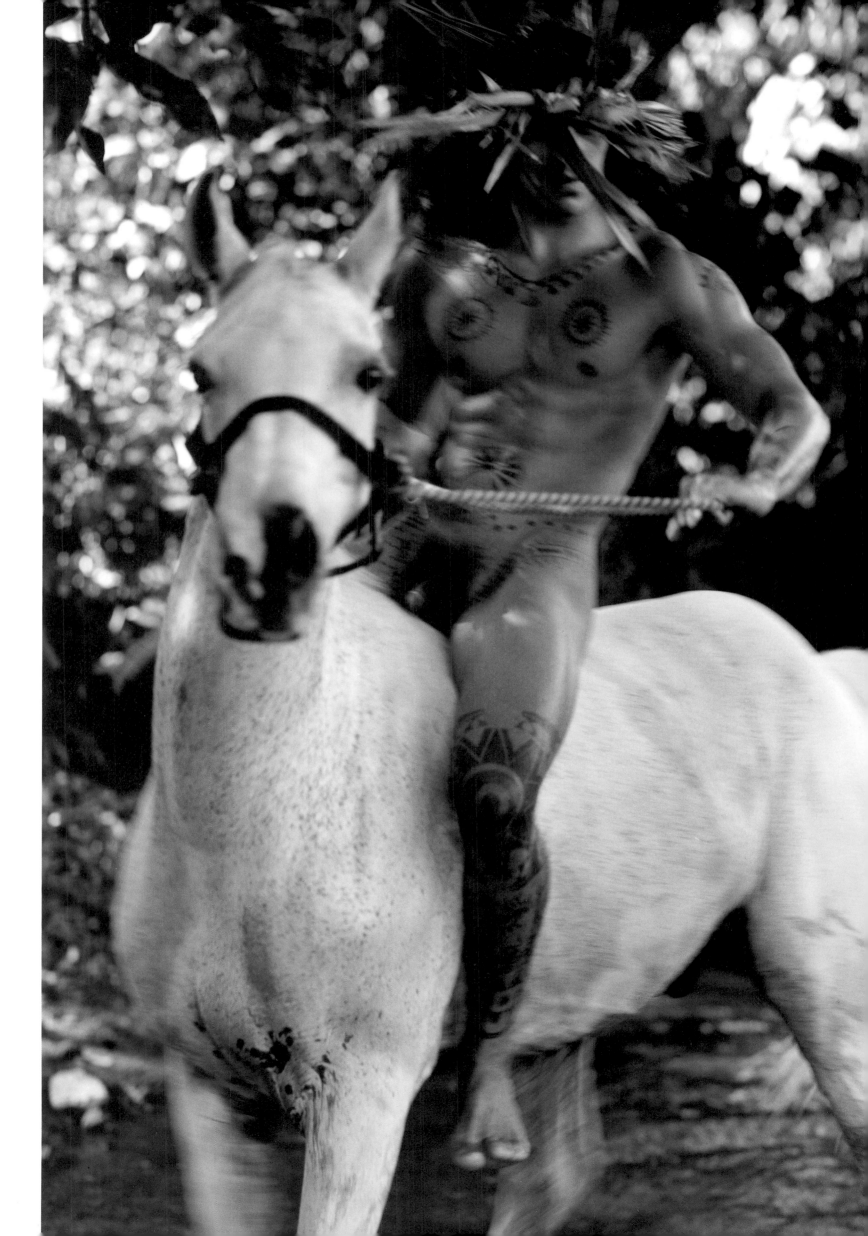

scent of beauty which intoxicated my very soul, mingled, like a powerful essence, with my sense of our friendship, the mutual attraction of simple and composite.

And there were just the two of us.

I felt a presentiment of crime, a desire for the unknown, an awakening of evil.

And a weariness with the role of the male: he who must always be strong, the protector, who carries the burden of heavy shoulders. Just for a moment, to be the weaker being, the one who loves and obeys...

I moved closer, unchecked by laws, my brow throbbing.

But the path had come to an end; as he prepared to cross the stream, my companion turned towards me, presenting his chest.

There was no sign now of his androgyny. He was indeed a young man, and his innocent eyes had the limpid clarity of still waters.

Immediately peace returned to my soul; I felt an infinite pleasure, spiritual no less than physical, as I dived into the cold water of the stream.

'To'eto'e' ('It's cold'), he said.

'No, no,' I answered.

And this exclamation felt like the conclusion of the struggle that I had just fought against the corruption of an entire civilisation; it rang through the echoing mountains. I plunged energetically into the thick undergrowth... My companion, close to me, continued on his way, his eyes as calm as ever. He suspected nothing; I alone bore the burden of my evil thought.

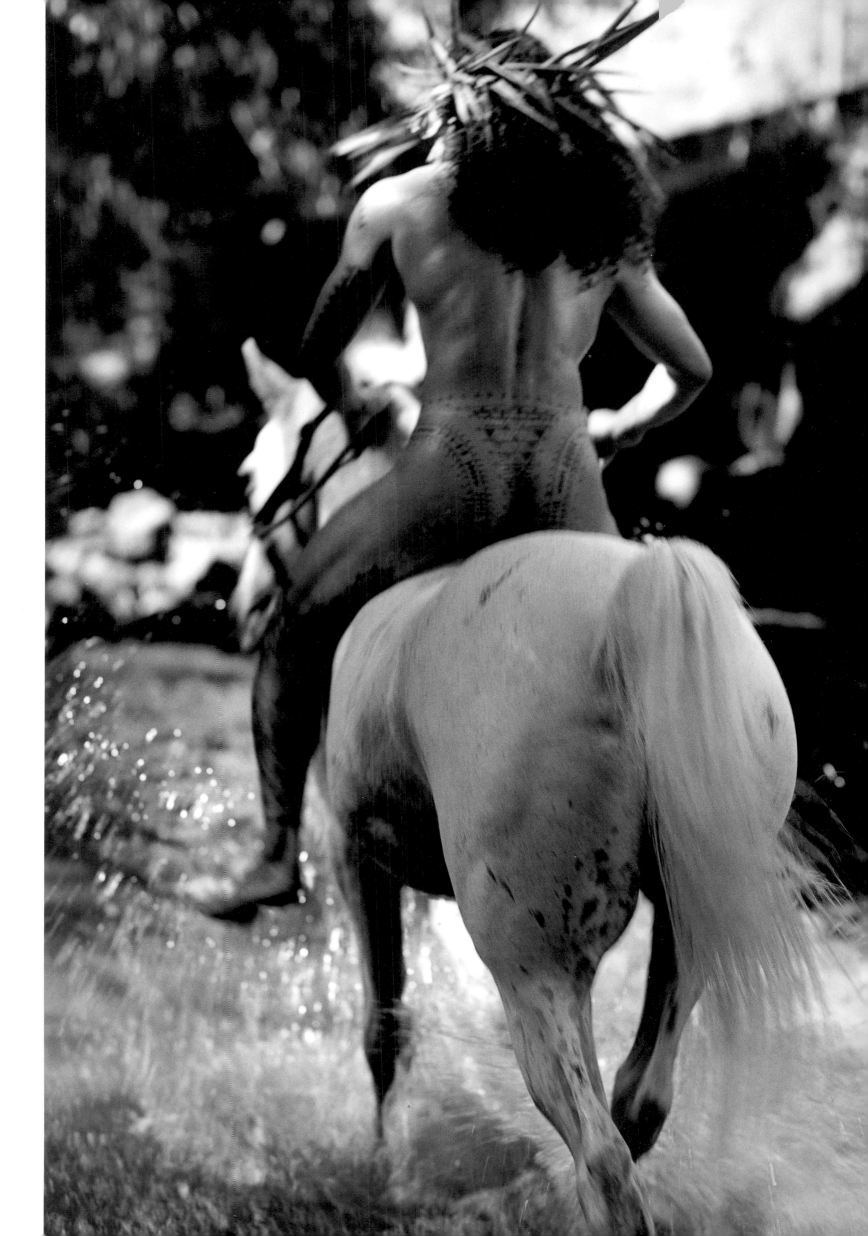

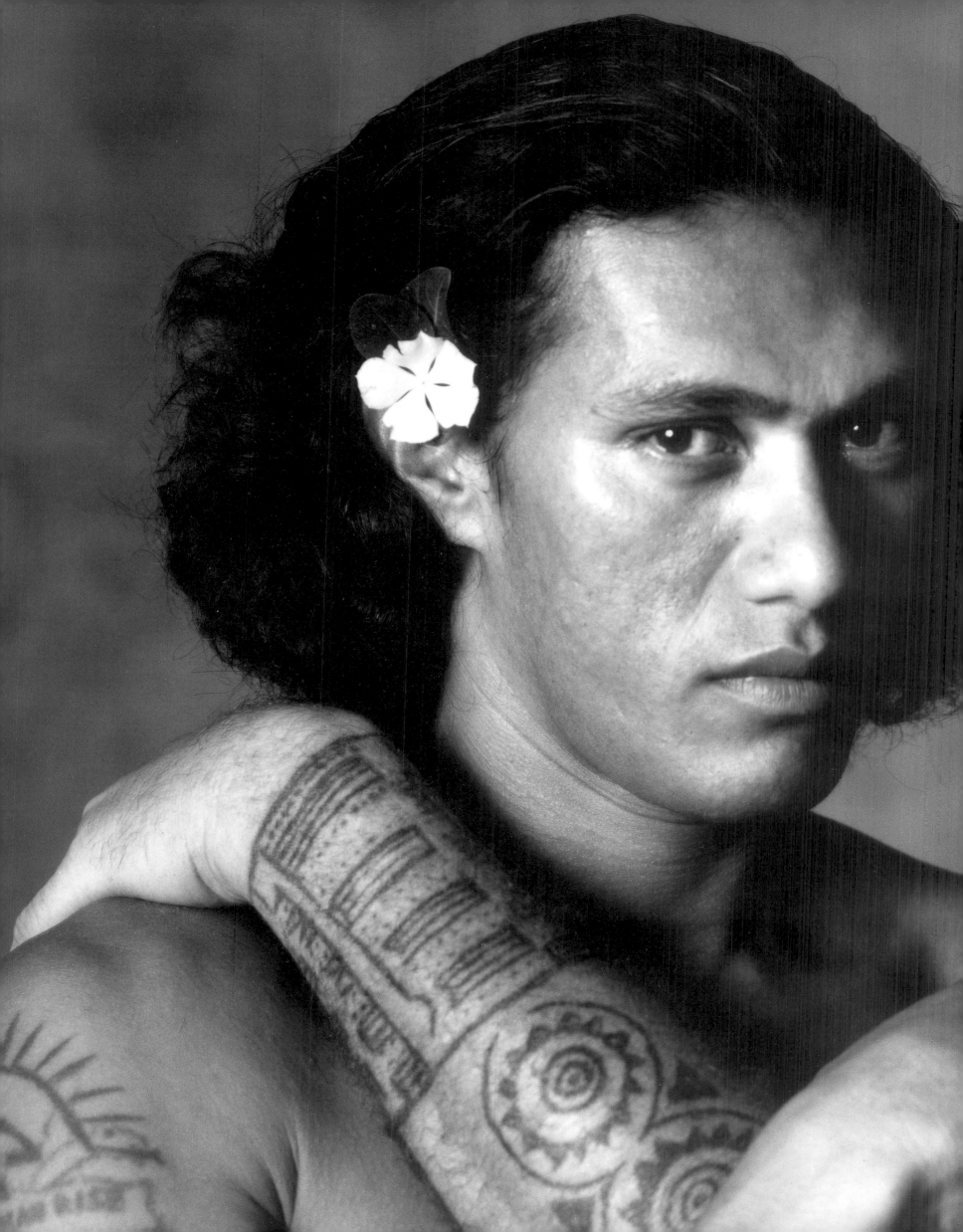

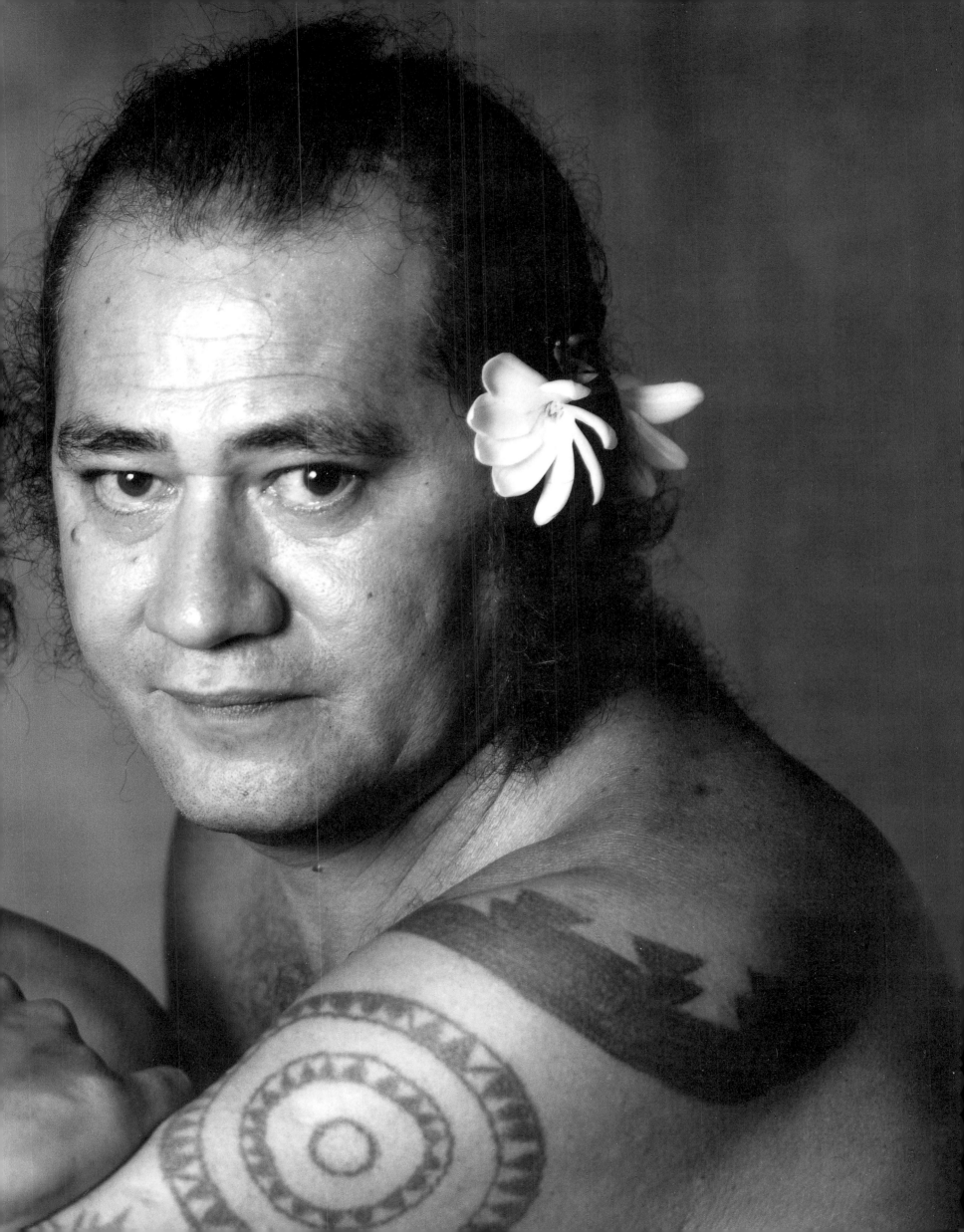

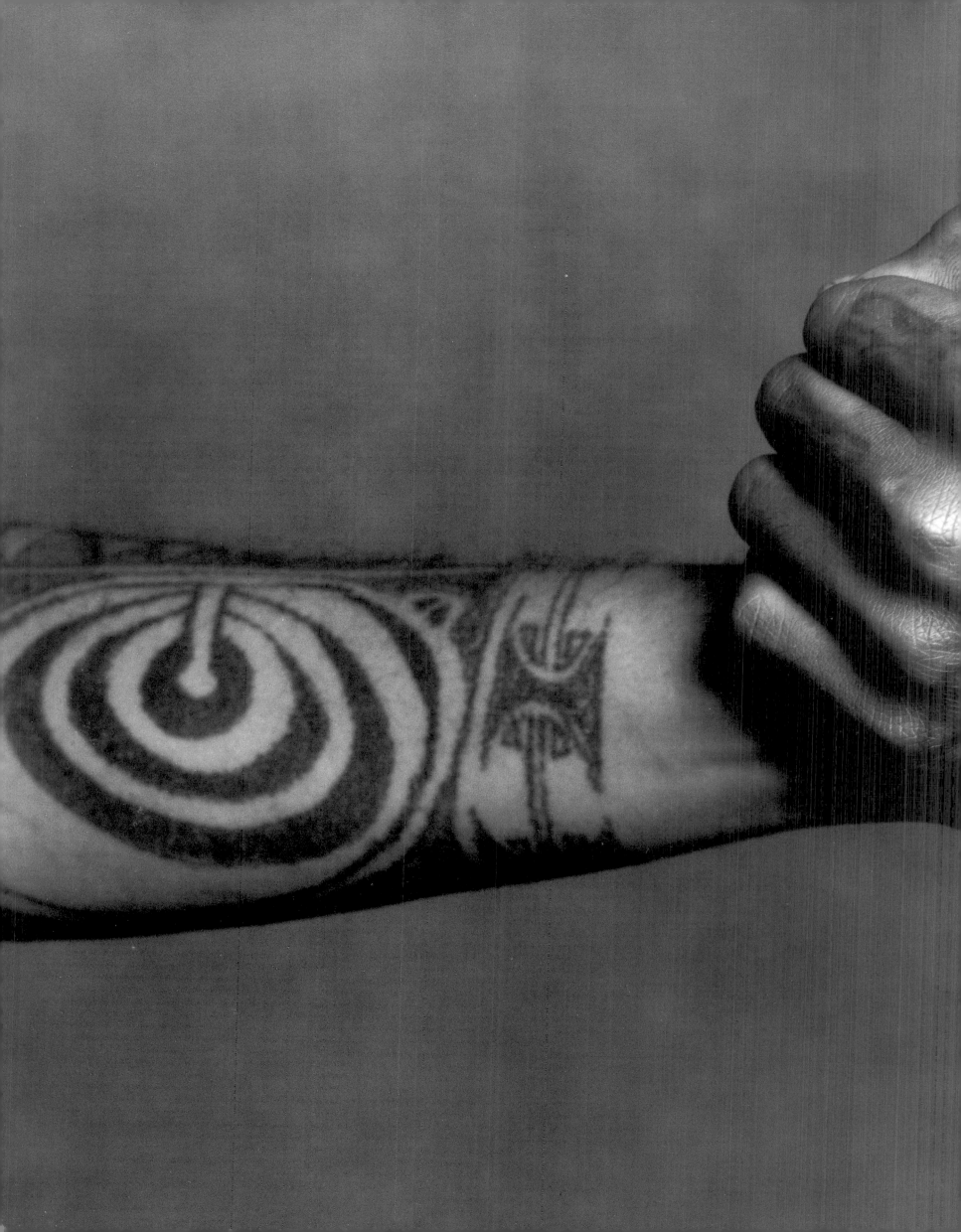

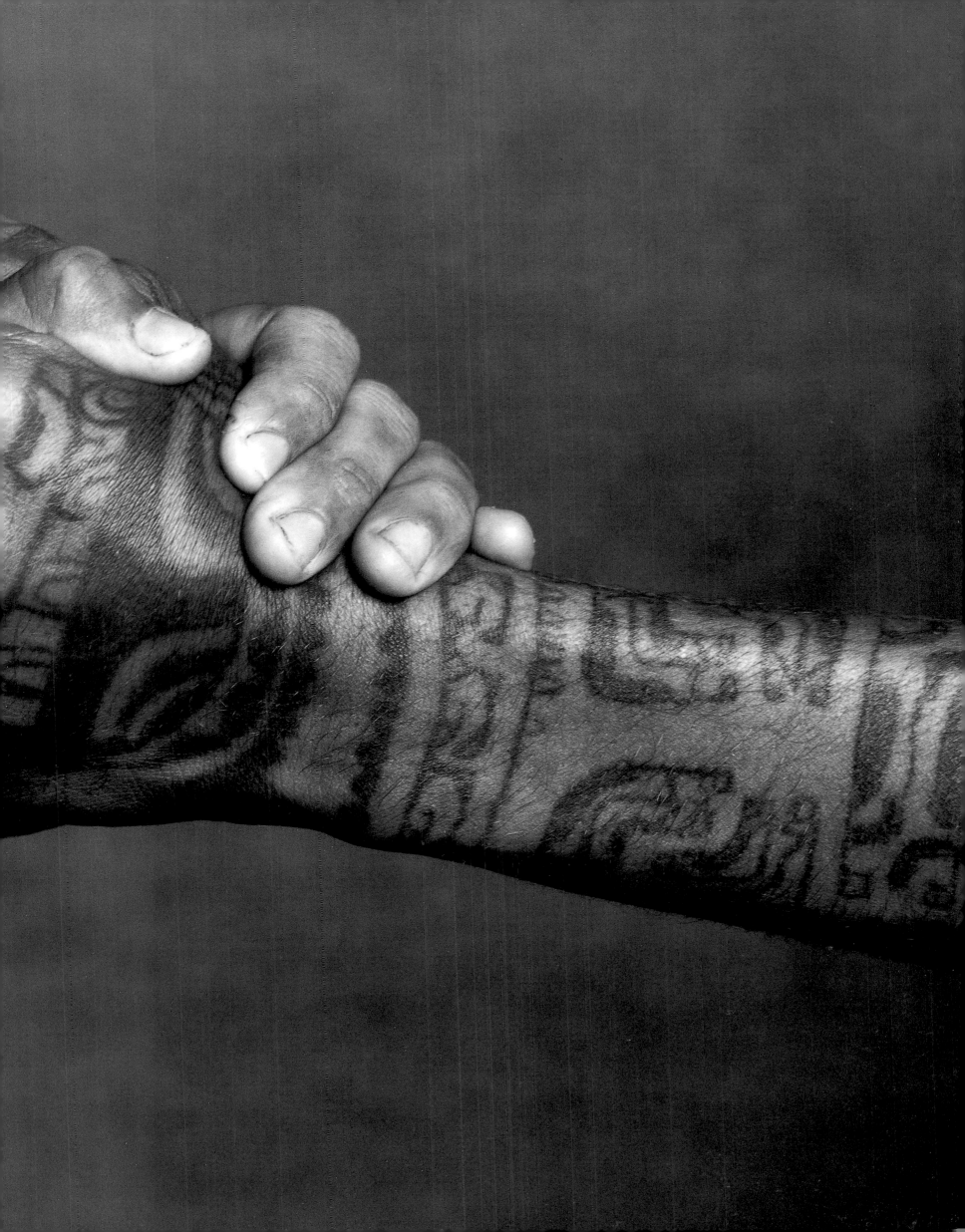

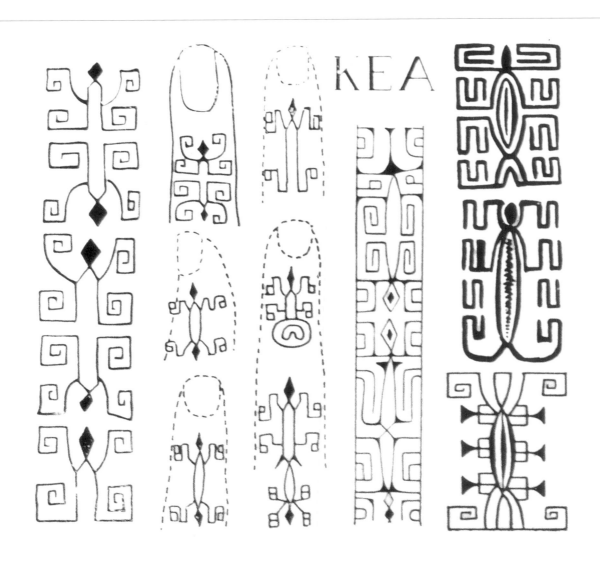

KEA

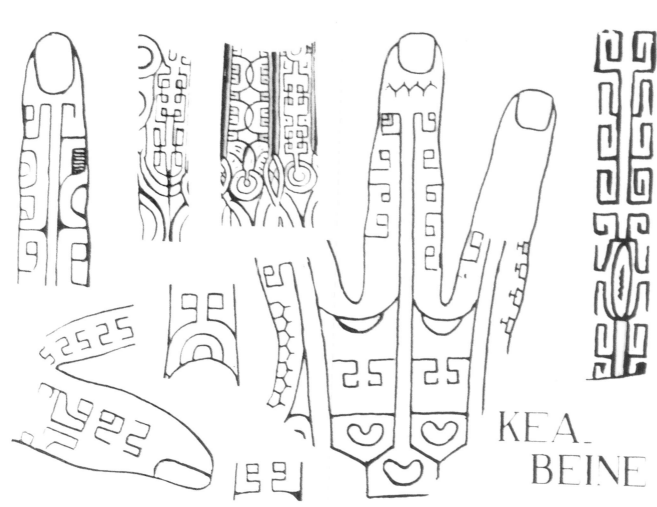

KEA
BEINE

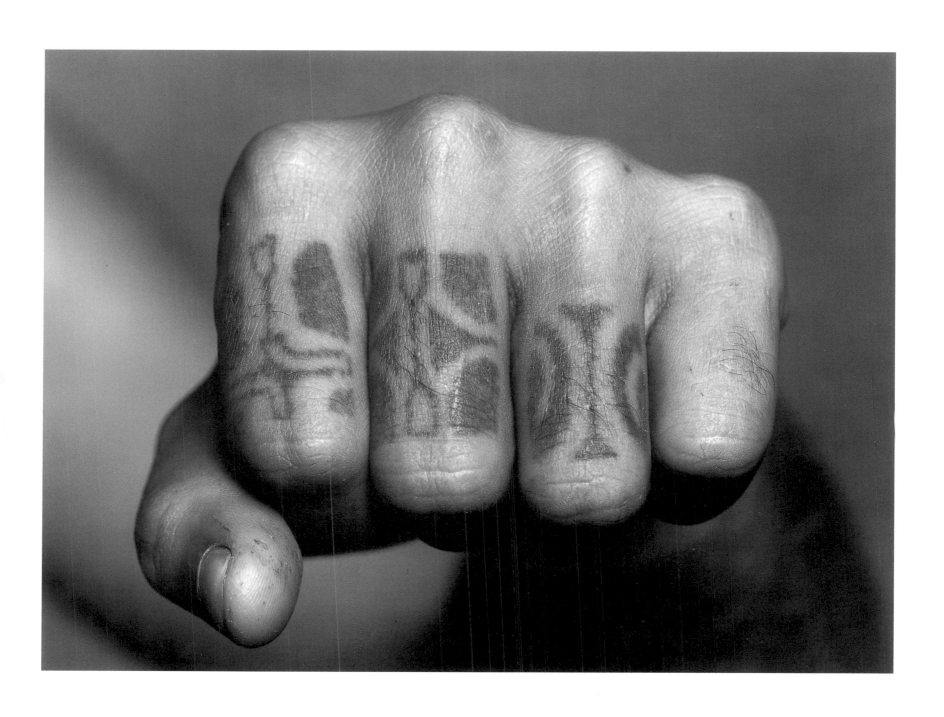

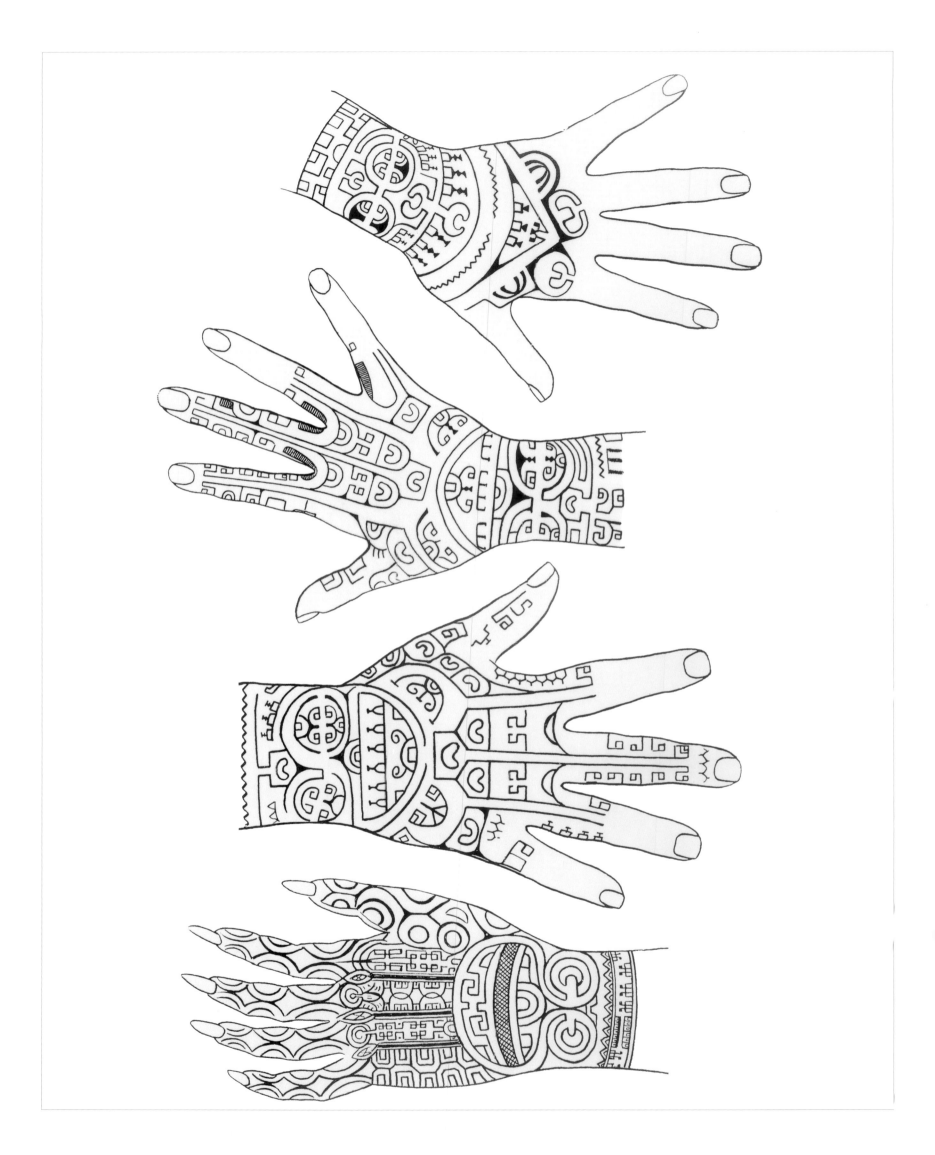

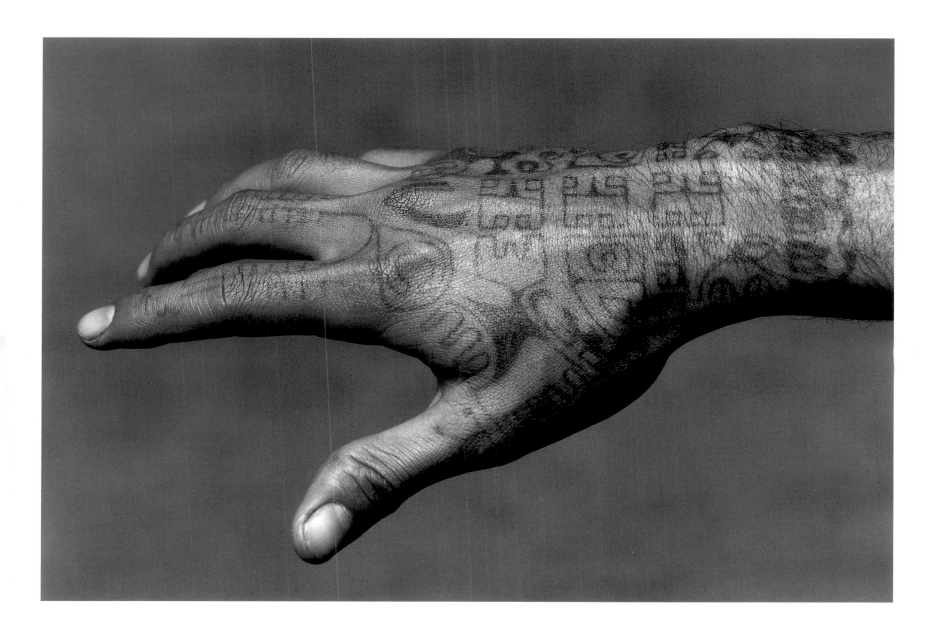

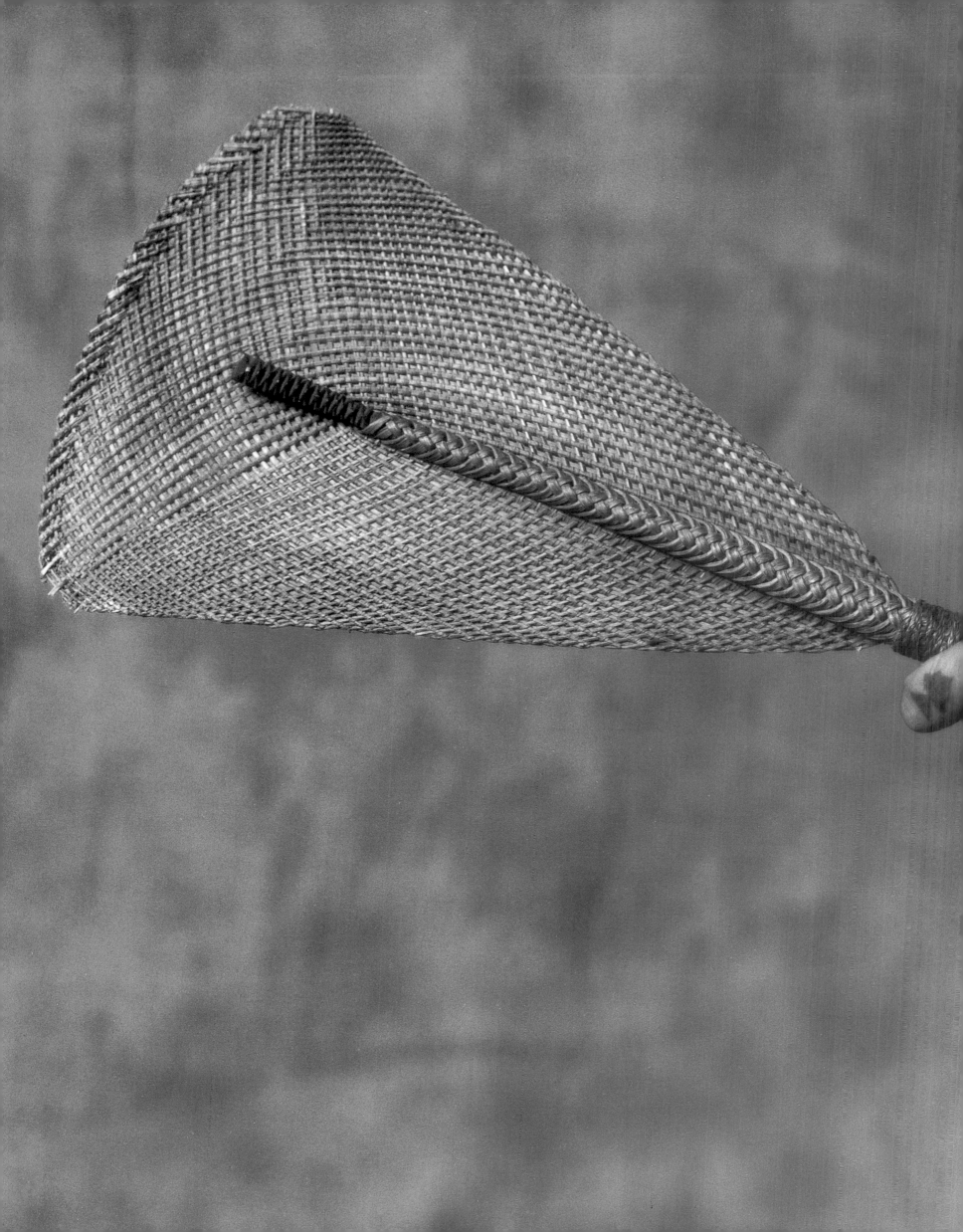

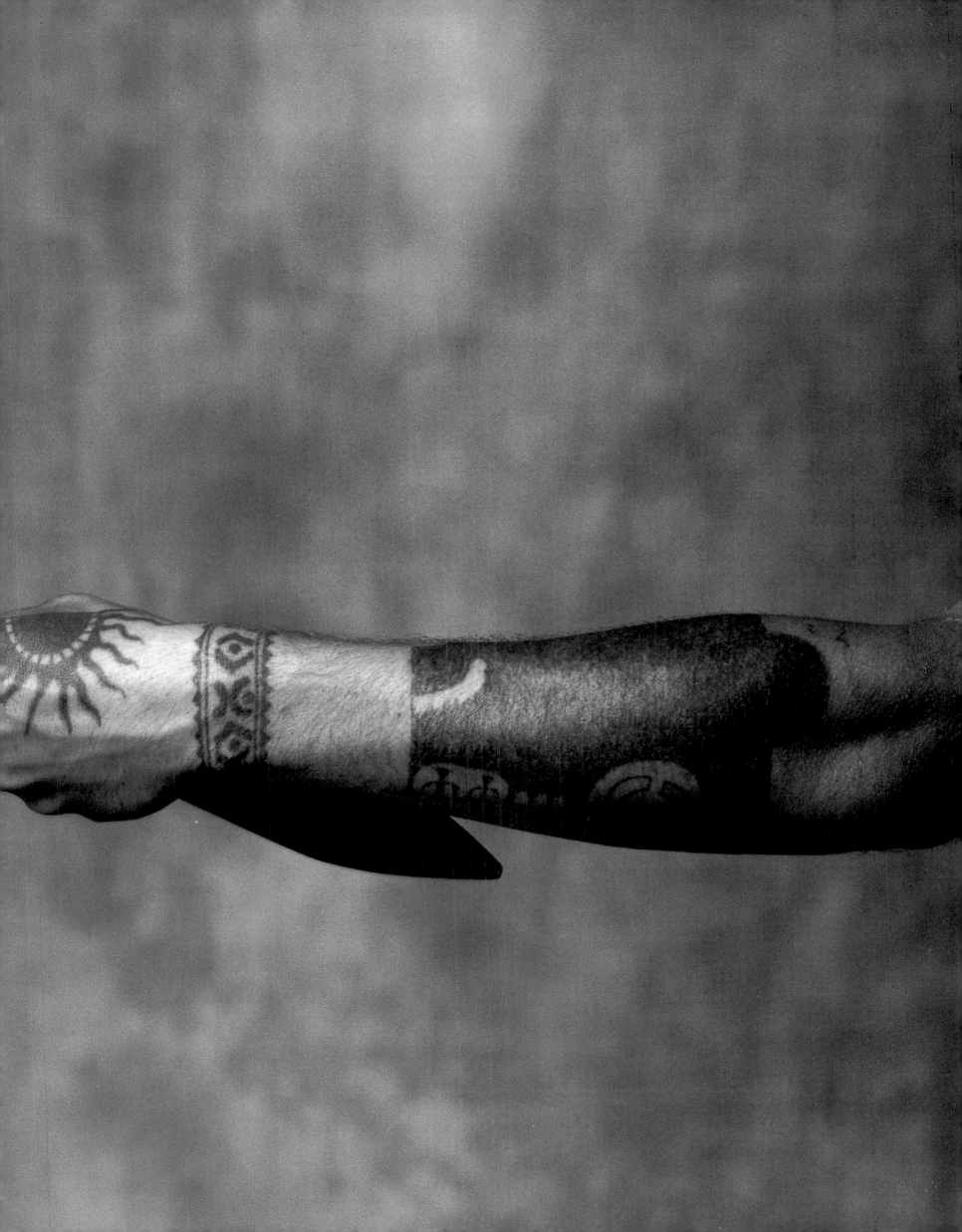

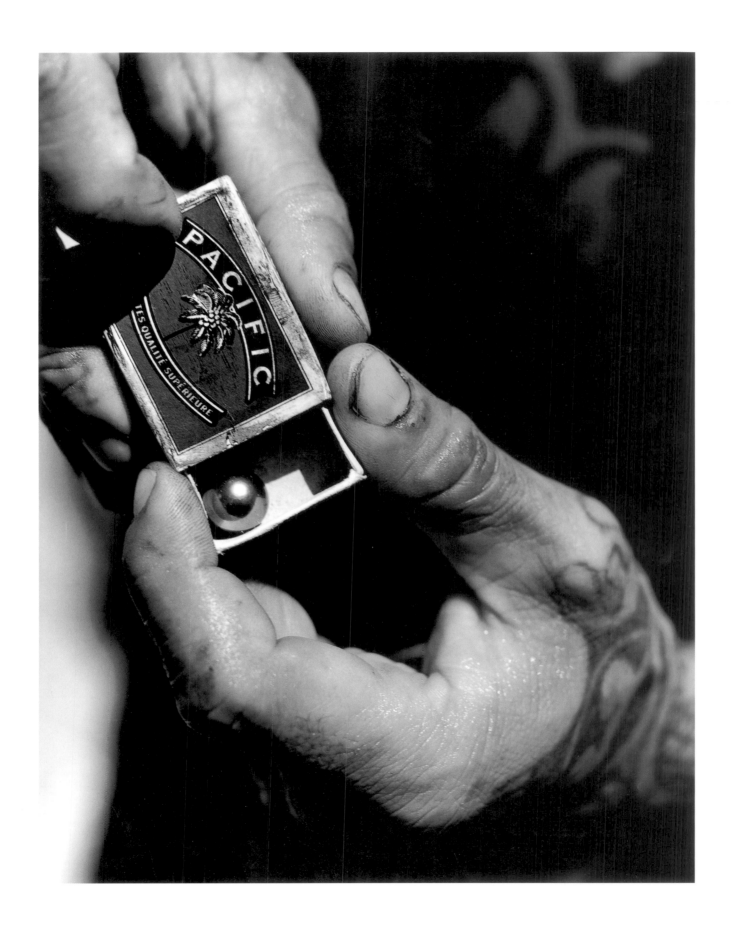

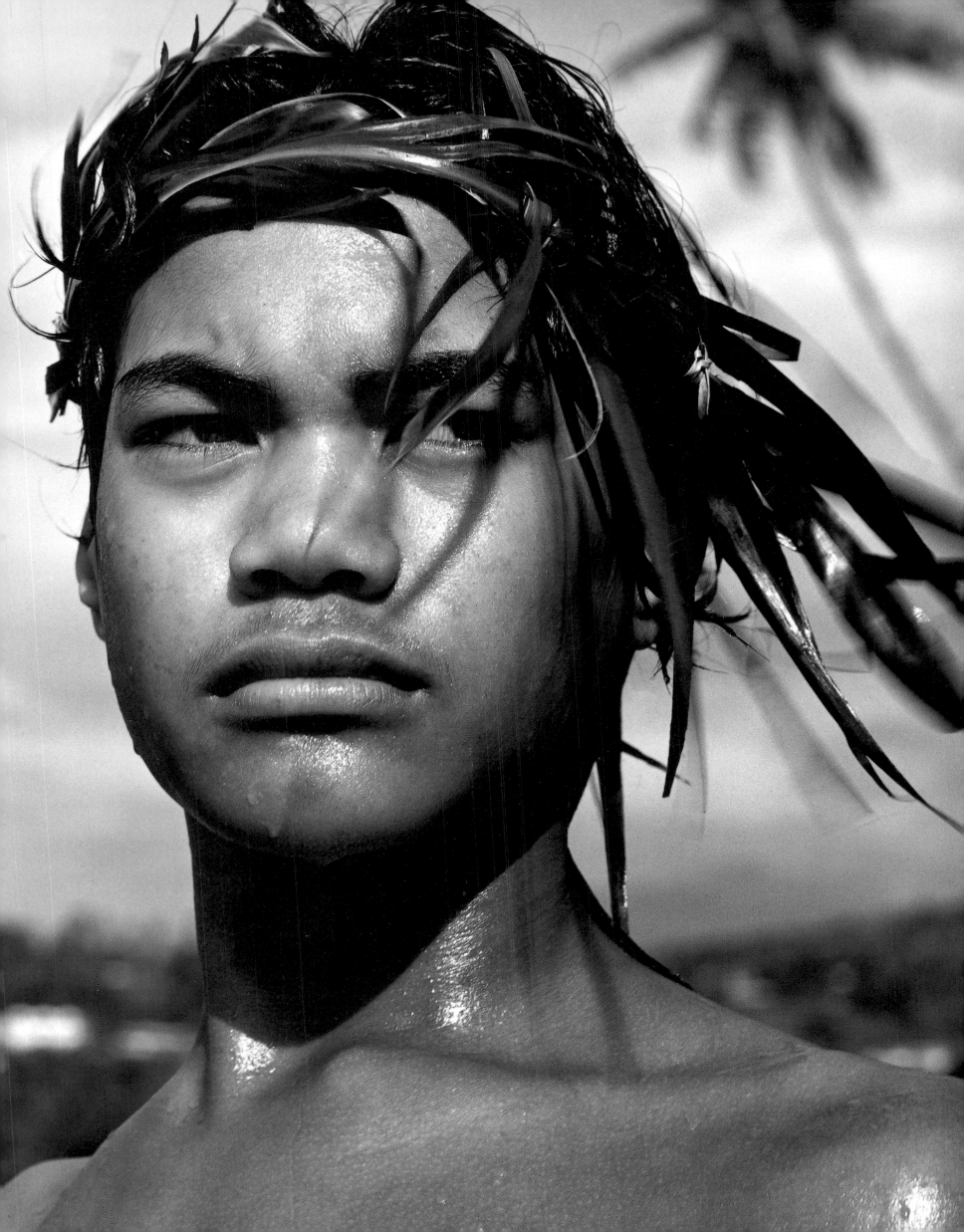

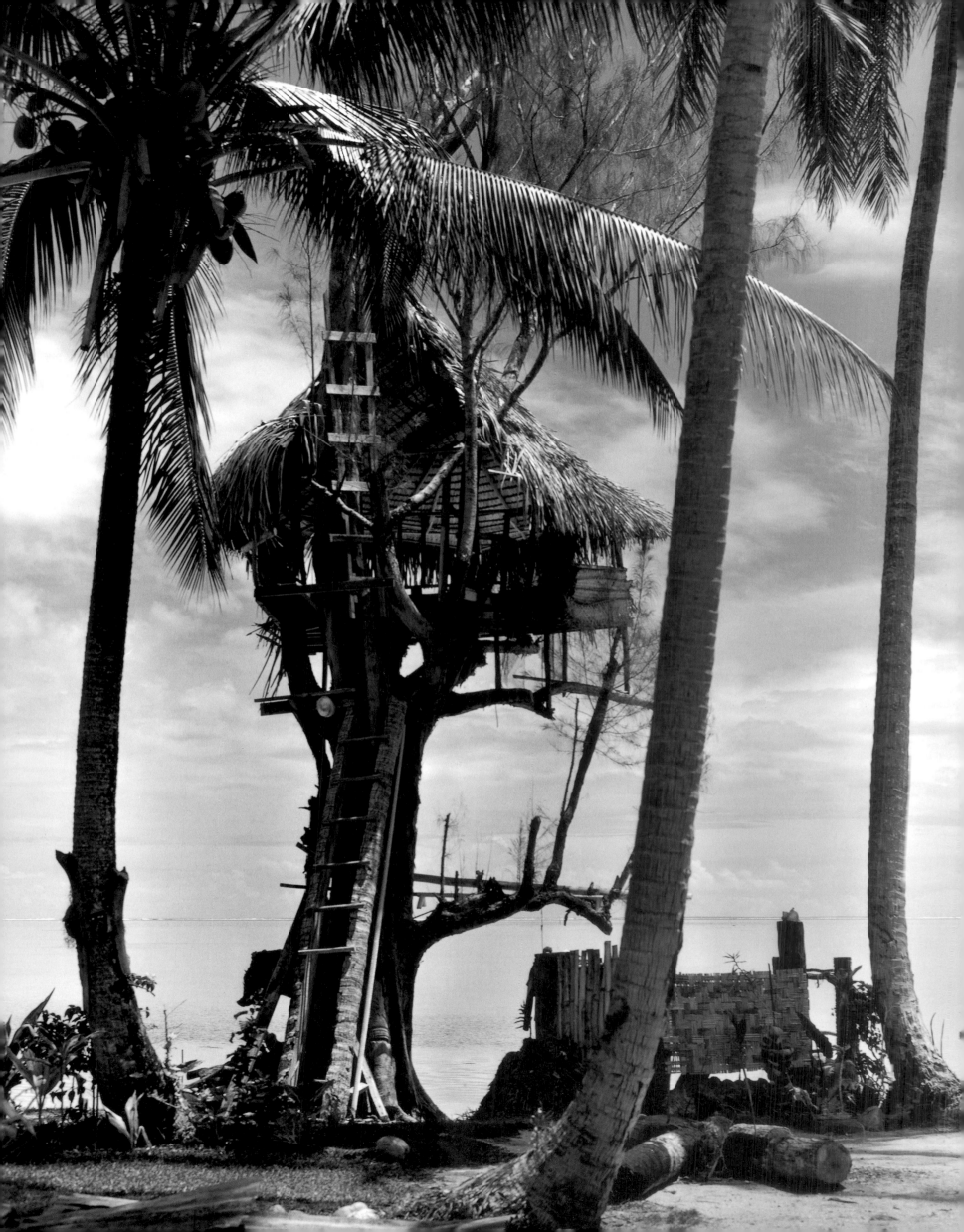

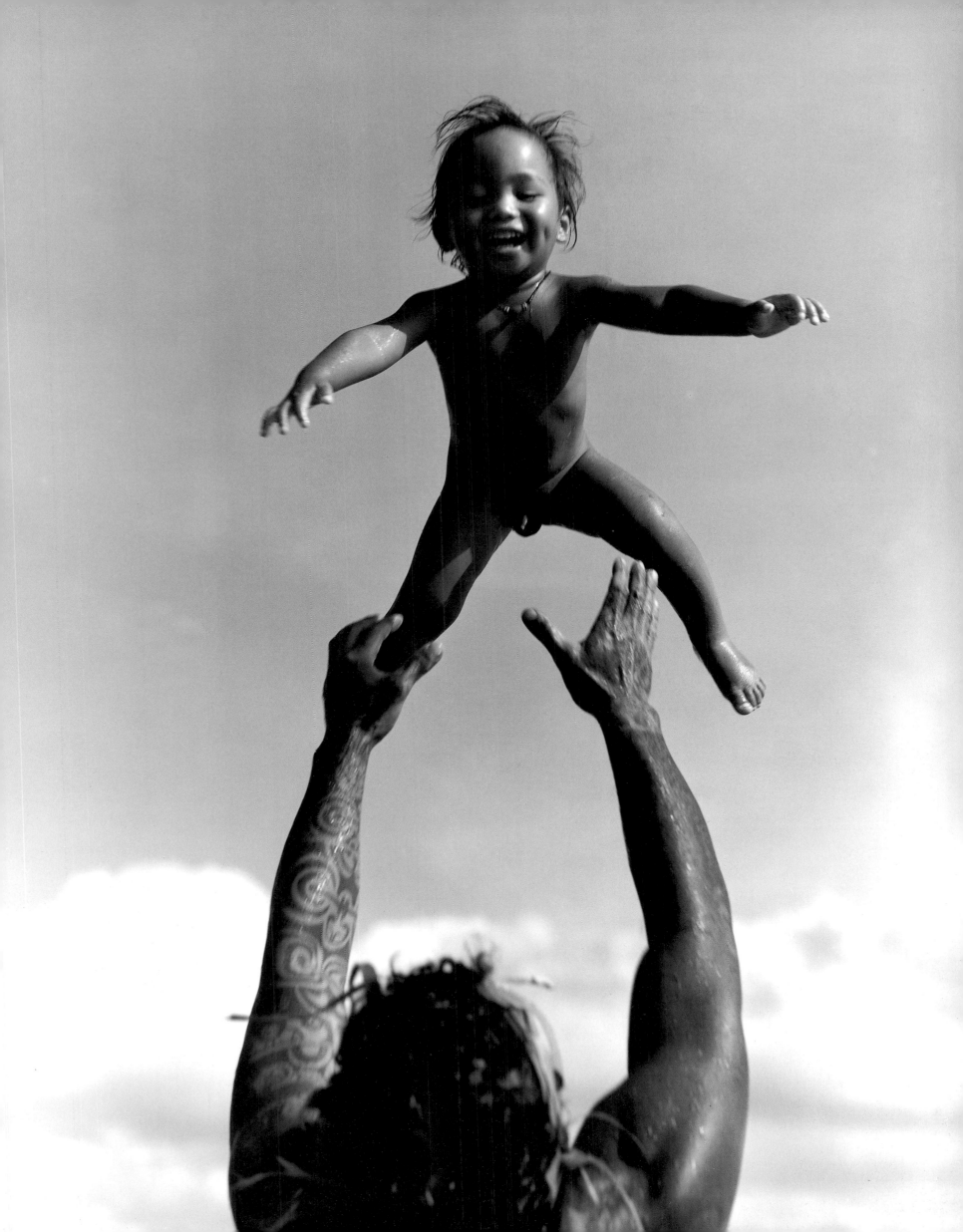

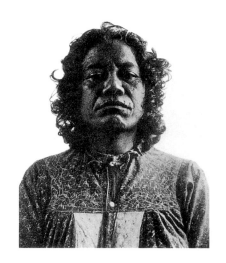

Near her stood a woman a hundred years old, an ancestor of hers. Her ghastly decrepitude was the more terrible for her show of perfect, cannibal teeth… [O]n her cheek [was] a tattoo, a dark mark of uncertain shape, like a letter of the Latin alphabet…

I had already seen many tattoos, but none like this; this one was certainly European. I was told that the missionaries, in their campaign against lubricity, had imprinted certain women with a sign of infamy, an admonition of hell. This filled them with shame – not because of the sin they had committed, but because of the ridicule and opprobrium attracted by that sign of destruction.

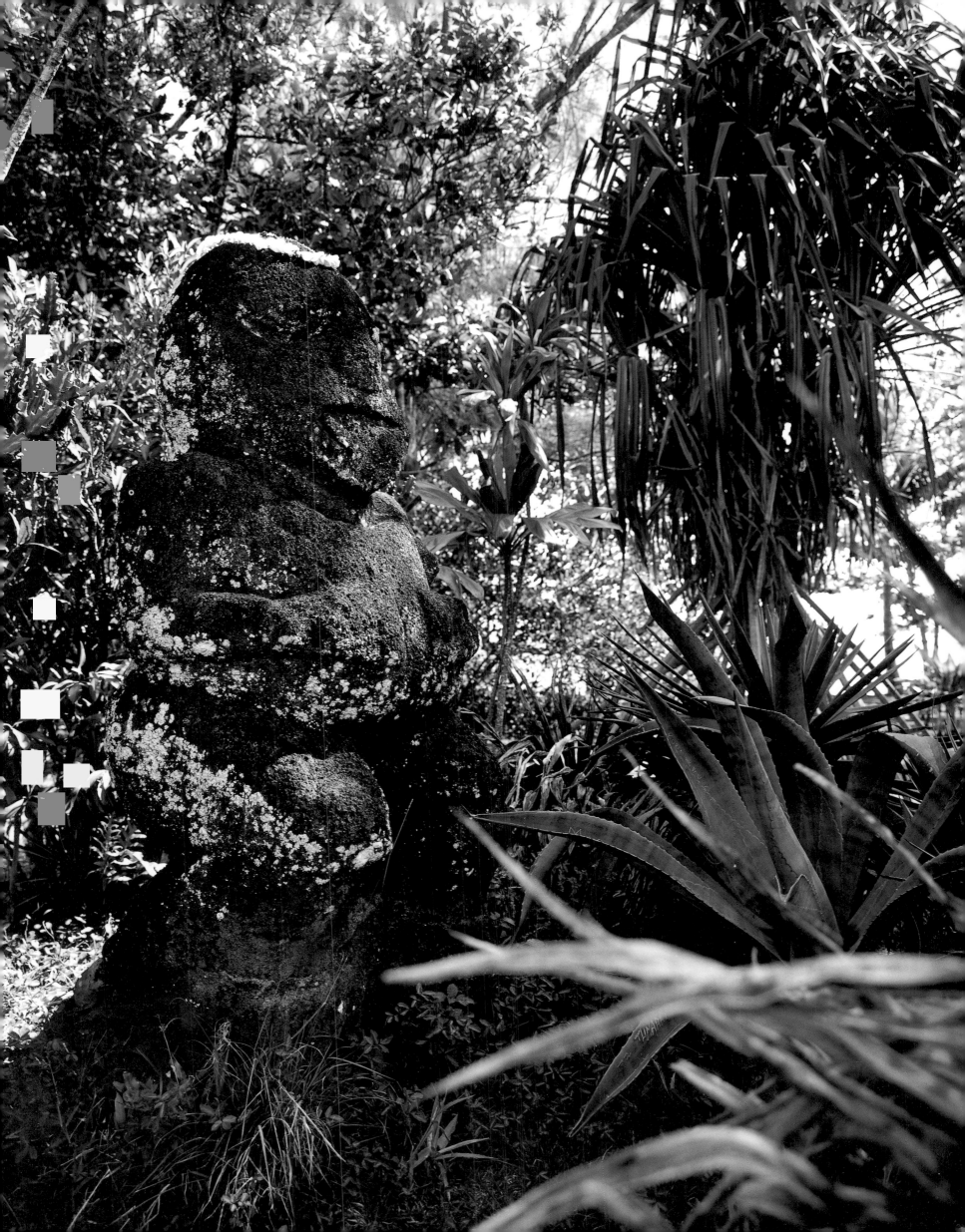

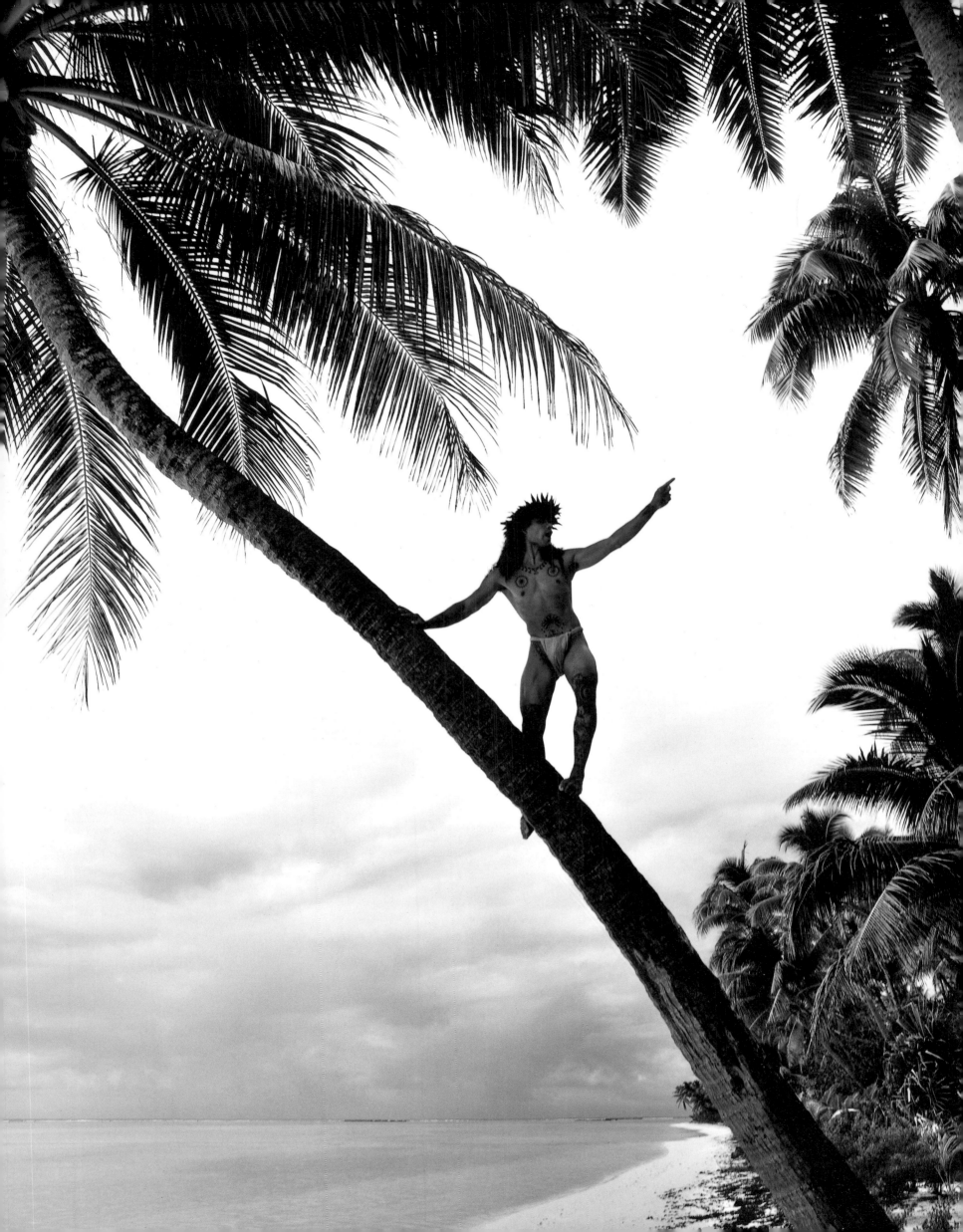

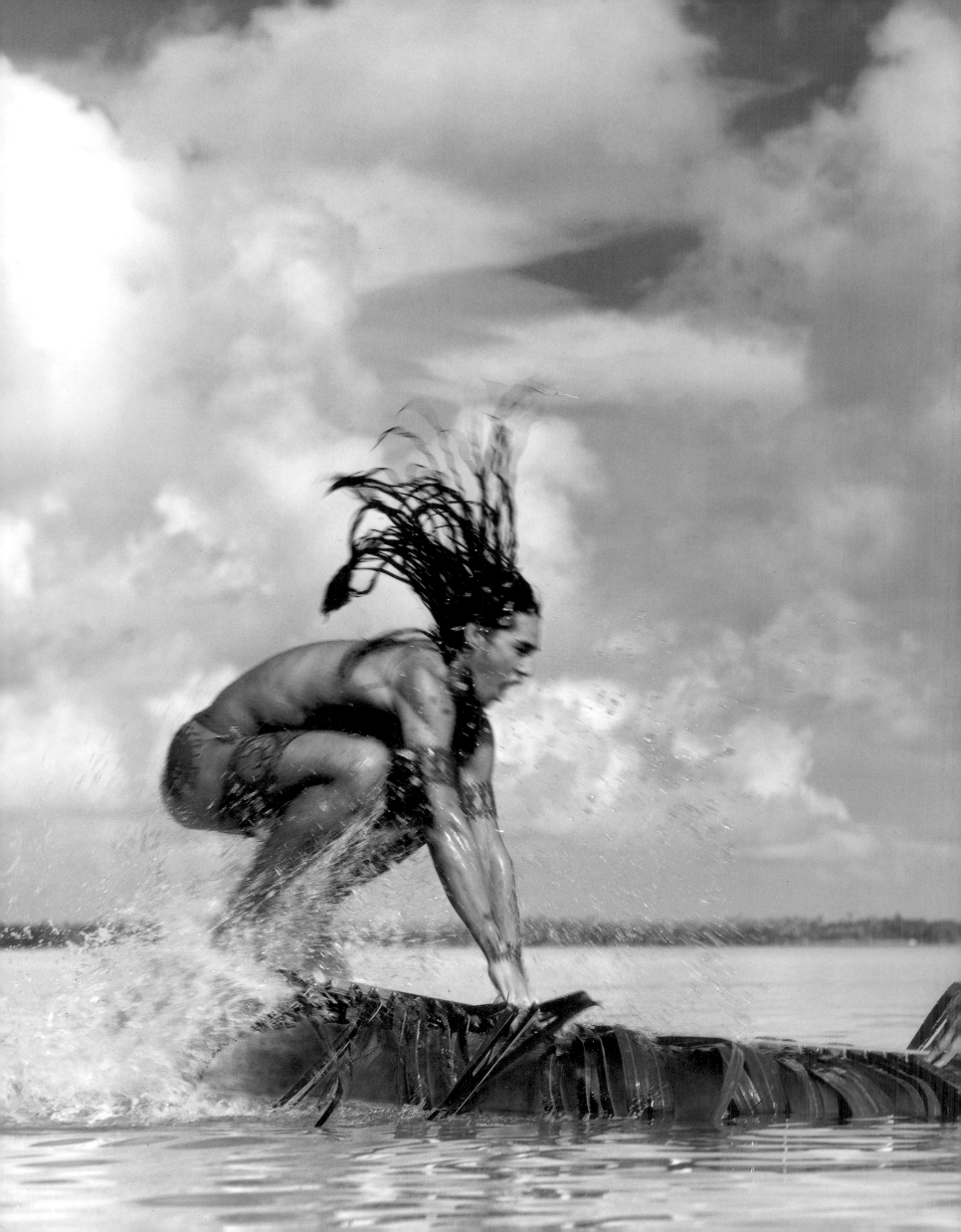

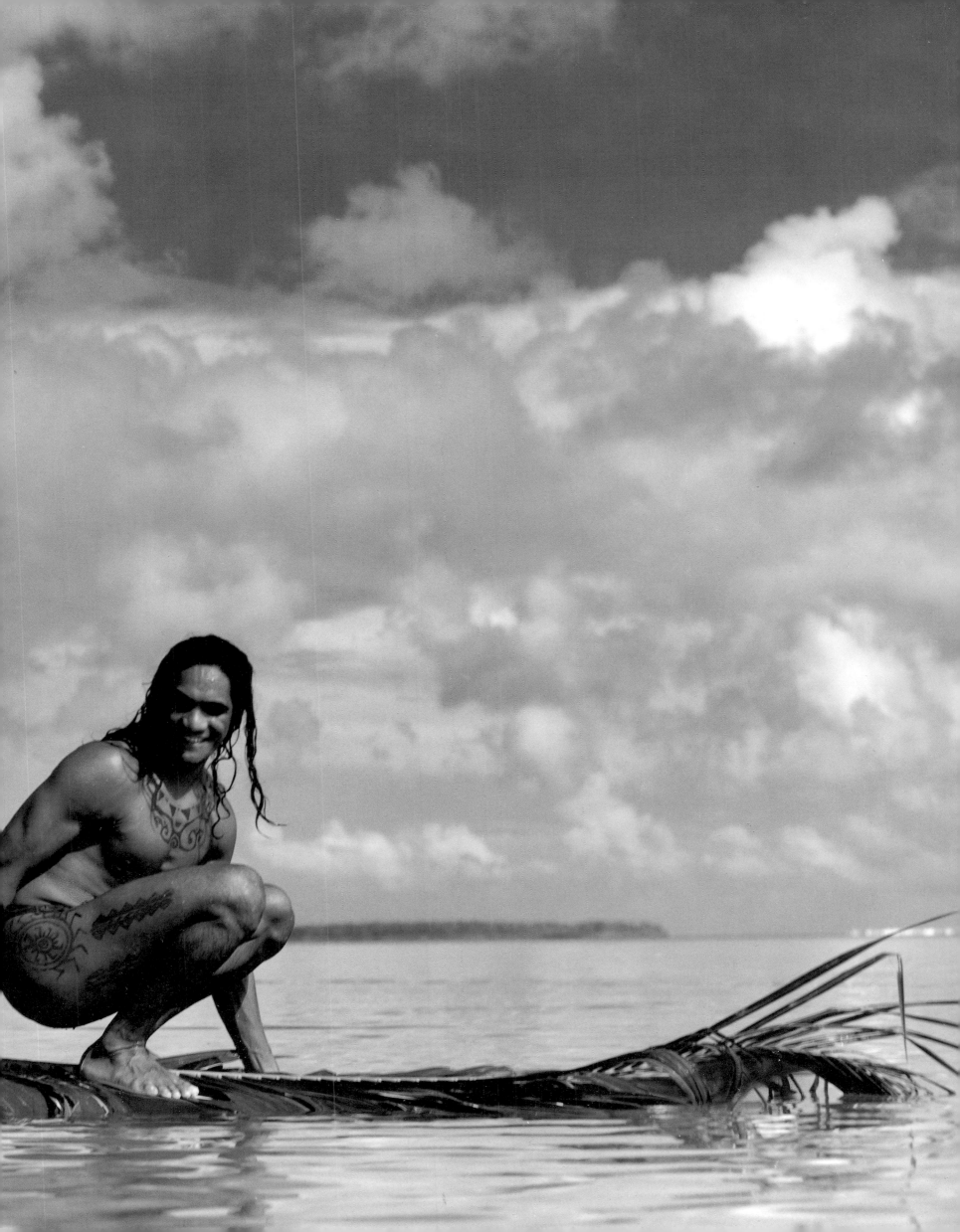

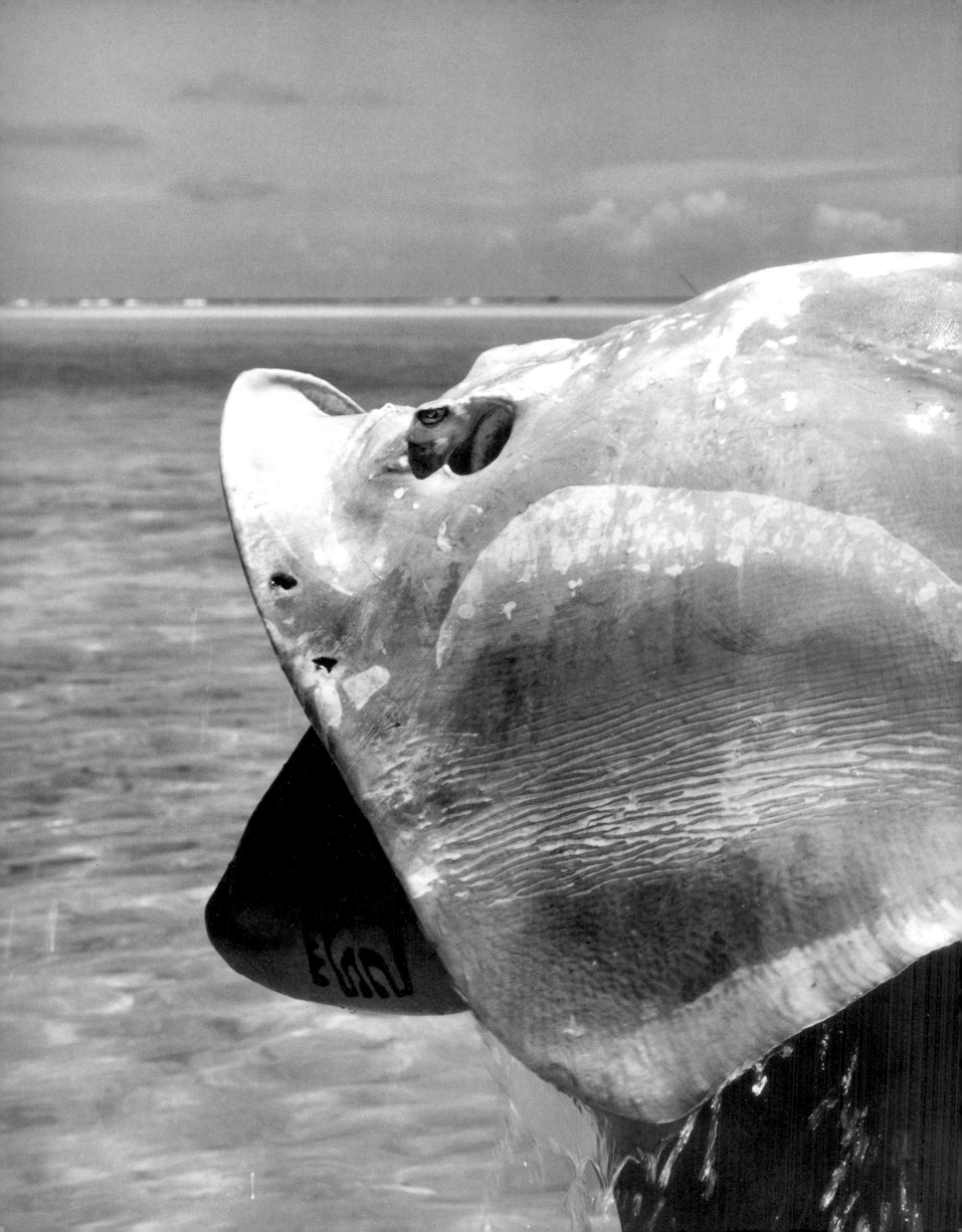

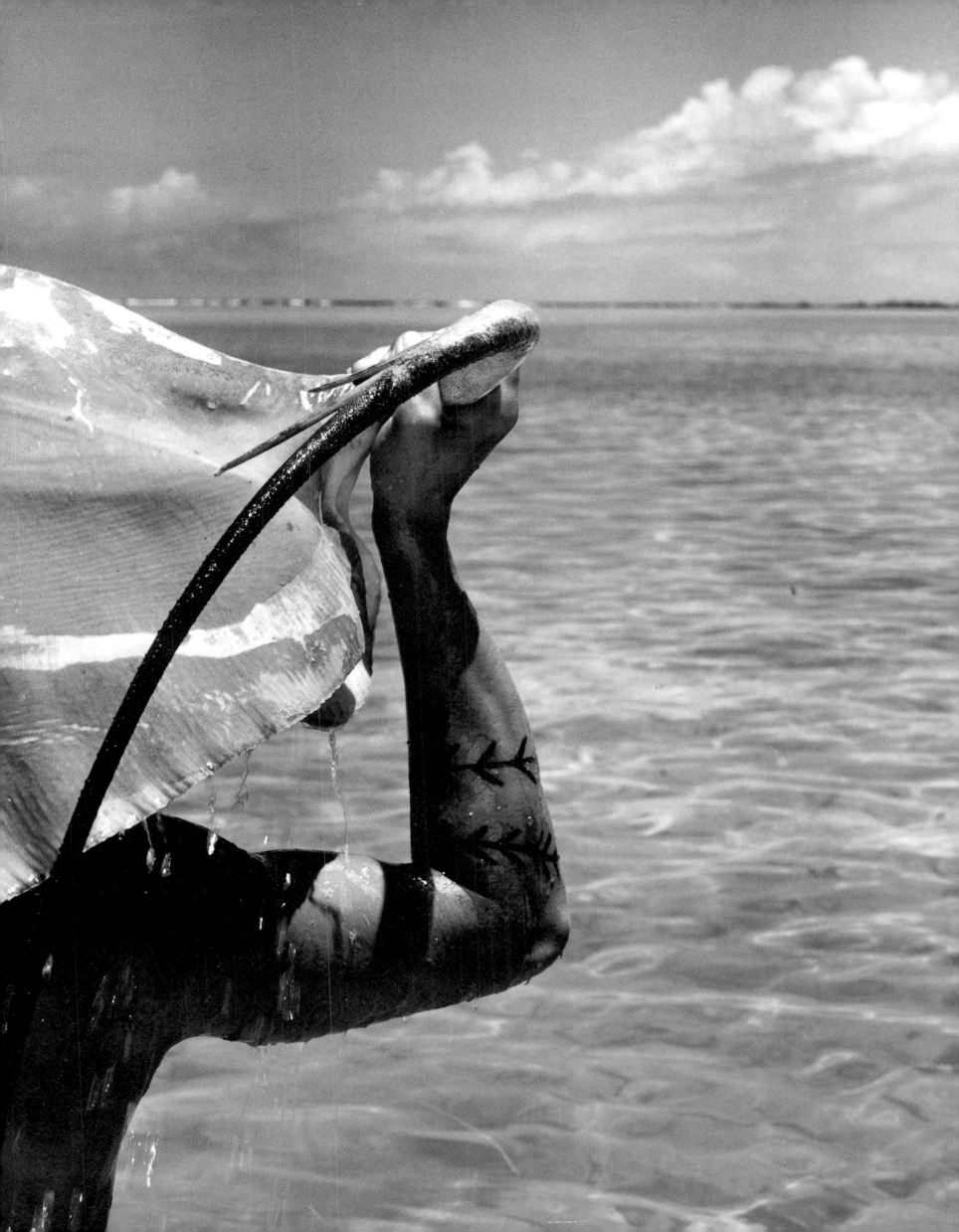

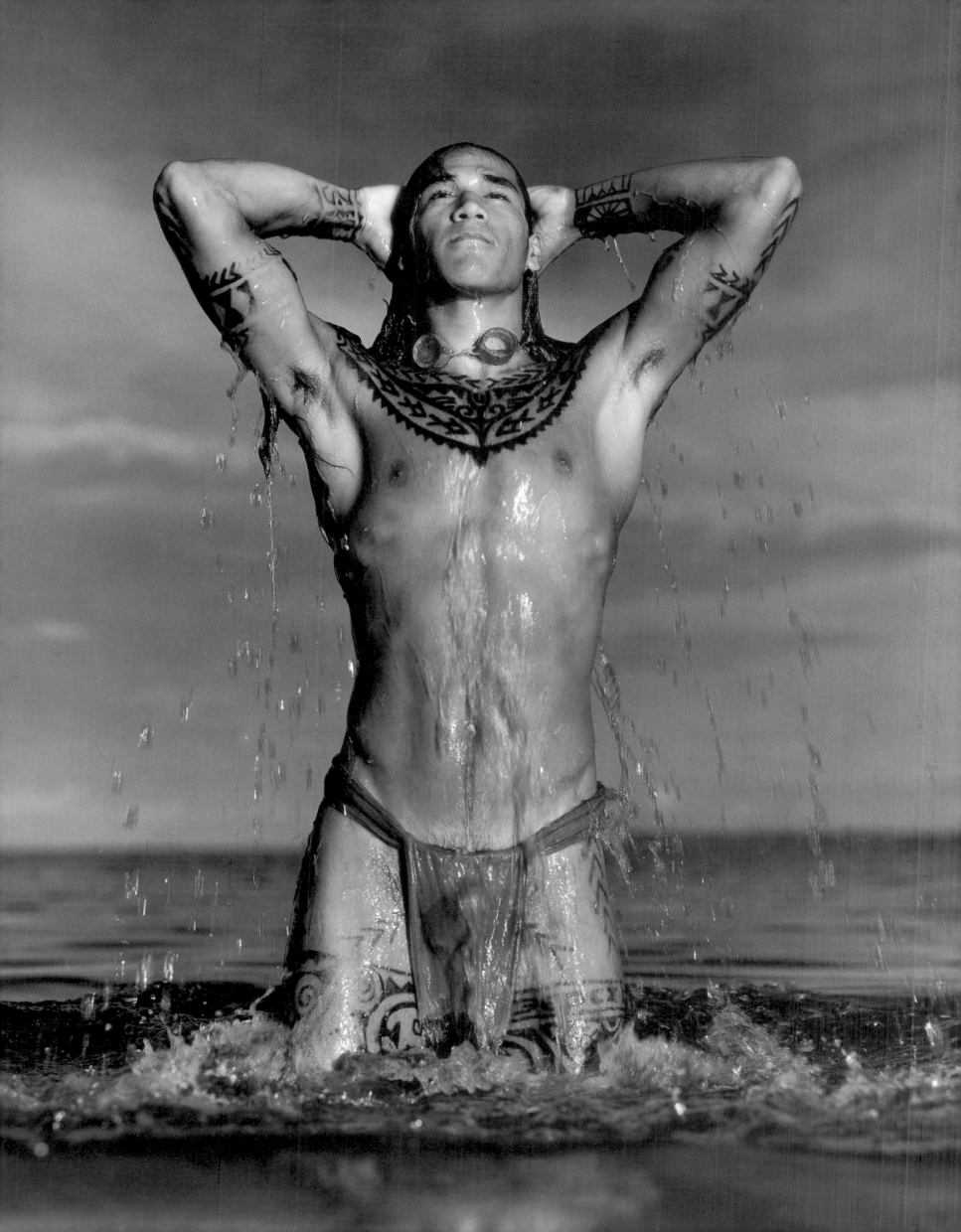

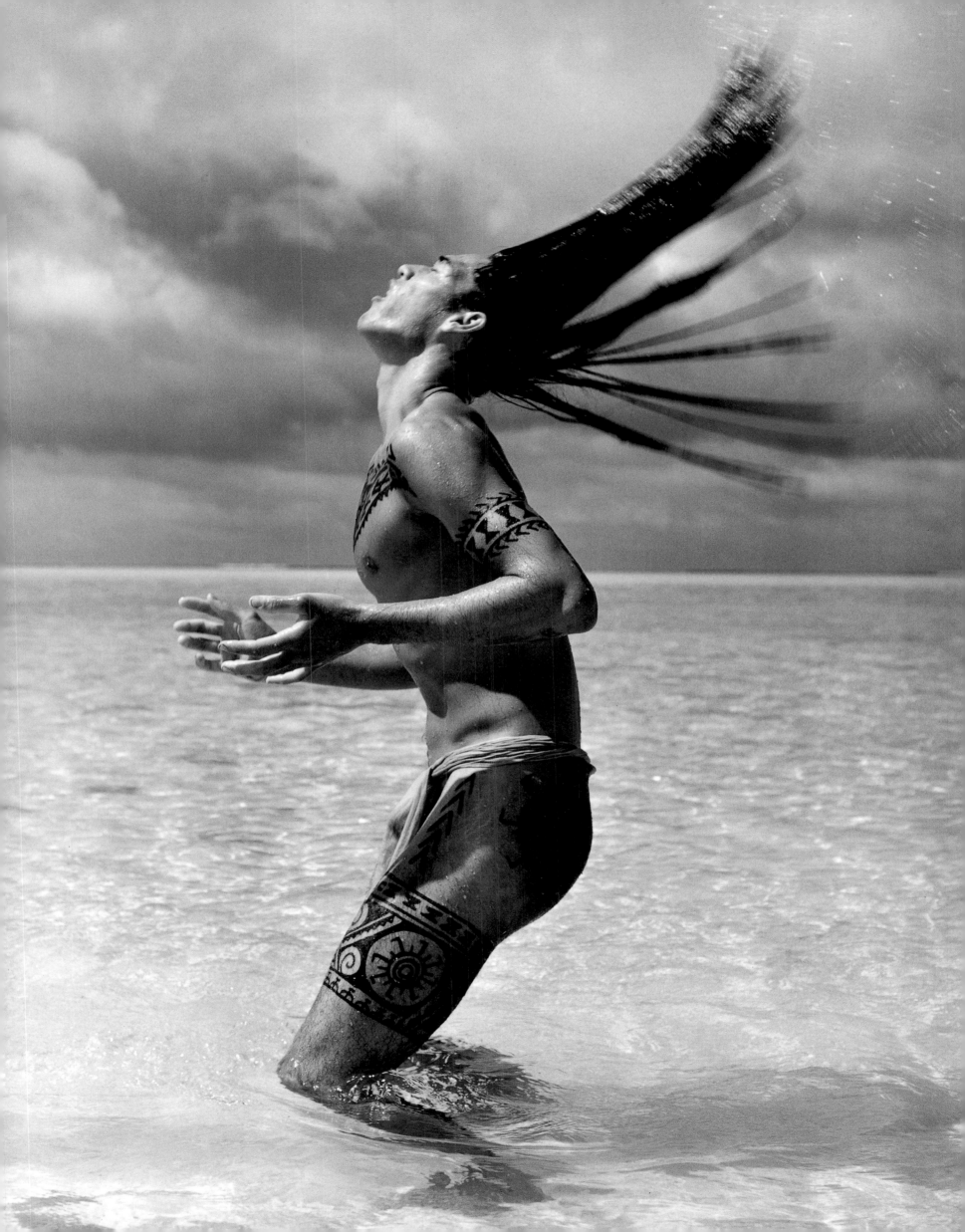

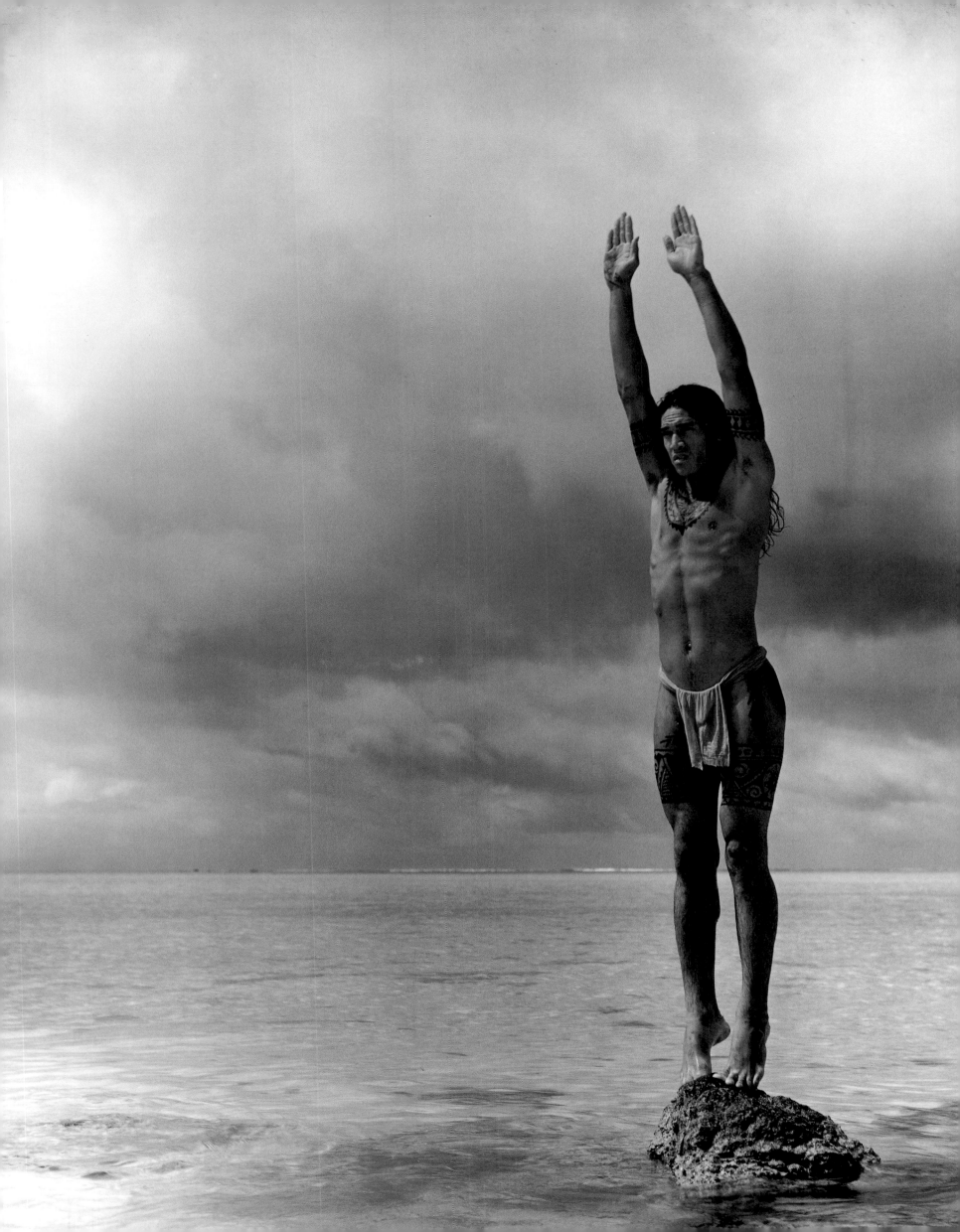

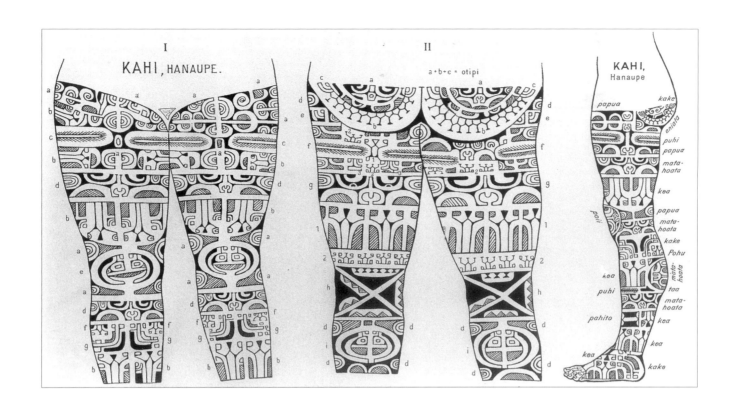

I
KAHI, HANAUPE.

II
a + b + c = otipi

KAHI,
Hanaupe

papua
kake
oniata
puhi
papua
mata-hoata
kea
papua
mata-hoata
poii
kake
Pohu
kea
mata-hoata
puhi
taa
mata-hoata
pahito
kea
kea
kea
kake

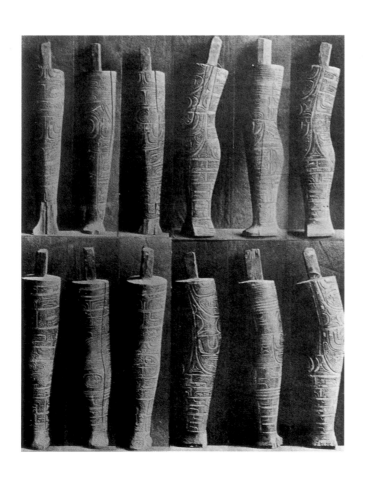

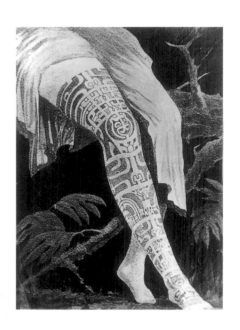

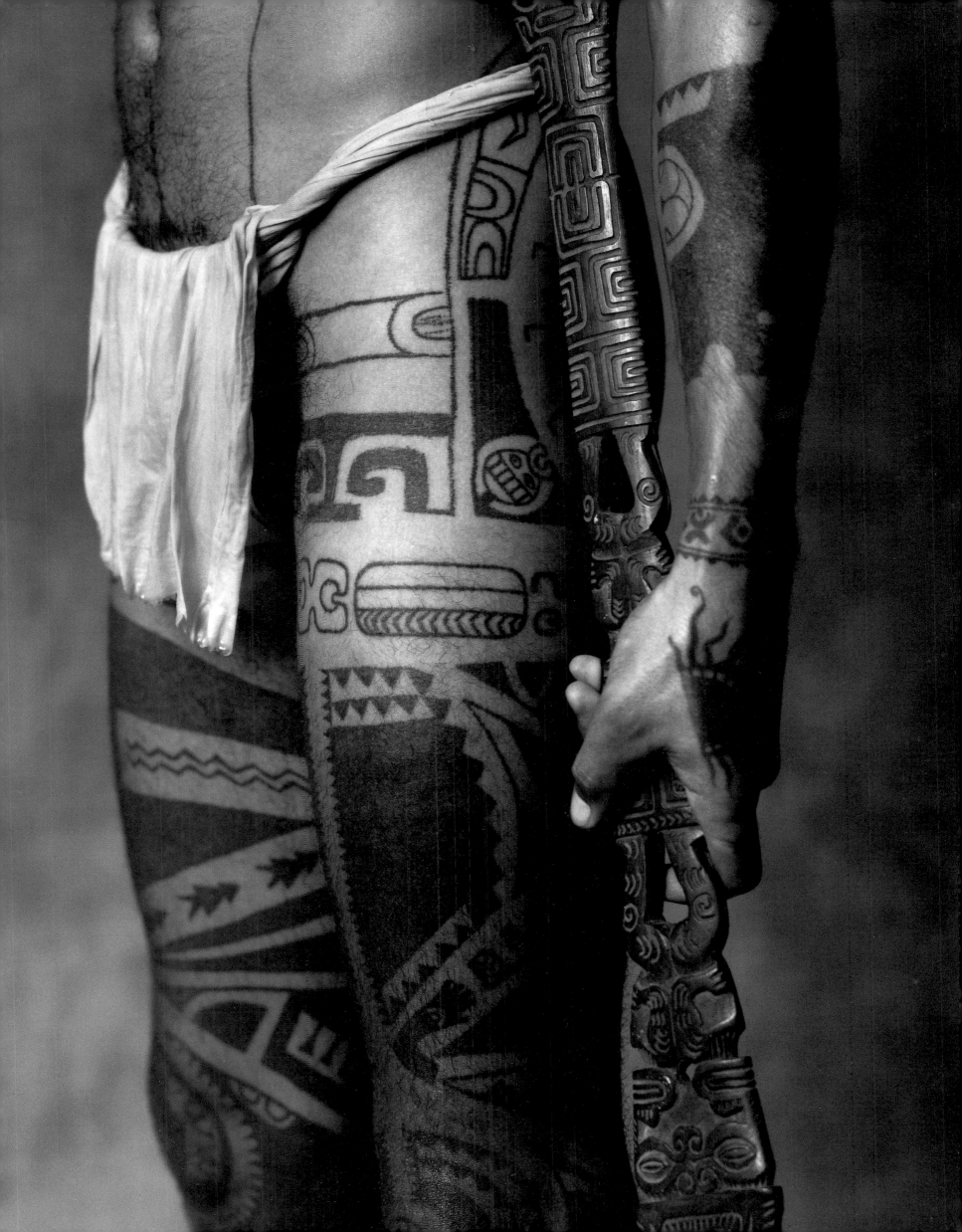

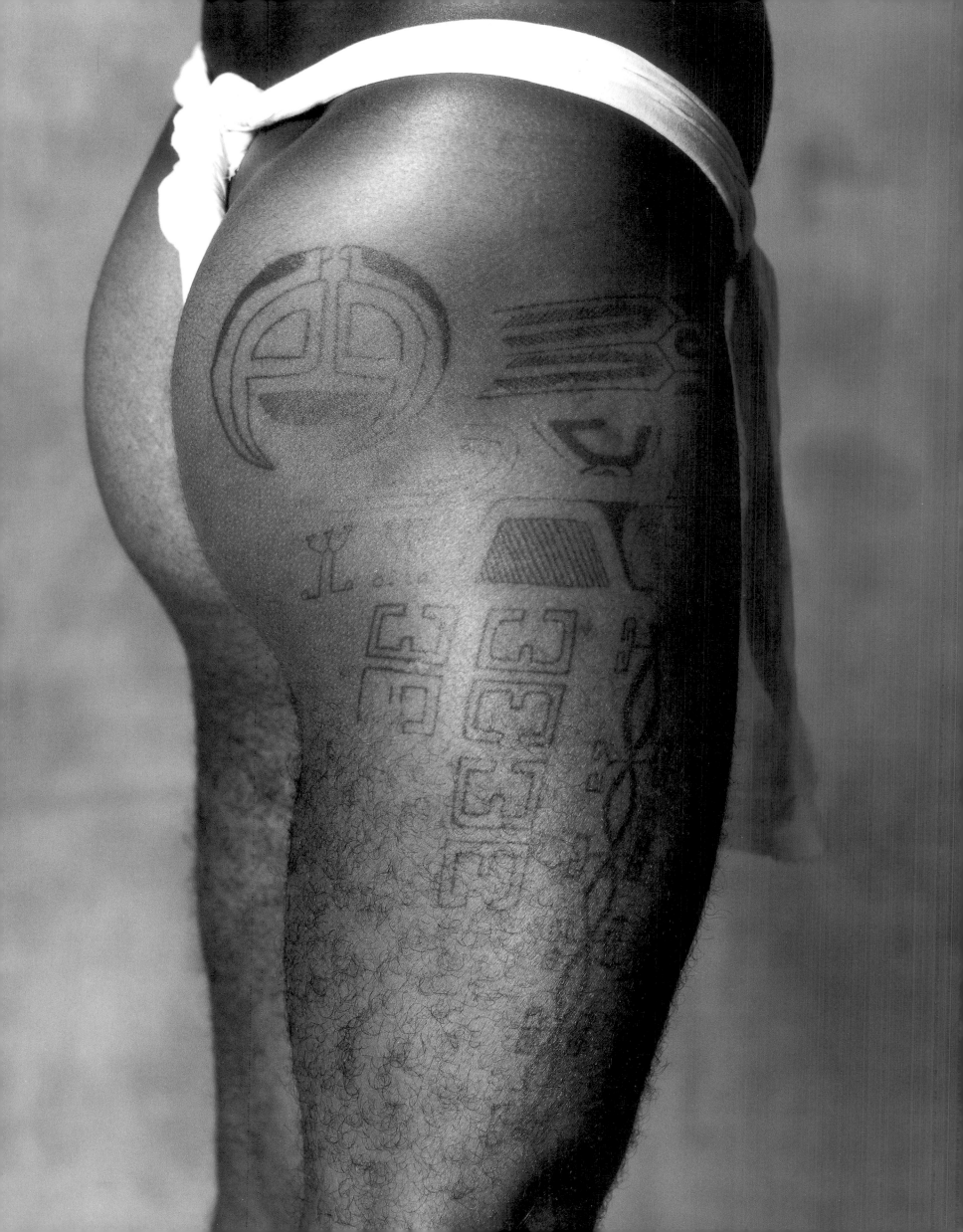

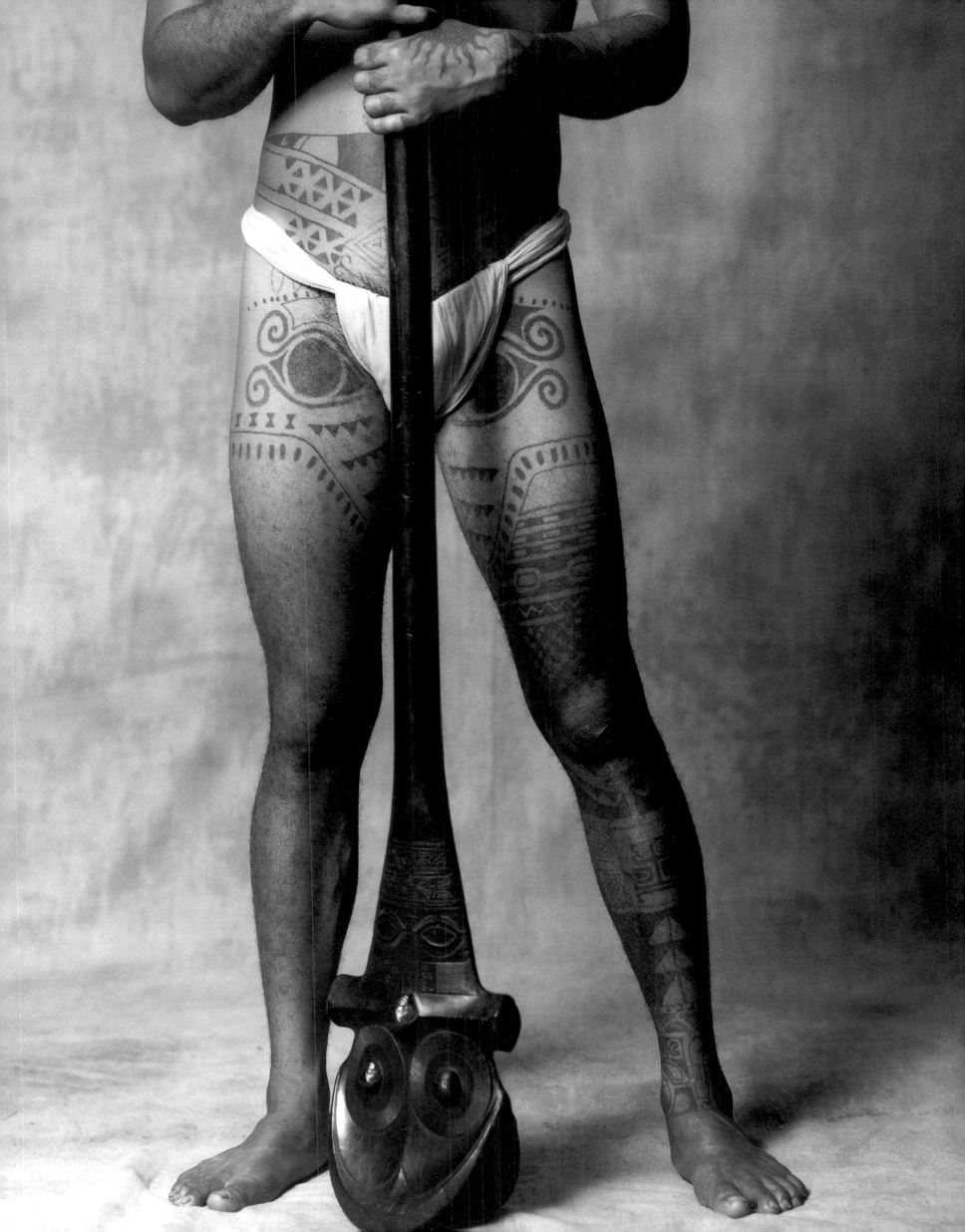

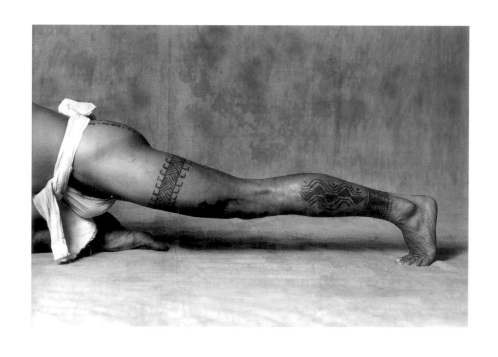

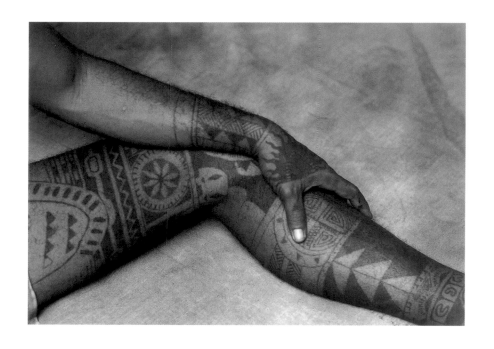

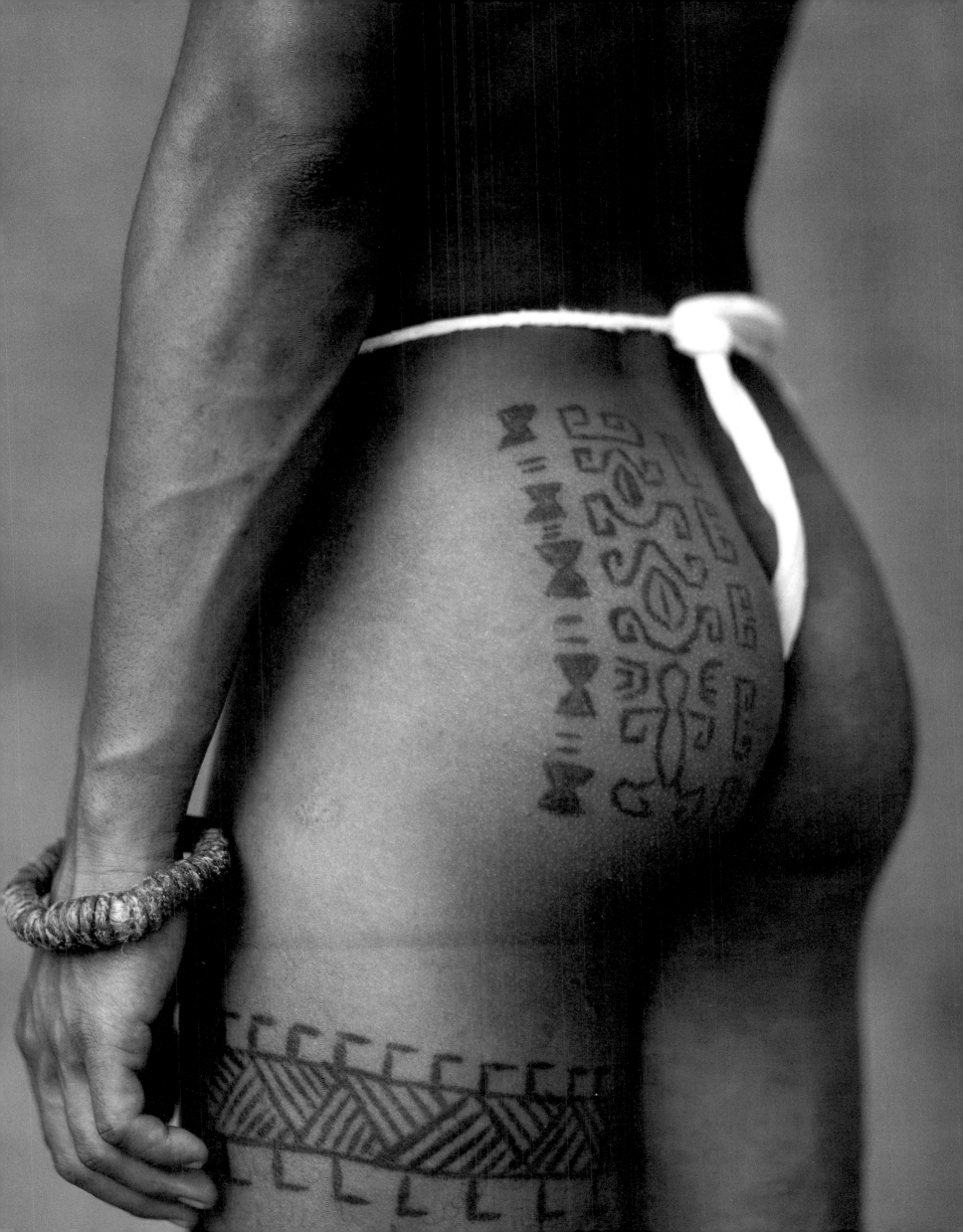

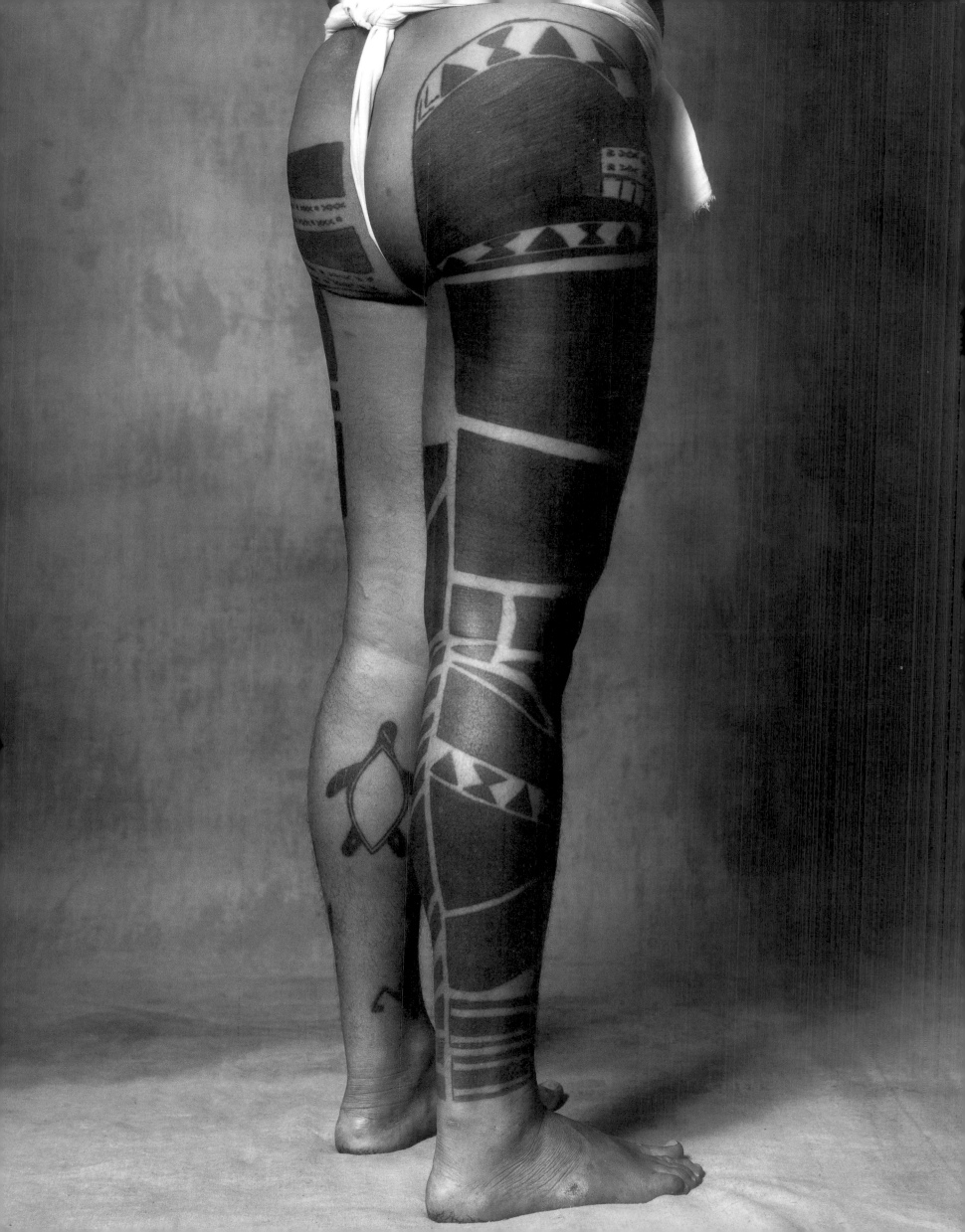

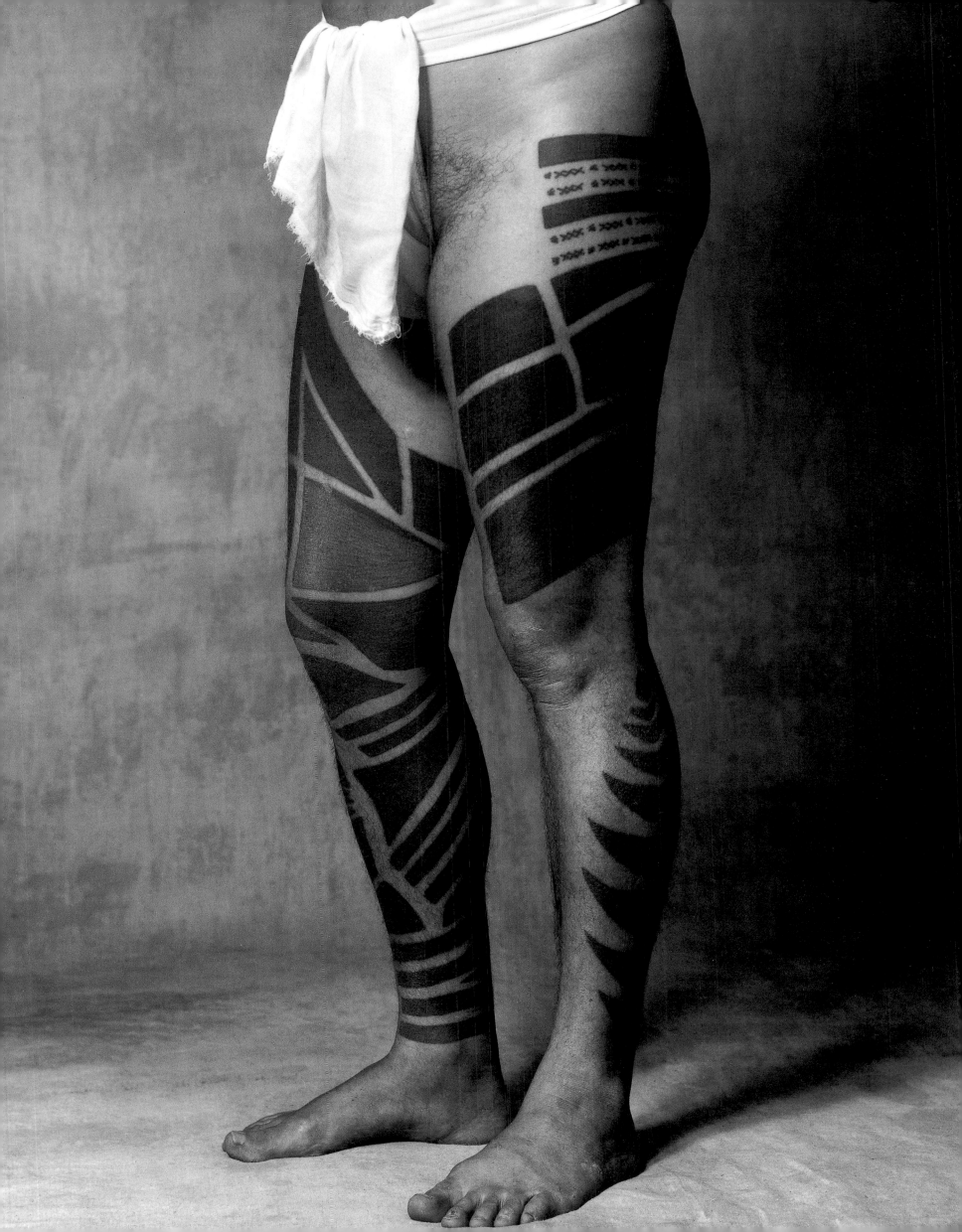

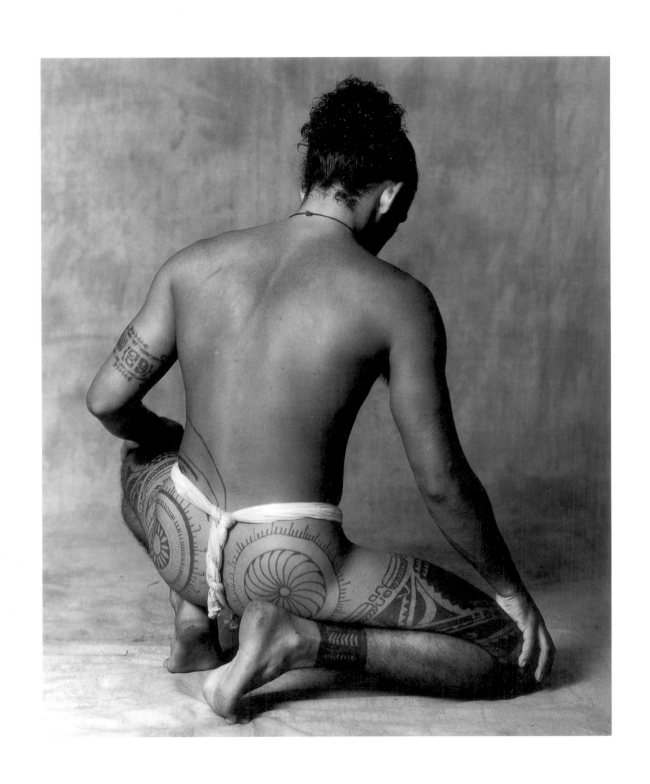

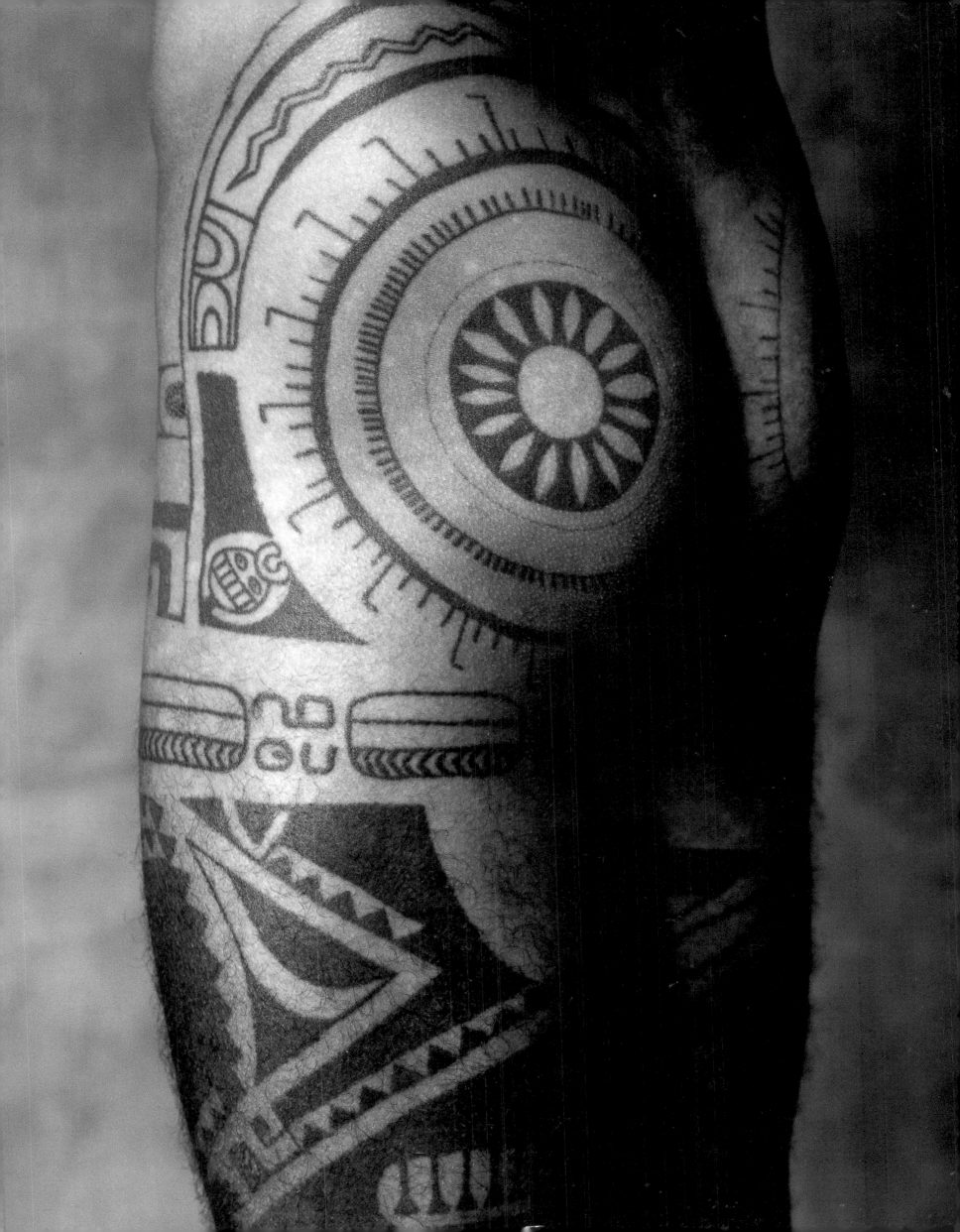

Thanks to

Manouche Lehartel
Director of the "Musée de Tahiti et des Iles"
for access to original ancient artefacts
in the Museum collection

Patrick Picard Robson
of the Tahiti Tourist Office

Perles de Tahiti
Musée Gauguin
Daniel Palacz
Patrick Brunel
Teiki and Lorenzo
Tumata Robinson
Centre des métiers d'art de Papeete
Ellacot William
Tarita Teriipaia
Lagonarium Tahiti
Robert Wan

Special thanks to

Fernando Chiesa
Martin Coeroli
Alberto Vivian

Photographs

Gian Paolo Barbieri
Assistants
Fabio Russo
Nunzio De Martino

Graphic design

Armando Chitolina
Assistants
Caterina Balzani
Alberto Meneghetti

Research

Auro Varani

Photographs printed by

Studio Parolini

Photographs retouched by

Giorgio Santagestini

Polaroid Italia

Illustrations taken from

"Die Marquesaner und ihre Kunst"
by Karl Von Den Steinen, Hacker Art Books, NY 1969

"The Art of Paul Gauguin"
National Gallery of Art, Washington (DC), The Art Institute of Chicago

© 1998 Benedikt Taschen Verlag GmbH
Hohenzollernring 53, D-50672 Köln
© 1998 Gian Paolo Barbieri
Photographs: © 1998 Gian Paolo Barbieri
Graphic design: Armando Chitolina, Stu lio grafico, Milan
English translation: Chris Miller, Oxford and George Giles Watson, Udine

Printed in Germany
ISBN 3-8228-7763-8
GB

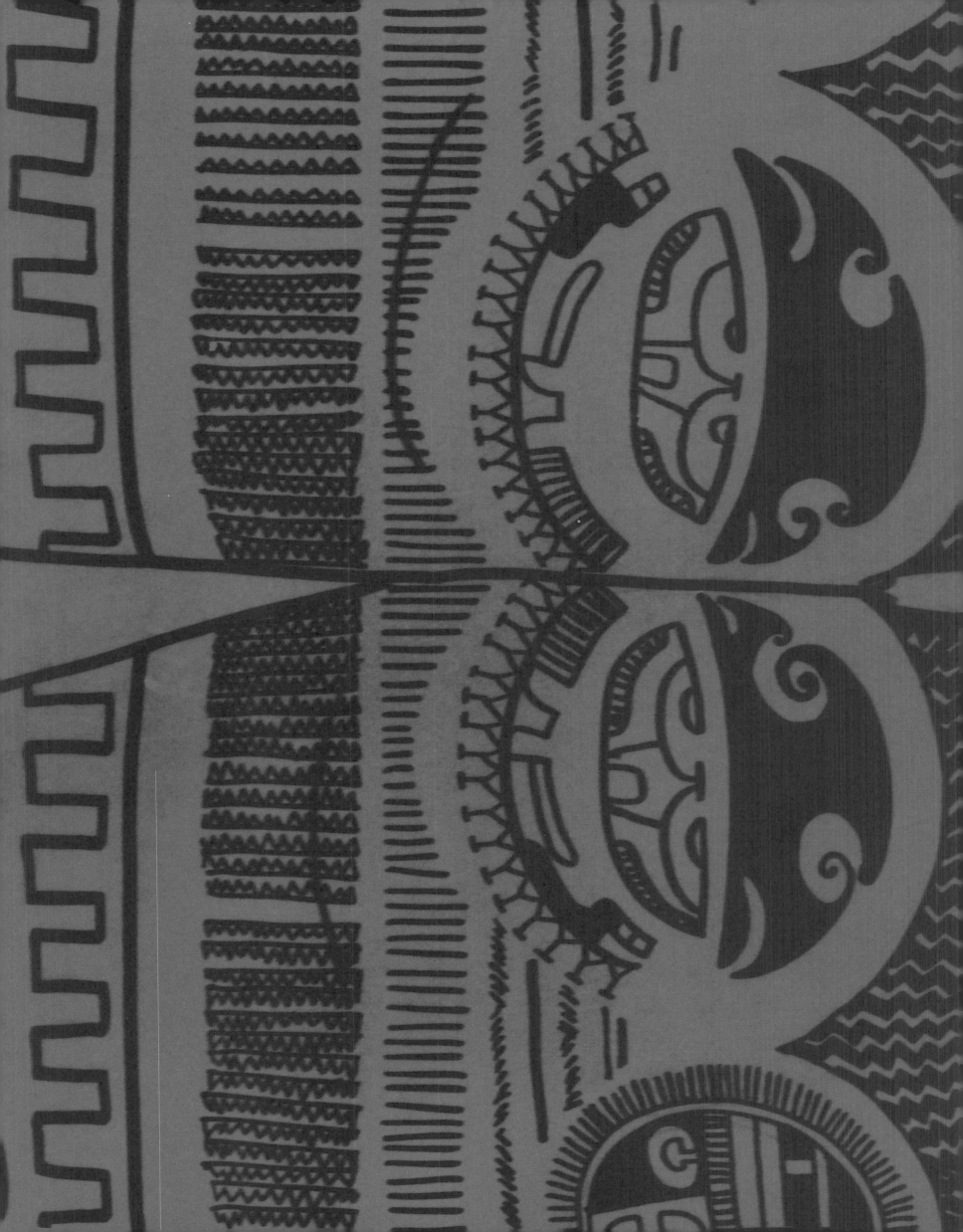